The Contemporaries

The Contemporaries

TRAVELS IN THE 21ST-CENTURY ART WORLD

Roger White

WITHDRAWN

BLOOMSBURY

NEW YORK · LONDON · NEW DELHI · SYDNEY

Bloomsbury USA
An imprint of Bloomsbury Publishing Plc

1385 Broadway	50 Bedford Square
New York	London
NY 10018	WC1B 3DP
USA	UK

www.bloomsbury.com

BLOOMSBURY and the Diana logo are trademarks of Bloomsbury Publishing Plc

First published 2015

ISBN: HB: 978-1-62040-094-4
PB: 978-1-62040-096-8
ePub: 978-1-62040-095-1

LIBRARY OF CONGRESS CATALOGING-IN-PUBLICATION DATA

White, Roger, 1976–
The contemporaries : travels in the 21st-century art world / Roger White.
pages cm
ISBN HB: 978-1-62040-094-4
PB: 978-1-62040-096-8
ePub: 978-1-62040-095-1
1. Art, Modern—21st century—Economic aspects. 2. Art and society—
History—21st century. I. Title.
N8600.W49 2015
709.05'12—dc23
2014029813

2 4 6 8 10 9 7 5 3 1

Typeset by Newgen Knowledge Works (P) Ltd., Chennai, India
Printed and bound in the U.S.A. by Thomson-Shore Inc., Dexter, Michigan

For Maggie

CONTENTS

INTRODUCTION

DAVID TRUE CAME to New York City to be an artist in 1967, straight from school in Ohio. He set up a studio in the garment district for a year until the landlord turned off the heat, and then he gravitated downtown, to a nameless neighborhood where a bunch of other young artists were moving. They were homesteading a declining industrial zone: plumbing and electrifying disused lofts, constructing ad hoc bars and cafes, opening cooperative galleries and performance spaces, and generally getting on with the business of making art. In 1973 he moved into a raw space upstairs from a cigar factory. It was cheap but overrun with mice, and he spent his first nights there on an army cot surrounded by a ring of mousetraps. When he'd heard enough squeaks and snaps, he would get up, empty the traps out onto the street, and reset them. In the morning he'd take a moment to admire the growing pyramid of dead mice beneath the window. And then he started painting.

In his first decade in downtown New York, David participated in the self-organization of a creative culture under nearly optimal conditions: lots of young people, ample space, low rents, and negligently enforced zoning laws. His memories of the time are dutifully mythic: visiting a junk sculptor on Mercer Street who kept warm by burning wooden pallets in a metal trash can in the middle of his loft; wading through seas of decomposing cardboard on Wooster to watch people dancing in a garage.

Art was everywhere—and it was all over the place too, moving in a million directions at once from the dominant art forms of the beginning of the decade, abstract painting and geometric sculpture. David saw Nancy Graves's life-size camels, made of burlap, fur, and fiberglass, uptown at the Whitney Museum of American Art; he ran into Gordon Matta-Clark welding scrap metal to stop signs and lampposts on the deserted streets of the neighborhood. He watched Joseph Beuys perform *I Like America and America Likes Me* in a shabby upstairs gallery on the corner of Grand and West Broadway. The piece is now a canonical work cited in every recent history of art; at the time, it was just a little-known man from Düsseldorf who had inexplicably locked himself in a room with a coyote.

As the gravitational force of the downtown scene drew other interests to SoHo—as this neighborhood came to be called—real restaurants and bars replaced the art restaurants and art bars, commercial galleries opened next to or in place of the cooperatives. This migration laid the groundwork for the explosive art-market growth that would begin in earnest a few years later and continue, more or less unabated, to the present day.

By the time I met David in 2000 and walked around the neighborhood with him, its art scene was a faint residue underneath SoHo's gleaming retail grid. I could almost imagine costumed actors, à la those at Colonial Williamsburg, paid to walk the streets dressed as young artists from the 1970s for the entertainment of tourists. I pictured them climbing up and down the stairs of de-furbished lofts, smoking and gesturing wildly, replaying the circumscribed world of art as it existed in New York thirty years ago: a seven-block radius and a sense that things were just about to start happening.

They were: this vision of the art world is completely different from the one I was getting to know in the first years of the new millennium. Processes that began in David's heyday had completely transformed the landscape.

While David had come to the city to camp out in a loft, I came to attend graduate school—he was one of my teachers in the MFA program at Columbia University. In a few decades, the idea of being a professional

artist had gone from a join-the-circus fantasy to a plausible vocation for scores of young people in America. Contemporary art was now fully incorporated into the curricula of colleges and universities, and I took part in what was nearly a mass movement toward the field; more artists now come through art programs in the United States each year than were produced by the city-states of Florence and Venice during the entire fifteenth century.

Because there were more of us, the communal dramas of my artistic milieu—who were we, as artists? What would we be remembered for? How would we pay the rent?—were being played out at that exact moment in countless other places: not just all over New York but also in Pittsburgh, San Antonio, Mexico City, Leipzig, Seoul. What's more, we knew it: the comfortable illusion that my friends and I were unique had been dispelled by the glare of the digital media. A few clicks brought up both the mounting archive of art history from Lascaux onward and the even more staggering volume of art being made right now.

After two years spent becoming a master of fine arts, I—much like David—headed for the nearest cheap, artist-friendly neighborhood I could find, along with all my peers. Manhattan was off the table; we were definitely looking in the outer boroughs—Bushwick, Gowanus, Long Island City, Sunset Park. Some were post-postindustrial neighborhoods in the midst of creative-sector occupation and had cosmetic similarities to the SoHo template: wherever I lived, the heat was bad and I usually had mice. But the life cycles of these neo-bohemias seemed to be running in fast-forward: no sooner had they emerged as potential artists communities than they were too expensive to live in anymore. So we moved outward from the center of the city in an expanding ring.

As we tried to get our work recognized, we interfaced with dealers, critics, consultants, and curators. More and more often, these people had been through years of school too. It was unclear, in fact, where academia left off and the art market began. The minute we'd set foot in our first seminar room, we were all already inside the industry. The professional art world came complete with career training and business etiquette,

sophisticated trade publications, and a dense thicket of interlaced insti-
tutions. Major galleries now enlisted the services of PR firms to sculpt
the reputations of their artists. Works traveled across the country and the
world between the hubs and nodes of the network.

The money looked phenomenal. Collectors of contemporary art were
a varied lot: upper-middle-class enthusiasts, prosperous urban profession-
als not five years out of college, large and small corporations with salaried
art advisors, the megarich from all corners of the globe—not to mention
the assorted film stars, pop stars, and famous athletes who contributed to
the art world's growing celebrity cachet. Art fairs helped in this regard:
flush with sponsorship cash from car companies, liqueurs, or banks, they
swelled to accommodate these steadily multiplying throngs of mobile
buyers and spectators now following the contemporary art market on its
dizzying ascent. Art was discussed openly and seriously as an asset class
and a portfolio diversifier, young artists as investment opportunities. A
wag in Chelsea called his first gallery show "Initial Public Offering."
Whirlwinds of financial speculation sucked auction prices up into the
stratosphere.

Not just the whole but also the parts were getting bigger. Museums
franchised themselves, and prominent artists followed suit. Art-making
had gone from the intimate creation of handmade goods, or the mod-
est pursuit of ad hoc experiments, to the quasi-industrial manufacture
of objects for a global market or ambitious ventures into other modes
entirely: feature films, festivals, political movements. The whole thing
resembled, in scale and complexity, a hybrid of fashion, continental phi-
losophy, organized gambling, and the adjacent sectors of the entertain-
ment industry into which art seemed to be rapidly dissolving.

This is the art world at first glance: professionalized and financialized.
But a closer look reveals profound tensions within the whole churning
apparatus and deep contradictions at the foundation of the industry.

The economics of the contemporary art world presents the most
salient of these. Despite well-publicized extravagances at the high end of
the market, art remains a subsistence occupation for most people involved

in it. And as the economic value—of a work of art, an MFA program, or even a museum—comes to the foreground of popular consciousness, it threatens not just the structure of the art world but also perhaps the nature of art itself. Is being an artist a job like any other? Is a work of art simply one more product in the marketplace? Treating it as such displaces other accounts of art's significance: as critique, philosophical inquiry, social experiment, quest for beauty and truth. Contemporary art dramatizes the perceptual blurring that happens when the same object is regarded by different actors as a commodity, the focus of critical or academic study, and part of a life's work. Because time-traveling back to simpler days isn't a viable (or necessarily attractive) option, participants in the professional art world encounter the realities of its thoroughgoing institutionalization in a variety of ways: adaptation, embrace, resistance, flight.

These attitudes are expressed within, and through, the pluralization of contemporary art. A casual sampling of significant works in any exhibition season reveals an unprecedented spectrum of art objects, actions, and events: interactive theatrical tableaux, sculptures made via state-of-the-art digital imaging, small and homely wood carvings, hacked computer games and Internet archives, paintings that look like older paintings and paintings that look like new advertisements, functional schools and health clinics, seemingly random accretions of found industrial waste, slick digital videos and jerky 16mm films, dance routines, lectures, slide-shows, cars, chairs, houses, hair salons, nothing.

Decades after theorists of art inveighed against pluralism (seeing in it a diffusion of art's critical potential), it's an entrenched principle within the field.[1] A critic or journalist could spend a lifetime charting the shifting arrangement of discordant genres that coexist more or less peacefully under the heading of contemporary art. This, too, isn't without its complications. Counterintuitively, the wildly expanded range of art's material and conceptual possibilities (from trash to databases) has meant a commensurate restriction of art's definitions: In the vast, heterogeneous field of culture, contemporary art is what passes through the institutional wickets of the school, the market, the art press, and the museum. At a

moment in which digital technologies enable the widespread production of images and objects, this institutional imprimatur is one way that contemporary art is set apart from, and valued over, the myriad of aesthetic forms our society generates on a daily basis.

This book considers the ways that artists encounter the contradictions of the art world and respond to them in the form of art. It examines the interplay between the creative imagination and the circumstances that shape and galvanize it—a dynamic exchange that drives contemporary art forward.

To tackle its subject, the contemporary art world, in all of its exhilarating, self-contradictory sprawl, the book is presented as six parts: each presents one aspect of the kaleidoscopic whole. Like artworks in an unruly exhibition, the chapters echo, amplify, and argue with one another, presenting a recent history of art-making and a glimpse at where it might be heading.

The first half of the book addresses three complex situations, and it begins where most artists enter today's art world: the academy. The escalating popularity of MFA programs has come during an era in which there's scant agreement across the field of art education about what teachers should teach, or what students ought to learn, about the business of being an artist. Curricula are hotly contested from one program to the next, and fault lines of aesthetic and ideological difference emerge within faculties. And as the art market retracts from its high-water mark in 2007, it's possible that today's crop of MFAs—frequently shackled by tens of thousands of dollars in student loan debts—may face even more astronomical odds than their predecessors. Chapter 1 looks at one program in particular, the MFA in painting at the Rhode Island School of Design, during one of its marathon group critiques of students' work. As the students and faculty wrestle with the particular meaning of each piece of art on display over the course of multiple sessions, the economics and goals of art education constitute the unspoken subtext of the critique.

Emerging from the academy, young artists face the age-old problem of how to make a living while making their art. Many solve it by making someone *else*'s art. For as long as art has been a vocation, artists have

employed studio assistants—from the young apprentices in Renaissance Europe who worked their way up from cleaning brushes to painting scenery, to the collegiate acolytes in the 1950s and '60s who helped aging Abstract Expressionists stretch their enormous canvases. The explosion of artistic forms in the past half century, and the massive growth of the global art industry, have created a new welter of working relationships around the practice of art; some of them pose serious challenges to even the most cavalier notions of authorship and creativity. Chapter 2 looks at the history of assistantship from the assistant's perspective (through accounts of studio life from Domenico Ghirlandaio to Jeff Koons) charting the recent evolution of labor in art-making—and our understanding of what constitutes labor.

One result of the educational and cultural mainstreaming of contemporary art is a country dotted with regional art centers and connected by digital media. But for all that, the art industry in the United States is still consolidated in three market centers: New York, Los Angeles, and Chicago. As these centers become prohibitively expensive for young artists entering the field, many of them search for alternatives. In the third chapter, I investigate the politics of localism in contemporary art—a contested topic for much of the twentieth century and into our own—in the relatively small but unusually visible contemporary art locale of Milwaukee, Wisconsin. There, a handful of enthusiastic artists have constructed an internationally prominent DIY art scene without the support of an indigenous art market or institutional structure.

The book's second half examines three artists and their divergent approaches to art and career. A close look at these contemporaries lets us see differences and commonalities within the category of art, and how conditions in the greater field of art shape individual artistic practices.

During the 2000s, the combination of a massive contemporary art bubble and a thriving MFA system meant that it was entirely possible to go from art student to art star without slogging through tedious years of struggle, bedbugs, and temp jobs—a once-obligatory chapter in the artist's life. This confluence itself coincided with a periodic upswelling of general interest in painting, a medium famously declared dead by the art world

every few decades. The result was a perfect storm of painters who vaulted from thesis exhibition to commercial success in a few deft steps, through combinations of talent, timing, and luck. Dana Schutz, one of the most celebrated painters of recent years, had all three, and within a few years of graduation she had amassed a substantial record of shows, reviews, and collectors from New York to London to Venice. Chapter 4 appraises her work and career in relation to its many contexts: the vicissitudes of the art market and upheavals of the United States economy, the rise of Internet culture, and the political climate of the "war on terror." "Six Dana Schutzes" asks how painting, the most traditional of artistic media, can represent current events in the age of digital communication.

The uncategorizable work of artist Mary Walling Blackburn occupies a very different position in the greater scheme of contemporary art than Schutz's. Comprising performance, video, sculpture, dance, and criticism, and engaging its audience in challenging interactions, it seems tailor-made to elude the commercial system of the art world. At the same time, Walling Blackburn herself must negotiate the institutional landscape that contours the life of the young artist today. Chapter 5 follows her through a series of projects that unfold across media: an experimental school, a re-created documentary, a transnational exercise in UFO-ology. At stake in her work—and the chapter—are the relationship between artist and audience, and the changing nature of critical art.

Chapter 6, "The End," is a survey of the unique, five-decade career of Conceptual artist Stephen Kaltenbach. In 1970, Kaltenbach left a vaunted position in the bustling downtown art scene for a nearly anonymous professional life in Northern California. Thirty-five years later, he reappeared as a very different kind of artist and resumed participating in the international art world. This chapter looks at what happened to Kaltenbach in the meantime—an experience that the artist claims as a work of art in its own right. "The End" is both a pre-history of contemporary art, returning us once more to the flashpoint of the late 1960s, and a meditation on how contemporary art comes to historicize itself.

■ ■

I DECIDED I wanted to be an artist around the time I started high school, in the late 1980s. I grew up in an agricultural town in California called Salinas. Our family was comfortably middle class, but art was just not our thing; our thing was farming lettuce. So, like many young people in the United States who decide they want to be artists, I'd never actually seen a piece of art outside of a book, an art class, or the county fair. My knowledge base about art extended as far as Salvador Dalí, Andy Warhol, and the Arnason's *History of Modern Art* textbook from 1975 that my grandmother gave me. I also had a small collection of M.C. Escher T-shirts. I assumed that today's artists did something along these lines.

I also assumed that this was still called modern art. We were living in modern times, weren't we? And indeed, applied literally, the term "contemporary art" presents a conundrum: what art *isn't* made in its own time? Even Michelangelo was contemporary once.

Contemporary art, as the generally accepted name for the stuff that gets exhibited now in galleries and museums, bought and sold at major art fairs, written about in trade publications like *Artforum* and *Frieze*, and lectured about by art historians on the last day of Art Since 1945 class, has made a long journey to arrive at common usage.

The phrase made its institutional debut in London in 1910, with the formation of the Contemporary Art Society—nineteen years, even, before the Museum of Modern Art opened in New York. In 1946, London's Institute of Contemporary Arts was founded, and two years later, the Institute of Modern Art in Boston followed suit and adopted its current title, the Institute of Contemporary Art.

In these early uses, "contemporary art" explicitly meant art made by living artists. The Society was a philanthropic fund that bought such art and gifted it to museums, and the London and Boston institutes prioritized exhibiting the work of the quick over that of the dead.

It's only within this century that the term has come to designate something more specific and theoretically concrete than art made in the present day and to enter into dialogue with taxonomical relatives like "modern art" and "postmodern art." And there's still no consensus about when contemporary art began—or about whether you could meaningfully

answer that question with any specific date or precipitating event. The year 1989, that of the fall of the Berlin Wall and Tiananmen Square, is a commonly cited if provisional starting point.[2] But ever since the term took hold in discourse, it has functioned like a backdated check: earlier and earlier works of art or movements—from decades that are firmly in the past—are now described as examples of contemporary art.

As with the term "modern art," a chronological adjective tells us quite a lot. Modern art is both made during the modern era and concerned with ideas of progress, self-reflection, newness, and experimentation. Likewise, contemporary art isn't just the art that happens to be floating around in the galleries right now. In its broadest definition, it's a form of art philosophically concerned, perhaps even obsessed, with the idea of *right now*.

As you've no doubt experienced, *right now* is a hard idea to wrap your head around. It's at once immediately, intuitively graspable and difficult to theorize; blink and you've missed it. The experience of *right-nowness*, or contemporaneity, is also, by and large, composed of the experience of other times: of memories and anticipations, what you were doing last week, year, or century, and what you might do tomorrow.[3] Being in the moment is the province of yoga or unconsciousness.

Many of these subjective qualities carry over into contemporary art. Despite its much-vaunted complexity or unintelligibility, a lot of it is at least partially accessible to us by virtue of its materials and subject matter, which are both derived from the time we share with it. *Untitled* (*Perfect Lovers*), a piece of Conceptual art made in 1990 by Felix Gonzalez-Torres and consisting of two synchronized clocks installed next to each other on a wall, may suggest themes of intimacy and mortality in the era of AIDS. Cady Noland's *Gibbet*, a minimalist re-creation of a village stocks (holes for hands, feet, and head) adorned with an American flag, will most likely have something to do with punishment and the state. But even as they lend themselves to understanding, translating these works into propositions about the nature of the world (or even just the nature of art) is a complicated endeavor: the meaning of the art is unfolding in real time, part and parcel of the real-world conditions it describes.

Contemporary art is also preoccupied with times other than the present. It places a significant premium on tomorrow: the next thing, the newest development, the cusp. But yesterday and the day before are crucial as well. Unlike the supposedly straight line of progress followed by modern art, contemporary art has a tendency to loop and double back, repeating itself or jumping abruptly between different points in time. It revisits and rekindles art forms of the past. A lot of it doesn't even look particularly *right now*; one surprise of recent art has been the resurgence of traditional media like ceramics and textiles, now seen in cutting-edge galleries and museums rather than at craft sales and in folk art contexts. Perhaps when we look back on contemporary art (the "post-contemporary," though not quite here yet, is an historical inevitability), its most significant feature will have been its anachronism.[4]

■ ■

THE IDEA OF contemporaneity has been given a huge boost by recent history; its availability to thought is a function of the technologies, ideologies, and political orders that make it possible for us to imagine the present as something experienced by everyone in the world. And while contemporary art is a transnational phenomenon, reflecting on and made possible by the flows of capital and information that mark the era of globalization, this book is somewhat strictly limited to the consideration of art made very recently in the United States.

Why is this? For one thing, the issues of education, work, and geography it tackles, though certainly not unique to the context of art in the United States, all have particular shapes in this country. I'm most familiar with these shapes, rather than the versions of them existing elsewhere in the world.

For another, during an epoch in which other forms of culture have followed clear paths into the digital (consider the film and music industries), contemporary art has kept one foot stubbornly planted in real space. It's among the few fields remaining in which you go to experience

culture, rather than it coming to you. Gallery and museum exhibitions, biennials, even art fairs, propose a spatial, bodily interface with the work of art, standing in front of it or in it—even if the work itself isn't something that can be related to physically. This carries over into most aspects of the culture of art: artists exchange studio visits (even if they no longer work in studios), curators travel to sites to prepare exhibitions, and art is still largely bought and sold in person. This is all changing, of course, though more slowly than anyone might have predicted. But to spend the most possible time looking and talking in person, and to produce a book that aims at being intensive rather than extensive, I fixed the boundaries of my travel in practical terms.

This is also, for the most part, a book about artists. Other types of people show up in it, certainly—critics, dealers, collectors, curators, historians, et cetera—but artists are indisputably at the center here. This, too, comes with a caveat: there are many cooks in the kitchen of contemporary art, and artists play only one part in preparing the meal. Besides, one of the realities of life in the art world that the book documents is that few people do only one thing in it anymore.

I'm an artist myself and I like hanging out with other artists. They've chosen to make their lives in a challenging and perplexing pursuit, and to let that pursuit make their lives. They're also closest to what I've come to see as the defining moment of contemporary art: the one in which meaning seems to emerge from thin air, something new becomes visible, and the fun begins.

1

THE ART SCHOOL CONDITION

CONTEMPORARY ART IS *a cuttlefish*, I thought, looking down at the video monitor on the table. *It glides through the ocean of the present, tentacles waving, taking on the color of everything it passes.* On the screen, animated figures ran back and forth against a jungle backdrop. The image had the washed-out, runny look of an old VHS tape copied and recopied, then digitized and compressed. I made a note: be sure to mention this washed-out, runny look.

Or, it's a vast, continent-spanning fungus: on the surface it seems like a million different organisms, but underground it's all one big mushroom. The crit space was filled with an impressive amount of work that everyone was trying not to bump into as they milled around, clutching paper cups of coffee and dragging folding chairs. A person-size linoleum obelisk rested on a kidney-shaped swatch of Astroturf. A pedestal displayed the base of a piece of kitsch ceramic statuary, now absent its shepherdess or sad clown. A wood-paneled partition created an alcove in one corner of the room, lined with red shag carpet and decorated with collages and drawings. The four monitors on the table broadcast loops of footage (the telecast of a professional football game, some home movies, the cartoon I was now staring at), creating a dense, lurching noise. The overall effect of the installation was of a suburban rec room that had been dismantled,

its contents itemized, placed in boxes, and shipped to Providence, Rhode Island, and then carefully reassembled by people who had no idea what a suburban rec room was. By aliens perhaps. (I wrote down "aliens.")

What was the mythological creature with the head of a lion, the body of a horse, et cetera? Ah ha. *Contemporary art is a chimera. It has the head of pop culture, the torso of critical theory, and the loins of finance capitalism.* Was this a better or worse analogy than the cuttlefish, the fungus? I was floundering. The cartoon figures rushing maniacally around on the screen resolved into professional wrestlers from the 1980s. I recognized Hulk Hogan, Captain Lou Albano, and one other, tantalizingly familiar . . .

People were now vying to position their chairs on the side of the room opposite the table with the TVs on it. "Can you turn the sound down?" somebody asked. Doug, the artist whose work we were contemplating, leaned over and fiddled with some knobs. The noise subsided to a low hum.

This was Wednesday morning, the third and final day of the spring 2012 midterm reviews at the Rhode Island School of Design, Department of Painting, Master of Fine Arts program. I was there to offer feedback to the students in my capacity as a critic for the department. We (nine faculty in all, including myself, and nineteen students) had been critiquing art more-or-less nonstop since Monday evening.

We had seen and discussed many things: tie-dyed bedsheets, a chair made out of concrete, a copy of a Picasso painting, a photograph of spackling paste. My concept of painting, not to mention art, was starting to fuzz out around the edges. Jimmy "Superfly" Snuka—that was the name of the wrestler. There were five more critiques to get through today.

The midterms at RISD last thirty-five minutes each, with five-minute breaks in between and an hour for lunch. To keep to this schedule, the reviews alternate between two critique rooms in the studio building, one on the second floor and one on the fourth. A complex choreography takes place between the sessions. While the rest of the group migrates from one room to the other, the student whose review has just ended and the student whose review will happen forty minutes later stay behind, to

help each other take down and hang their respective artworks. Both then rejoin the session under way, like performers returning to the stage in the middle of the next scene. In theory, this allows a fluid process of nonstop art criticism with minimal downtime. With so much art to talk about in so little time, even short interruptions or overages can snowball into extensive delays, with cascading disruptions to professional and private life: canceled classes, missed trains, unpainted paintings.

Each art school is a world unto itself, with its own deeply ingrained manners and quirks, but I've done three semester's worth of midterm

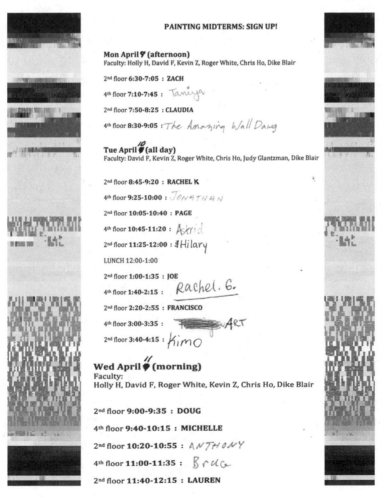

PAINTING MIDTERMS: SIGN UP!

Mon April 9 (afternoon)
Faculty: Holly H, David F, Kevin Z, Roger White, Chris Ho, Dike Blair

2nd floor 6:30-7:05 : ZACH

4th floor 7:10-7:45 : Taniya

2nd floor 7:50-8:25 : CLAUDIA

4th floor 8:30-9:05 : The Amazing Wall Dawg

Tue April 10 (all day)
Faculty: David F, Kevin Z, Roger White, Chris Ho, Judy Glantzman, Dike Blair

2nd floor 8:45-9:20 : RACHEL K

4th floor 9:25-10:00 : JONATHAN

2nd floor 10:05-10:40 : PAGE

4th floor 10:45-11:20 : Astrid

2nd floor 11:25-12:00 : Hilary

LUNCH 12:00-1:00

2nd floor 1:00-1:35 : JOE

4th floor 1:40-2:15 : Rachel. G.

2nd floor 2:20-2:55 : FRANCISCO

4th floor 3:00-3:35 : ~~ART~~

2nd floor 3:40-4:15 : Kimo

Wed April 11 (morning)
Faculty:
Holly H, David F, Roger White, Kevin Z, Chris Ho, Dike Blair

2nd floor 9:00-9:35 : DOUG

4th floor 9:40-10:15 : MICHELLE

2nd floor 10:20-10:55 : ANTHONY

4th floor 11:00-11:35 : Bruce

2nd floor 11:40-12:15 : LAUREN

Figure 1.1

reviews at RISD now, and I've begun to get a handle on the dynamics of the situation here. In the entire two-year MFA program, these are the only occasions in which the entire program is gathered in one place for a public discussion of a student's work, and a sense of ceremony accompanies each one. The midterms create a seasonal narrative. In the fall they tend to be harsher, and in the spring they're gentler. In the fall, students are stripped down in preparation for a cold winter of artistic self-doubt and desolation, and in the spring they're renewed, cultivated, and psychically reconstructed. The reviews are operatic: they reach soaring heights and plummeting depths of emotion, with boom-ing ensembles and sustained arias of enthusiasm or doubt, approval or invective. Like operas, they can also be tedious, and they're grueling for everyone involved. Page Whitmore, a second-year student, told me that the experience is "like getting the shit kicked out of you in the most lov-ing and respectful way."

From kindergarten through college, an art class means a room of peo-ple making art together: you flail with the crayons, paint, or clay, perform-ing a traditionally private activity in full view of the group. At the graduate level, actual art-making happens off-hours, outside the classroom. Here, an art class means conversation; the flailing is exclusively verbal.

Zach

On Monday evening, for the first session of this spring's reviews, we'd walked into a room full of sculptures, not paintings. This was less surpris-ing than it sounds. RISD organizes its graduate programs into separate, medium-specific fiefdoms (painting, sculpture, photography, digital media, and so on), but not everyone here in Painting makes paintings. Painting is more like an organizing principle, or a coat of arms, than an actual thing that students are required to do. So Zach, an artist in his first year in the program, was leading off the midterms with a group of festive assemblages in cardboard, wood, and fabric, dripping with whorls and

curlicues of brightly colored paint. They occupied the critique room like a clan of hippie street urchins. Perhaps as a concession, he had also tacked an unstretched canvas up on one wall.

Duane Slick, the director of graduate studies, called the group to order. Zach listed the titles of his sculptures, pointing to each: "This one is *Party with Punchbowl*, this one is *History Painter*, there's *Saskia*, *Prince*—"

Figure 1.2

"Prin-*TSS* or Prin-*SUH?*" someone asked.

"Prin-*SUH*. Then there's *Trap, Valentine with Meatballs, Time Machine, Tree, Dead Mermaid . . .*"

Someone asked for the chronology of the work, and Zach obligingly repeated the titles in order of completion: *Dead Mermaid, Valentine, Time Machine . . .* This ate up the first two minutes of Zach's allotted thirty-five.

"The first word that comes to his mind is *decorative,*" said Chris Ho, another critic in the department, and a few seconds passed while we mulled this over. The group had by now fanned out along the perimeter of the room, and we were craning our necks to see one another between Zach's sculptures. *Decorative how?* we wondered. Decorative as in *merely,* as in *frilly,* as in *the opposite of serious?* Or decorative as in *smart and subversive*—as in, Zach is embracing traditionally feminine practices hitherto marginalized by the discourse of advanced art? The word sat in the middle of conversational space like a thrown gauntlet.

Zach leaned on the doorframe, possibly contemplating a quick exit if the critique went further south on him, and didn't say anything. He wore a rumpled black blazer over an untucked gray shirt with dark-rinse jeans and black boots. He had big round glasses and a flop of brown hair parted on the right. At thirty-four, with a four-year-old daughter, Zach was on the older end of the age spectrum in the program. Whereas many of his classmates came in straight from college, undergraduate art school, or part-time jobs, Zach had been working in the trenches of the art world for about a decade, running a nonprofit gallery in Binghamton, New York.

After he was invited to interview for candidacy to the program in the fall of 2010, his house burned down—on the day after Christmas, no less—while he and his daughter were out. Firefighters saved as much of Zach's house and his stuff as they could.

A month later, he drove a van full of his surviving art to Providence for the RISD interview and stayed in a hotel. He went out to a bar and had a few drinks. He couldn't remember where his hotel was and had to

get a ride back there with the bartender, whose generosity of spirit made him feel that Providence was a fine place. He couldn't find parking on College Hill near the Painting Department offices, so he walked to the interview with his art in a plastic bag. The bag ripped, drawings floated down the streets of Providence in the snow. He showed up late. Earlier that morning someone had accidentally leaned against an expensive painting by a visiting artist that was hanging in the gallery outside the interview room. It had made a dent and everyone was freaking out. The interview began. A professor wondered what Zach ideally saw himself doing in ten years. "I don't know," he answered. "*Living?*"

"I want to know if Zach knows what Chris means when he says, 'The first word that comes to his mind is *decorative*,'" asked Holly Hughes, the chair of the department. Still nothing from Zach.

Chris clarified. "The objects are worked in a decorative way," he said, "and the elements that stick out for me as incongruous are the objects that are unmanipulated by you." One kitelike thing suspended from the ceiling with bungee cords had a tattered paperback copy of *Dianetics* strapped to it; another wore three or four electric bug zappers.

A professor named David Frazer voiced a preference for the single painting on display, a crudely painted room with a striped couch and a blobby pink humanoid in the foreground. The sculptures, in contrast, seemed aimless to him.

Zach was finally moved to a response. "I have a full concept of the shape and form of what these are going to be," he said, a little huffily.

I left my chair and walked out among the sculptures. It's good to have a strong opening line in group critiques, I've found, to let everyone know where you stand and that you're going to be a central player in the debates to come. There's a certain amount of verbal one-upmanship that happens when artists, who spend a lot of their time in small rooms by themselves, are suddenly put in a larger room with one another and told to have a conversation. All the day's pent-up language comes out at high velocity.

I pointed out a detail of Zach's art: at the base of several of his sculptures, he had placed small bowls with roundish lumps of painted clay in them. What could they mean? "They look like turds, or donut holes," I said. Silence from the room.

Holly was still goading Zach, trying to get him to commit to a line of interpretation. She listed things that his work reminded her of: the reality TV show *Hoarders* and "people being buried alive by their own possessions," the Burning Man festival, the choreographer Pina Bausch, German Expressionism—"you know, 'let's all get naked and play primal man.'"

"Are they hermaphroditic? Can they reproduce?" she asked. We surreptitiously inspected the sculptures for signs of male or female genitalia. Duane Slick called time.

Astrid

Different MFA programs structure their group critiques in different ways, determined by each program's idea about who should or shouldn't be allowed to talk. In the Painting Department of Virginia Commonwealth University, students undergoing candidacy reviews at the end of their first year introduce their work but refrain from speaking during critiques after that. In Mary Kelly's weekly three-hour critique class at UCLA, a former student told me, students under review maintained a strict silence until the end of the discussion. At Columbia, where I did my own MFA, everybody just talked over one another. I doubt that any of these protocols are ever written down; they seem to pass silently from year to year, slowly hardening into institutional habits.

At the start of each review at RISD, the student is given a few minutes to preface his or her work with a brief statement, and the rest of the critique is nominally open. In practice, the faculty talks for about 90 percent of the time. Even among us, it's hard to get a word in edgewise. You either have to cut someone off or time your remark down to the millisecond.

Each of the faculty members has a signature style of critique, with distinctive verbal flourishes and motifs. They function like an ensemble cast. Holly Hughes, the chair, gruff, good-natured, with whorls of auburn hair pinned back in a bun. Chris Ho, a stylish and animated young critic. David Frazer, a senior professor, white-bearded and avuncular, affably combative. Kevin Zucker, an associate professor and the youngest full-time member of the faculty, thin and quick-witted, with chunky glasses.

Joining them onstage are Dike Blair, a soft-spoken senior critic, in charcoal shirt and dark jeans; and Duane Slick, the director of graduate studies, in black jacket and jeans, who reserves most of his commentary for pivotal moments in the critiques. Lastly, your narrator, distracted during this session of reviews by attempting to simultaneously talk and write everything down.

For her review, Astrid chose to invite the group to her studio rather than to install her work in either of the critique rooms; her large inkjet prints are difficult to move around without dinging up the corners. She makes most of her art on the computer, so her studio is generally tidy, but for the review, it was immaculate: everything but her work had been pushed to the far end of the room and wrapped in brown kraft paper. We sat on the floor.

Astrid's work had to do with travel: pictures taken through the windows of a train showing a blurry landscapes, pictures taken through the windshield of a car as the windshield wipers swept across the glass. David Frazer pointed to several enlarged photographic close-ups of chunks of Spackle scraped against a wall with a putty knife. He preferred these to the car and train imagery, he said; the latter were based too much on taste. "Like someone who photographs a bunch of lovely doors in Puerto Rico and then arranges them by their palettes."

Kevin Zucker disagreed. The spackle pictures reminded him too much of the games at the back of the *Ranger Rick* children's magazine, in which the reader is presented with a cropped and magnified picture of a pebble or a ladybug wing and is instructed to guess what it is.

Before I went to graduate school, I thought that people there talked about art in crisp, gnomic propositions, laden with references to theory and art history. I'd imagined serious young artists trading glosses on Walter Benjamin, professors in black crepe jackets nodding sagely at sculptures and saying, *Ah, so you see, Conrad, the significance of the form is contradicted by the form of the signification.*

Later, I realized that that's how people *write* about art. How they *talk* is looser and rougher: an improvisational word-cloud breathed out around objects and endowed with a temporary, contingent significance, like the nonsense syllables that seem momentously important in a dream but evaporate upon waking. The talk is groping, tentative, fluid, but not always graceful. This is as much a matter of style—a preference for the offhand over the polished—as it is a necessary result of the way critiques are conducted. People are responding in real time to something they haven't seen before, and time is limited, so they tend to go with the first thing that pops into their head.

So here, for example, "Ranger Rick" became shorthand for the simple perceptual trickery that Astrid might be wise to avoid, and we batted the phrase around for a few minutes. Was the work too Ranger Rick? Is Ranger Rickness a valid agenda for art? What is the historical function of Ranger Rickitude? "Unless you're really going to blow my mind, I don't think it's enough," Kevin said.

"This may sound mean, but I mean it as the defense of a struggle," said Holly, who was perched on a paper-wrapped desk or file cabinet near the back of the studio. We quietly waited for her to rip Astrid's work to shreds.

She didn't. The meaning of Astrid's work, Holly said, is its inability to communicate the emotions of the artist regarding the subject matter it presents: the wan glances through car and train windows, the aching beauty of the irretrievable, infinitesimal moment between two passes of a wiper blade across a rain-streaked windshield. "You're continually referring us to something you value, and the mechanism of the art part is banging around and clunking," she said. We picked ourselves up and headed on to the next crit.

Claudia

The critique room on the second floor is a double cube of about seven hundred square feet with generously high ceilings, bisected by a thick support column. You enter on the northeast corner of the room and face a wall of windows with dark green wainscoting and vertical plastic blinds, grubby around the edges with residual charcoal and paint; the other three walls are drywall pocked with a million thumbtack-diameter holes, painted in layer upon layer of matte white latex. The floor is an institutional light gray. On the ceiling are strips of fluorescent lights and tracks of movable halogen floods—the floods counterbalance the deadening effect of the fluorescents on the art. A metal duct runs down one concrete column on the northeast wall, joining a system of intake vents and ducts that runs through each studio on the floor, collecting solvent and paint fumes and then moving them along a central pipeway, up an airshaft, and eventually out of the building through an exhaust fan on the roof in one big neurotoxic cloud. The whole system makes a continuous low whooshing sound, so the reviews sound like they're happening in the cabin of an airplane.

The critique room on the fourth floor is smaller, squarish. It's on the western corner of the building and has two walls of windows with a narrow sill, on which it's almost possible to balance during reviews. The room overlooks a parking lot. Students sit and smoke on raised planter beds on the sidewalk below. Across the street, you can see the dining hall of the Johnson and Wales business and hospitality school.

Down on the second floor, Zach's sculptures had disappeared. The lights had been switched off, and the chairs were arranged in a neat semicircle facing the northeast wall. Twin projectors sitting on pedestals projected the cluttered desktops of two MacBook Pros. "Everyone, if you can turn off your cell phones," Claudia said while ushering us to our seats. On the wall opposite the projections were two five-by-five-foot paintings lit by tungsten floodlights on stands: one was a white circle with gray polka dots, the other was a pink field with lighter pink stripes.

Claudia pressed a few keys on a laptop and one screen came to life, showing ominously rolling thunderclouds, a dramatic soundtrack of

shrilling, synthetic chords, and then Claudia in a tight black top, skirt, and high heels, flanked by two female dancers. While the clouds rolled smoothly across the screen, the figures vamped for the camera in jerky stop-motion. The music crescendoed, a beat kicked in, and the other screen displayed a wall of flame lashing against a black ground, and then Claudia again, in extreme slow motion, wrestling with a man in a white wife-beater who was trying to pin her in an embrace. This went on for eight minutes, and then both videos ended abruptly, one a few seconds before the other.

David Frazer started the discussion with a barrage of questions: Was the ending meant to be so choppy? Was this a finished piece? Why were the paintings lit that way?

Claudia, who is from Chile and once impersonated Britney Spears on a reality TV show there, said that the paintings were derived from the backgrounds of album covers: the circle with polka dots was from *Mi Reflejo* by Christina Aguilera; the pink stripes came from a German mashup of Coldplay and Nicki Minaj. The lights were meant to suggest a photo shoot. Yes, the video piece was finished; yes, the ending was meant to be abrupt. "I wanted it to be very painful to look at."

Figure 1.3

Kevin said, "I'm concerned about where the pain takes us."

A guy with longish hair and glasses pushed up onto his forehead said he preferred the paintings over the videos: the paintings, because they were essentially props, had an "open-ended productive capacity" in which viewers could make their own images. The video provided only "a somewhat predictable roughness masked as critique." He turned out to be a professor in the Digital Media Department, and he disappeared after Claudia's review.

We discussed production values: Were the videos meant to seem amateurish? If Claudia had had an unlimited budget, would the work look the way it does? Claudia said she wanted to make art the way a fan does.

Chris Ho proposed that the fan, as per Claudia's description of her process, "is not the expert, and also not a mere passive enjoyer" of art or music; instead, "the mediocrity of the fan proposes a new subject position for art-making." Someone mentioned Lil' Kim as we filed out of the room.

Wally

On the fourth floor, in the last review of the evening, a long wooden box hung from a pulley system screwed into the ceiling. It was about six feet long, open on top, lined with plastic, and full of water. A set of metal rails ran down its length.

I had no idea what it was supposed to be. I worried that I'd suddenly lost the ability to understand contemporary art, and I suspected that this feeling was similar to the proverbial dream of the actor forgetting his lines. It was getting late. I glanced around the room; the other faculty, more accustomed to the marathon lengths of these things, seemed to be doing fine.

The artist, Wally, saved me by walking up and introducing himself. He had short dark hair, a faded T-shirt with a picture of an Indian chief on it, teal jeans, and Birkenstocks. He showed us a video of an impressive project from last semester: a huge, glass-bottomed pool mounted above

the heads of viewers in a gallery, into which twinkling droplets of water fell from lengths of monofilament.

Then he addressed the big box. He placed a white panel on top of the metal rails, squirted some black acrylic paint out of a squeeze bottle onto it, kicked aside a set of blocks and grasped two of the rope ends dangling from the pulleys. The box started to rock back and forth on a central fulcrum, sloshing the water inside from one end to the other. The panel slid on the rails, causing the puddle of paint to move slowly across its surface. Eureka — the box was a wave-powered painting-making device.

Wally strained at the ropes, leaning backward and then easing up, to get the big box moving of its own accord. "It's like you're sailing," someone observed. The blob of paint undulated on the panel, but it didn't seem to be producing quite the interesting abstract pattern Wally was aiming for. After a couple of modifications to the setup, he eased the box down on its supports and dropped the ropes.

David Frazer said he found it interesting that the machine was so elaborate, yet it seemed to do so little.

"What if it did nothing?" asked Kevin Zucker.

"It's already doing nothing," grumbled Wally.

Holly Hughes cited the work of George Rickey, a kinetic sculptor.

Wally said that the piece we were looking at, titled *Water Table*, was a sketch; what he'd really like to do is make a forty-foot-long wave machine. A second-year student named Bruce said he'd enjoy just watching a forty-foot wave travel back and forth; for him, having the device make a painting was superfluous.

"But then it's just, like, a large stoner toy — one of those lamps," said Art, another second-year student. Conversation looped back to the symbolic dimension of the piece: was this about gravity, physics, machines, the politics of water?

"Did you learn something from this that you now want to examine?" asked David.

Wally paused. "My mind just went blank," he said. "I want to get back to painting but I just don't know how to do it." He was interested

in building more sculptures, he said, but he also felt an imperative to paint—after all, this was the RISD MFA painting program, not the RISD MFA wave machine program. The dilemma was causing him anxiety. "My brain is my own worst enemy!" he said.

■ ■

RENAISSANCE ART ACADEMIES flowed from medieval guilds, and functioned more like chambers of commerce than schools: if you were in one, you were already an artist in good standing. The first thing we'd recognize as an art school was founded in Paris in 1648 by the Académie Royale de Peinture et de Sculpture, which set up in the Louvre to organize lectures and life-drawing classes, bestow honors and accreditation, and properly supervise the training of the country's young artists.

Art school in America has never been quite that glamorous. Toward the end of the nineteenth century, when the first fine arts colleges opened their doors, aspiring artists were trained for one of two career options: technical illustrator or school teacher.[1] Art students would be taught to draw in order to gain credentials as draftsmen for industry or, much more commonly, to pass their newfound drawing skills on to other students.

Today's schools preserve the vocational function of their predecessors. In addition to the fine arts of painting, photography, printmaking, and sculpture, RISD offers degrees in industrial, furniture, and apparel design, animation, textiles, interior and landscape architecture, and art education, all rounded out by offerings in the humanities: history, anthropology, philosophy, literature, art history. An undergraduate can come out of the school having hit the trifecta of a marketable skill in the creative sector, a liberal arts education, and an enviable network of alumni.

At the graduate level, though, the idea of the vocational becomes a source of tension. A Masters program in the fine arts must prepare artists for professional life—but not exclusively, for reasons having to do with how art education was first incorporated into the American university system.

In *Art Subjects*, the definitive scholarly book on art education in America, Howard Singerman traces studio art's journey into the mainstream of contemporary academia. To pass muster within liberal arts colleges (not just in freestanding art schools), art education first needed to distance itself from its historical attachments to industry and the teaching of teachers. This required advocacy and standardization; the College Art Association was founded in 1911 and linked studio art training to its more academically respectable sibling, art history.

Having secured a place for itself at the college level, the next step for art in America was to scale the walls of the university. In a historical repetition, MFA programs emerged in the postwar years as pedagogical degrees: vehicles for the accreditation of art professors. The MFA was—and still is—to art professors what the Ph.D. is to professors in the sciences or the liberal arts: the terminal degree in the field, required for job consideration at the college level. (The visual arts Ph.D., though now offered by a handful of institutions, is still widely and sanely disregarded as a bit over-the-top.)

Beginning in the 1960s, the meaning of the degree began to change. Artists started enrolling in MFA programs not just to get accredited for teaching but also to participate in the intellectual community they offered. Programs disseminated art knowledge from the creative hub of New York by bringing artists to campuses across the nation, in the form of the visiting artist lecture. As this happened, the programs established themselves as important sites of innovation within the field. More and more, one got an MFA not to be an art teacher but to be an artist.

As *this* happened, the MFA program changed the discipline of art. In fact, you could say that it made art into a discipline in the first place: a branch of knowledge complete with its own professional system, clearly limned evaluative criteria, and specialized language—not just a bunch of paint-spattered bohemians spouting off about inspiration and self-expression in Greenwich Village bars. Art education now contoured art practice along lines dictated by the university: discursive, polemical, self-reflexive. Art school was research, and its area of research was art.

In 1999, the year his book came out, Singerman lectured in the Columbia visual arts MFA program, where I was a first-year student. By that time, the idea of attending graduate school for art had gone from inconceivable to possible, and then had shot past recommended and was coming to rest somewhere near compulsory: if you wanted to be taken seriously as an artist, I heard again and again from professors and peers, you needed the degree.

The art market, too, had lately been taking an interest in art schools. From the perspective of the gallery, journalistic, and museological spheres, it was a fantastic idea: the MFA system regulated the production of artists. The schools turned out a crop of new talent every spring, their currency, so to speak, backed by the reputation of their degree-granting institutions. They were pre-socialized. They could talk competently about their work. They had a working knowledge of the codes, explicit or implicit, governing professional conduct in the art world. They could be relied on not to urinate on your carpet if you invited them to a cocktail party in your town house, but rather, as Jackson Pollock did at Peggy Guggenheim's place in 1944, to use the fireplace.

What's more, the MFA system provided a way to organize and therefore market young artists. The schools provided context, kinship, and affiliation for the new faces appearing in the galleries at the start of each season in greater and greater numbers.

In 1999, on the ascending slope of the first twenty-first-century art boom, serious amounts of money were starting to find their way into the art school sphere. Deborah Solomon of the *New York Times* went to Los Angeles to report on UCLA's MFA program, which was churning out a lot of successful young artists; many of our peers were quoted in her article. Three years later, schools were said to have hot streaks in which students were snapped up by galleries before graduation, and dealers and collectors prowled thesis exhibitions in search of new talent. Two years after that, the management guru Daniel Pink would declare the MFA "the new MBA": a twenty-first-century answer to the business administration degree prized by Wall Street talent spotters and corporate HR officers,

and a potent source of creative thinkers to populate tomorrow's business world.[2]

Fast-forward nine more years, to 8:45 on a Tuesday morning in Providence in the year 2012, and there were doughnuts and coffee in the second-floor critique room, and we had to get back to work.

Rachel K.

Rachel had installed a group of mixed-media sculptures in a triangular zone in the northeast corner. Opposite, she'd arranged the folding chairs in precise diagonal rows. The largest sculpture involved a bundle of cloth tangled around a length of rope, all of it slathered in white acrylic gesso and then hit repeatedly with bursts of spray paint; the bundle was draped over an armature made of plumbing pipe, the rope trailing downward and coiling intestinally on the floor. The smallest was an unidentifiable white plaster thing, like the crushed skeleton of a bird, placed on a paint-daubed cinder block.

Rachel read her opening statement from a notebook: She gathers materials from thrift shops and home supply stores and subjects them in the studio to various sculptural transformations. She thinks about this process in terms of death, decay, and regeneration; the sculptures show "different degrees of dead." The group pounced on this immediately: Why death? In what way do the sculptures evoke decay? Where did this morbid interest come from, anyway?

Today's faculty lineup was different from yesterday evening's. Since Holly and Duane had to leave after lunch to conduct a job interview for the Painting Department, the group included Judy Glantzman, a senior critic, and Dennis Congdon, the former chair. Dike Blair had agreed to take over Duane's job as the customary timekeeper for the midterms. Since he didn't want to feel like a fascist for cutting off the discussion at the thirty-five-minute mark, Dike had programmed an alarm on his iPhone. "That way it isn't me—it's the device," he said.

Fashionwise, the faculty splits down cleanly demarcated generational lines. Chris, Kevin, and I, products of the 1990s, performed variations of

a retro–New England collegiate look involving V-necks and Oxford shirts: Chris's well-maintained, Kevin's purposefully threadbare and tattered, mine in the nondescript middle. Duane, Holly, David, and Dike wear SoHo-in-the-'80s black; Judy and Dennis, the East Village alternative of bright, clashing colors. (On Tuesday, Judy wore a fuzzy yellow-green sweater with red clogs; Dennis, fluorescent green Nikes, a green-and-white-striped shirt, khakis, and a red baseball cap with the word BROWN on it.)

With few exceptions, the students dress in smart, metropolitan-twentysomething streetwear. During the reviews, pants were usually dark-rinse denim. The most common tops were heather-gray T-shirts (men) and silk blouses worn under a cardigan (women). The most popular shoes were black-and-white leather Adidases; I counted at least four pairs. The students were certainly not investment bankers, but they could be law students or baristas. If you were an HR officer, you'd hire them for most jobs.

This isn't true of RISD students in general. Across the river, in the hub of the undergraduate campus, you see tattoos and piercings, baby-doll dresses and combat boots, thrift-store tees and mossy neck beards—in other words, the time-honored sartorial iconography of American art education. I did a studio visit with a RISD undergrad who channeled the young David Hockney so comprehensively—platinum bob, granny glasses, and all—that I almost asked for his autograph. I surmised that the graduate students, with a few exceptions, have either transcended the need to visually self-identify as art students or are engaged in some kind of reverse-fashion psych-out campaign.

Dennis Congdon scrutinized the little plaster thing on the cinder block. "In a way, the past life of these materials is the least interesting thing to me," he said. Rather than repurposing thrift-store finds, he suggested that Rachel work directly in plaster.

Judy Glantzman said, "These are very *female* things." They had fake flowers stuck in them, lots of violet and fuchsia, glitter. Holly talked about empathy for different stages of female life; one piece, she said, was like "an aging coquette." Judy cited the work of minimalist sculptor Fred Sandback, who conjured invisible volumes in space using only bits of

colored string; maybe Rachel should use different armatures than cinder blocks and lengths of metal tubing?

"I like the idea of rebar and steel —" David Frazer began.

"Because you're a man!" Judy said.

The phone chimed.

Taniya

Up on the fourth floor, a fellow student had stationed herself like a bouncer at the door of the critique room. Taniya wasn't ready, she said, so if we could all wait a few minutes, please. At an inaudible signal from within, she waved us inside.

Around the room, newsprint drawings pinned to the walls and laying in heaps in the corners depicted bulbous female figures, some of them missing limbs. The centerpiece of the installation was near the windows: a big rickety cardboard thing like a stage or an altar, about the size of a refrigerator, with white butcher paper walls and a wobbly corrugated roof dangling from the ceiling on lengths of fishing line. Inside it, Taniya sat on a raised platform in a cardboard contraption that encased her legs; it looked like a cubist recliner.

Everyone who has ever studied or taught art has a favorite art-school performance art horror story; I once saw a man strap himself to a cross made of Erector-set parts suspended from the ceiling of his studio and writhe for hours in pretentious agony. So it was with a certain amount of apprehension that I observed Taniya in the box, waiting for her to do something crazy. But she simply held her pose for a couple of minutes, staring intensely at a point in space. People took phone-videos. At another subliminal signal, someone helped her down from the stage. She exited the room, then immediately returned, genuflected before the sculpture, and faced the crowd. "Okay, I'm done now," she said. "This was my opening statement, so we can start."

After the requisite fact-finding questions (Taniya's work was inspired by a dream; she had been researching fertility goddesses), the conversation

Figure 1.4

found its focus almost immediately: "Can you talk a little about your con-
cept of skill?" David asked.

Regardless of whether Taniya's work was good or bad, it didn't show a
lot of technical facility in the traditional sense. Her drawings were roughly
executed, the single unstretched painting unfinished. By accident or
design, the cardboard stage-altar contraption seemed one sneeze away
from collapsing in a heap.

The question of skill is vexing to the culture of contemporary art edu-
cation. It ties everyone in knots. Singerman devotes a lot of space in *Art
Subjects* to the idea of "deskilling," a term borrowed from the sociology of
labor that describes the effect of automation on an industry's workforce.
For Singerman, the workforce known as artists had been undergoing a
similar transformation for some time.

So, Taniya's skillfulness or ineptitude was a tricky terrain that the
group spent some time climbing around in. Did Taniya aspire to a level

of competence that she was currently failing to achieve, or, as Chris Ho put it, "is the shittiness intentional?"

This opened the door to some riffing on the ad hoc quality of the work.

"The drawings seem intentionally spastic," said Dike.

Kevin said, "If this really *is* an offering, then the Gods are going to be pissed."

I chimed in and mentioned the Cabaret Voltaire of 1916, at which Hugo Ball recited nonsense in a cardboard bishop's miter: was Taniya mocking the idea of religious ritual?

Taniya bore these remarks stoically.

"You should work really hard at being reckless," said David Frazer, with sudden conviction. "You have what you need to work with. If only you would recognize it, and do it in a forthright fashion." This was a surprise: I had pegged David as the last champion of skill against a legion of deskillers. But here he was chiding Taniya not for lacking skill, but for *feeling bad about* her lack of skill. "You don't have the kind of background in Renaissance academic drawing that you think you would like to acquire," he said. "Well, it's too fucking late!"

Some discussion followed about whether or not it was too late for Taniya to learn to draw. Holly proposed that Taniya was functioning as a mystic, for whom the attempt to realize a vision transcended aesthetic concerns. "You've made a place where I can't say if it's wrong or right," she said, and wondered about documentation: did Taniya record her performances?

"I did make a film," sighed the artist. "I did make a film, but I did not like it."

BECAUSE OF THE relatively quick historical development of the visual art MFA, you still often find students studying for a degree with professors who never got one. In the late 1960s, Holly apprenticed herself to a portrait-painter friend of her jazz-musician dad, then headed for New York. She kicked around a handful of schools before winding up

with a BFA from the State University of New York at New Paltz but decided not to go any further up the educational ladder. "It was not an era where teachers got grad degrees," she told me. She started teaching at RISD in 1993.

In group critiques, Holly prefers to give what she calls "the cold read": looking at a student's work before he or she has had a chance to talk about it and responding to it using the clues it presents. "No disclaimers first. Either it's interesting enough to look at on its own terms, or let's skip over it. Once we've had some discussion, they can throw in the fact that they come from four generations of architects.

"The whole crit thing is a psychological minefield," she continued. "In teaching, you have to find ways to say things that are really honest. You can't be too careful, or they don't get what they're there to hear. But you don't want in any way to shut them down either. That's the hardest part: to be incredibly blunt but not to be a negative voice they'll hear later in their head that keeps them from doing something.

"We have a small-scale thing going on, and the intense community seems to reassure them enormously. They trust that they're with people who are not torturing them for amusement—that it really is about helping them move through a series of revelatory steps."

Page, Bruce, Hilary, and Joe

The day began to move quickly. Down on the second floor again, Page showed us a series of body-size abstractions in a conservative women's wear palette of beige, navy, black, and gray. Her installation was completed by two photographs (a body scanner at an airport, a drone airplane), a potted plant, and a miniature camera mounted on the wall at eye level that observed us as we observed the art.

"We have to talk about the status of critique in this," said Kevin. "There's a presumption of criticality. I assume a pointed critique. The real conversation here becomes about critique, its various possibilities and failings, whether it is relevant."

"Can you just say what you feel the content is?" asked Chris, exasperated.

"It posits something about its ability to posit something," said Kevin.

The conversation fragmented into multiple simultaneous exchanges: Kevin and Chris, Holly and Page, Judy and David. Someone said, "The dialectic." Maybe it was me; my note-taking broke down a little here. We headed upstairs again, through an acrid cloud of industrial disinfectant in the hallway of the third floor ("Did somebody throw up?" someone asked) to look at Bruce's paintings.

The year before, Bruce had been making jokey paintings and sculptures: Mars Rovers, towers of pizza boxes painted in shades of gray, deadpan equestrian portraits. This semester, he was making relatively serious-looking abstractions with spray paint and an ingenious method involving aluminum foil: using a palette knife, you spread thick layers of oil paint across the foil, flatten the foil paint-side-down against the surface of a stretched canvas, burnish it with a putty knife, and then tear away the foil. This produces a finely textured surface with unexpected coloristic results. Art students often feel proprietary about techniques—the idea being to get your unique aesthetic product to the marketplace before your classmates can deliver theirs—but as soon as Bruce figured out the tinfoil thing, he shared it with all his classmates. This wasn't out of altruism, he said; he wanted to spread the blame around in case the faculty hated it.

Judy Glantzman jumped in almost immediately. "What do you want us to experience?" she asked. "Is the subject of the work how we can figure it out?"

She mentioned an exhibition Bruce had done in New York in the fall. "I don't know if this is a harsh thing to say, but when I went to your show, I didn't stay. The tools didn't become means within which to enter. At a certain point I felt, 'Okay, I got it.' I got the way you made them, and then I didn't want to stay in them."

"I feel like I'm at the edge of a bridge that hasn't been fully constructed yet," said David Frazer. The general feeling in the room was that

Bruce's earlier works, while perhaps unsuccessful as paintings, succeeded as works of art; these, on the other hand, were undeniably good paintings, but they weren't very funny.

On the second floor again. To the east and northeast, big charcoal drawings of an apartment, life-size, on multiple sheets of paper, were pinned to the wall. Next to this were smaller drawings: a fishbowl repeated several times, a woman blow-drying her hair. The artist herself, Hilary, wore a tan sweater over a floral shirt and black jeans. After eight reviews, the arrangement of folding chairs in the second-floor critique room had begun to exhibit predictable behavior: it tended toward loose rows on the diagonal facing the southwest corner, so that now we were all facing the charcoal works.

I craned my head to look at a giant painting of a multicolored curtain, approximately life-size, on the wall opposite. In an experiment, I turned my chair around to face it.

"I see Roger has already made up his mind about which works are important," said Chris.

We grabbed lunch from a Japanese place around the corner from the studios, and then headed back to the second floor again for Joe, a first-year student. Joe is very tall, and out of everyone in the group, he looked the most like an art student; paradoxically, this was because he was wearing a tie. A crude chair made out of concrete sat on the floor next to a chair-size cardboard box with the words SHAKER CHAIR stenciled on it. A monitor on a pedestal played a video of the artist making concrete tennis balls and reading a magazine. "It's after Courbet's *The Stone Breakers*," he drawled.

"Joe, when you do DIY stuff, do you make it with intentionally poor craft, or is that the best you can do?" asked David Frazer. Primed by the deskilling dustup in Taniya's critique, Joe answered promptly that he intentionally made things poorly. In fact, the concrete chair was a little too sturdy; in order to work as a sculpture, he said, it really ought to fail more as a chair.

Figure 1.5

Discussion wheeled around the question of whether Joe made his willfully sad-sack sculptures in character as "Joe the inept craftsman," rather than as Joe the smart young artist in one of the nation's top-ranked art schools. If so, was this distinction consistent enough? The concept wasn't entirely clear to anyone, it seemed. "You're making irony of the clumsy builder?" asked Claudia.

Judy thought that Joe's work exemplified the prevalent mode of art-school art: smug self-awareness. She called the work "nudgy-nudgy."

"What do you want from us?" she asked. "What do you want from *me*, as the token woman of the moment?"

As if drawn by a magnetic force, Kevin mentioned Joe's tie. Was Joe-with-the-tie a persona, one that could be delineated from plain-old, open-collared Joe? Would the work be different if Joe wasn't wearing a tie for his review? Is it meaningful to pose the question in the first place? Later, Joe told me that having worked as a museum guard and at various

art-administrative positions over the years, he was simply accustomed to wearing a tie on special occasions such as these.

AN ART HISTORY–TRAINED Conceptual artist in a faculty of dedicated painters, Chris Ho is an anomaly in the RISD Painting Department. He started out teaching the seminars Art Since 1945 and Contemporary Critical Issues, two mainstays of the American undergraduate art school humanities curriculum. "The tradition I was telegraphing was one in which painting somehow ended in the late fifties and early sixties—and then everything else happened," he said.

I asked him what he thought about RISD's critique format. "It's not quite a tennis match," he said. "It's more like cooking, maybe . . . Its also very courtly, very seventeenth century. It's not passion that gets you through a crit. It's articulation, spacing, rhythm, phrasing. People who are great at crits understand these things."

Chris has a programmatic, optimistic approach to teaching art. "It's like classic enlightenment philosophy. I'm going to treat the students as peers—as if their work is the best work out there, and I'll respond to it as such. That fiction, or semi-fiction, will translate into reality, so long as I maintain it long enough. So if we have two years, I will treat them seriously for two years, as real artists, and hope that at the end they will have become that."

"Isn't it great to be around the next generation?" he remarked. "They know more than we do. They just don't know they know it yet."

Rachel G. and Francisco

I was on the fourth floor looking out the window through a telescope aimed at a brick wall across the street; a goofy chalk drawing of a hand gave me a thumbs-up. Rachel's work was composed of tiny, flea-circus arrangements of painted paper and debris; they were pinned to the walls, clustered in piles on the floor, and gathered on the windowsills, interspersed with pieces of optical equipment. Two large pen-and-ink drawings

next to the door resembled the moon; in fact, Rachel made them by looking through a telescope at an orange.

Judy Glantzman mentioned the work of the Swiss installation artist Pipilotti Rist. Typically, once somebody mentions an artist or a work, everybody starts doing it, and the critique becomes an exchange of proper names. Here, we volleyed Duchamp's *Étant donnés*, the miniaturized sculptural worlds of Charles Simonds, Hilary Harkness's fanatically detailed paintings of submarines. "It's amazing that nobody has kicked these over," Judy said. And, as if on cue, Francisco stumbled and nearly wiped out a pedestal topped with a miniature diorama. Joe grabbed his arm and averted the catastrophe.

Francisco wore a black T-shirt with the head of the Statue of Liberty on it. He had done a project during his first year in which he painted the Statue of Liberty seventy-eight times. This semester, he presented a complicated installation-in-progress including two giant paintings, a scaffold, a painted plywood floor, and a tailor's dummy with a dress made up of cut-up canvases. All of it was covered in jagged black-and-white stripes, much like his shoes—those ubiquitous leather Adidases.

Francisco had grown up in Mexico City and moved to Texas when he was six. When he'd studied art in college, he'd learned that Abstract Expressionism was the iconic visual language of American painting. "My teacher was *so* into it," he recalled. Lately he'd been looking at the dazzle camouflage used on British warships during World War I, the source of the patterning in all of Francisco's work.

"Koons, or Hirst, dazzle-decorated an art dealer's boat," Chris Ho pointed out.

"Do you mean the image to be readable?" asked David Frazer of one of the big paintings. "I assume it's a combination of images. Is that intentional? Is that a car . . . ?"

"I see a bag with—oh, I see a car," said Judy.

"We're all looking for proper nouns here," said Chris.

We wondered about the painted floor: "It's a stage," said David. "I expect a performative condition—some sort of rock band."

DAVID'S KEY WORD in critiques is *condition*, which can be coupled with different modifiers: accidental condition, preservation condition, condition of animation. It's indisputably *his* word, though other people in the program helplessly and unconsciously pick it up; for weeks after the reviews, I found myself incorporating it into my own teaching patter. The genius of *condition* is that it's sufficiently versatile to encompass a whole range of functions—or rather, a whole range of conditions—but has enough mystique to avoid sounding flat or generic. *Condition* is to Frazer what *Being* was to Heidegger.

David went to RISD as an undergraduate in the 1960s. He then got an MFA at the University of New Mexico, and shortly after that landed back in Providence with a sabbatical-replacement job teaching in the RISD freshman Foundation Studies program. He's been at the school for thirty-four years.

"It was a very ingrown group of guys, " he said of his professors then. "They were serious artists but not terribly engaged as teachers. There was sort of a tacit agreement between the faculty and us that if we left them alone, they'd leave us alone."

How different this was, he said, from the intimacy of teaching at the school now, especially at the graduate level, where teachers and students are expected to articulate anything and everything about the messy process of making art. Not only has the role of the art instructor changed (from silent and inscrutable icon to something more like a full-time life coach), but also the entire culture of art-making has shifted on its conceptual axis.

"The zeitgeist of my generation tended to be that art is a serious and painful activity that one engages in despite the fact that it is," David said. "Now, all these guys embrace the potential of art as much as they embrace other forms of entertainment. They recognize and believe that

there's no problem with generating work that's just provocative, or simply entertaining."

Art and Kimo

When we arrived on the fourth floor, Art instructed us to arrange the chairs in a circle, facing inward, group-therapy style. We were surrounded by murky abstractions: bedsheets that had been tie-dyed and tacked to the walls, canvases cut apart and sewn back together in crude strips, stretcher bars burned black and assembled into sculptures.

Art had a shaved head and wore gray jeans and a severely starched white dress shirt under a black V-neck sweater. The whole outfit cost him twenty dollars at Goodwill, he told me. He announced that he had no opening statement; he'd rather hear what we had to say and then "open it up to questions."

"One thing I like is they're so depressing," said Dike.

"There's a grimness here. It's like breaking rocks," said Kevin.

"The grimness is generative rather than recursive," said Chris.

"A morose nostalgia," said Duane Slick, who was just back from interviewing a job candidate.

Michelle, a soft-spoken second-year student, lodged an objection: "I don't mind grimness at all, but it seems like you're attracted to the aesthetics of what's grim and what's dark. I'm almost put off, a little bit, by your attraction to the glamour of what's sad."

For the remainder of the review, we parsed the negative emotions. The faculty, who had been flagging in the mid-afternoon heat, suddenly perked up to discuss the differences between depression and morbidity, melancholy and sadness.

We ended the day with Kimo. Like Joe, he'd dressed up a little for the review; he wore a sweater vest and a bolo tie with a piece of agate, or quartz, for a clasp. A big guy with small, bookish spectacles, Kimo came to RISD after a long postcollege stint as a nature guide in the Grand Canyon, during which time he painted en plein air. Here, he

Figure 1.6

shifted into abstraction, making small canvases in which acrylic paint pools and splurges around, and then carefully repeating those chance shapes on other canvases using stencils and tape. "I'm interested in what *counts* as nature," he said circumspectly near the beginning of the review.

David Frazer was up and circling the room. He riffed on the difference between the stenciled paintings and the freehand, drippy ones, the ones that had landscape references and the ones that were purely abstract. He wondered if Kimo's process could more closely mirror the actual processes of nature.

Meanwhile, Judy Glantzman was cocking her head to one side in the direction of two mid-size canvases on the northwest wall. "You know, it's funny," she said, "when I look at these paintings I like them horizontally." Everyone tilted their heads like Judy was doing. She asked permission to rotate one of them, and, liking the results, turned another. "There!" she beamed.

At 4:15 I went back to the hotel and fell asleep. Later, I woke up and tried to find some dinner. Providence has gone through a bit of urban renewal in the past decade, as indicated by the boutiques and cobblestone sidewalks in the arts district, where the studio building is—though many of the storefronts are vacant, or else filled with stop-gap devices like temporary art exhibitions or advertisements for "special event rentals." Kevin Zucker told me that the street used to be nothing but massage parlors. On the way back to the hotel with a sandwich, I looked for the chalked thumbs-up graffiti I'd spied through the telescope during Rachel's review, but I couldn't find it. Either she had come down in the meantime and conscientiously wiped it off the wall or I'd misremembered the direction of the telescope. I stood in the parking lot long enough for the attendant to come out of her booth and ask me what I wanted.

■ ■

ART EDUCATION HAS always had its critics, and most of them have been art educators. After all, critique is the backbone of the system. The attacks on art education launched from within the walls of the art academy make the ones leveled at it from without seem trite and ineffectual—nothing more than variations on the classic formula *You can't teach someone to be an artist*. You can; people do; artists have taught artists since there were artists.

Singerman ends *Art Subjects*, a largely dispassionate book, with an unexpected cri de coeur for the casualties of art education. "I cannot, however, let the cruelty of current art training go unremarked," he writes, before enumerating such pedagogical excesses as the "harshness" of the structure of critique, in which criticism of artwork slides easily into ad hominem attacks on the artist; the existence of "cliques of students and sometimes faculty who control the local circulation of discourse, wielding it as a weapon"; and, cruelest of all, the sorry fate of students who "fall through the cracks of teaching: those who leave art school with neither the

self-awareness that would allow them to thrive as artists in the professional sphere, nor the technical skills that would let them to paint or sculpt or draw as a fulfilling, personal pastime.[3] For these students, Singerman thinks, art education *is* the ruination of art.

The tenor of the internal critique of art school changes with environmental conditions in the art world outside it. Circa 2000, the year I left school, the art pedagogy panels and faculty hand-wringing sessions in top-ranked programs circled, optimistically, around something like the age of professional consent: how young was too young to groom someone for art stardom? Should students be exhibiting and selling their work while still in school, or should they wait at least until they graduate? If, according to Singerman, the field of research in art school is art, and art is primarily organized as a market, then the obvious danger is that art school becomes nothing more than a form of *market research*.

On the other end of the last decade's art boom, the problem with the MFA seems more serious. After a run of years in which a degree from a prominent school seemed to lead effortlessly to a seat at the art world table, the academia-market partnership began to fatigue. The redistribution of wealth in the contemporary art system after the financial crisis of 2008 left far fewer spaces for young artists in galleries, less funding for them in the institutional sphere, and fewer grants, residencies, teaching jobs, freelance writing gigs, assistantships, paid or even unpaid internships. The three numbers that never seem to drop are tuitions, big-city rents, and the total student debt.

A few years ago, Coco Fusco, an interdisciplinary artist and professor at Parsons in New York, issued a scathing broadside against the MFA in the independent monthly paper the *Brooklyn Rail*. Citing the escalating cost and diminishing professional returns of art school, she called for an inquiry into "the politics of charging vulnerable young people six figures as an entry fee into a milieu that cannot sustain most of them."[4] Recalling the unofficial apprenticeships she undertook in New York in the 1980s (basically, hanging around the studios of older artists), Fusco lamented

the translation of identical experiences into components of the MFA curriculum—the difference being that the student now pays through the nose to be mentored by older artists. She asked:

> How much longer should we endure our own version of a sub-prime loan crisis before we consider how art schools seduce relatively inexperienced consumers into borrowing huge sums for degrees by trafficking the same myths about art and the art market that they purport to "deconstruct" in required lecture classes?[5]

The problems that Fusco described extend much further than art school: skyrocketing operational costs, administrative bloat, and unreasonable loan policies plague the American educational experience across the board. But the MFA system in particular finds itself navigating between equally dystopian possibilities: the wholesale default of art education into career training, where success and failure are measured strictly in terms of graduates' performance in the art market; or its elevation to a pure research degree offered at onerously professional-school prices. The economic realities of art school form the second curriculum of every MFA program in America, an undercurrent of unease in each studio visit and seminar session convened.

LIKE DAVID FRAZER, Kevin Zucker attended RISD as an undergraduate; all his senior colleagues were once his teachers. As an artist whose professional life has unfolded through various institutional affiliations (he began showing his work prominently while still in graduate school), he was uncomfortably aware that he exemplified the promise of a certain kind of success that still attracts many students to the MFA, in a very different professional climate than the one he witnessed.

"I didn't go to graduate school expecting to have the experience that I did, or expecting it to have the effect on my career that it did," he said. "The fact that that happened to a few of us may have really shaped expectations for a number of years. I think those expectations have changed.

There's been an adjustment towards a more realistic understanding of what an art career is supposed to be."

Zucker is keenly attuned to the critique of the MFA that has unfolded in art academia over the past decade. "I believe that anyone teaching in art school who isn't aware of, and therefore at pains to avoid, the Ponzi-scheme worst-case scenario is doing the students a disservice—and that these tensions are things that should be openly discussed in the class-room," he told me. "But a pet peeve of mine in this whole conversation is that we too often group all MFA programs into something monolithic. I believe, or hope, that there are real differences between programs, and that those differences actually have significant ramifications—pedagog-ical, economic, and therefore ethical. These are almost always glossed over. You rarely see the potential benefits and downsides of grad programs being enumerated together in a way that would help young artists make better decisions, based on something other than fantasy and paranoia."

In my informal polling of the RISD MFA painting classes of 2012 and 2013, no one expressed any reservations about the program. The students were committed to the task at hand: understanding the history and cur-rent dispensation of the field of contemporary art and finding their own place within it, all in the span of four semesters. They were conscious of the long odds of success in the professional art world and of the dire finan-cial stakes of art school—a theme reiterated so often inside and outside the academy that it has now taken on the quality of a mantra.

They were also, predictably, somewhat reticent to talk about money. "That's definitely kind of worrisome," Kimo told me over a beer on the Lower East Side during the summer. "The idea of finance is a weird thing in the art world in general, especially among artists. You don't know who has a trust fund and who doesn't, and it's just uncomfortable for every-body to talk about that. It just becomes about who has the opportunity to make it post-school. Maybe I'm just perpetually optimistic."

Page, who waitressed in Brooklyn during the four-year interim between college and grad school ("I lost track of how many restaurant jobs I got fired from!"), wondered if the brevity of the program, its cost,

and the desire on the part of everyone for the students to thrive in it all conspired to soften any actual criticality. You can't run a successful MFA program if students leave feeling demoralized—word will get around.

"There does come this point where the teachers have invested so much in you that they almost want to believe that they've been effective— and so they approve of what you're doing," she said. "I almost wonder if there isn't a bit of . . ." She trailed off.

On the other hand, Art wasn't having any of this line of questioning. "Generally, these conversations about 'Is the MFA relevant anymore? Should people be getting MFAs?"—I think that's a lot of elitist bullshit. I'm the first person in my family to go to *college*," he said flatly.

Doug

Contemporary art is a time machine set exactly one second ahead of the present. Contemporary art is a sphere whose circumference is everywhere and whose center is unaffordable. On the final morning of the reviews, after reducing the volume on his squelching videos, Doug gave us a little introductory material about the rec room. Its elements were autobiographical, he said. The cartoon I had been attempting to interpret was "Amazons Just Wanna Have Fun," episode 7, season 2, 1986, of *Hulk Hogan's Rock 'n' Wrestling.*

Dennis Congdon, in an orange baseball cap and a brown cardigan, migrated from a seat near the windows to two sculptures near the door with video monitors in them. On one screen, a figure with a big, papier-mâché head stood in a field; on the other, it tap-danced in a tuxedo against a white background. He addressed the group with genuine enthusiasm.

"I want to make a pitch for these remarkable, plywood-enclosed video screens with underwater accoutrements," he said. "What's set up is a kind of fantastic framing device that's inseparable from the image. I wanna hang around that *big time*."

Figure 1.7

Michelle, Anthony, Jonathan, and Lauren

"How do you think we should sit? Do you think it should be all willy-nilly or . . . ?" Michelle waited for the stragglers to make it up to the fourth floor. The room was hung with small portraits, all of which she had painted from found photographs or from other paintings: Langston Hughes, hands steepled beneath his chin; Naomi Campbell posing in front of a sketched-in palm tree; two versions of a Dubuffet self-portrait; a Picasso bather; Queen Latifah in a black-and-white-patterned jumper.

"I thought your first question, about where we should sit, is an interesting one and appropriate to what we're seeing on the wall," said David Frazer.

"What's the title of your thesis?" Duane Slick asked Michelle.

"'Portraits.'"

"Not much of a clue there, Duane," said David.

Michelle elaborated on her idea of portraiture. The pretense of a traditional portrait is to show the individual qua individual, she said. "But I want to show an individual tyrannized by their environment, an individual dependent on their social network. You"—she gestured to David—"are 'David Frazer, my teacher at RISD,' not just 'David Frazer.'"

"The way you state your thesis is kind of stark and unyielding," said Chris.

In an aside, Duane asked Dennis Congdon why Michelle was painting African American people. This was an obvious question. The current student body included Mexican American artists, First Nations artists, Filipino American artists, artists from India, Indonesia, and Chile, Jews, Wasps, and a Mormon, and the only African American artists in the room were Langston Hughes and Queen Latifah, there on the wall. But the conversation veered back to the now-familiar ground of success and failure in painting. "You have to try to make better paintings fail," Holly concluded, and we bustled downstairs again.

THE OTHER WRONG idea I had about graduate art school, besides the one about how people there talked about art, was this: I imagined it as a utopia of experimental fuckaroundery. I thought you went there, holed up, and went completely avant-garde. You did forty-eight-hour spoken-word performances in which you read from the phone book, or dropped acid and methodically licked every square of linoleum on your studio floor. Or you did nothing: doing nothing was perhaps the only thing that couldn't be recouped as a form of production and talked about for thirty-five minutes—and even that wasn't a sure bet.

I didn't do any of this. Neither did my classmates. We worked, diligently, sometimes frantically, always mindful of the clock. Even the people who slacked off did so *demonstratively*, intentionally—as art; they practically put it on their CVs.

So I wondered, eventually, how I'd come by this anachronistic idea about art school. I'd probably absorbed stories about Black Mountain College, the experimental enclave at which Robert Rauschenberg, John Cage, and Merce Cunningham came together in a short-lived post-Bauhaus summer camp; or CalArts in the seventies, where artists like John Baldessari brought Conceptual art squarely into the curriculum and energized both. These hazy, half-mythological visions brought me to art school. This was like watching Rodgers and Hammerstein's *South Pacific* and then deciding to join the navy on the basis of the experience.

It's possible that the dream still lives on in today's artist-run schools, the do-it-yourself alternatives to the MFA system of which there have been an explosion in the past decade. There's Los Angeles' Mountain School of Arts, a free, volunteer-driven enterprise housed in a bar in Chinatown, and the Public School, an "autodidactic" proposal-based network of reading groups that now takes place in eleven cities worldwide. Most of these, however, present themselves as more academic than the academy, with a punitive self-seriousness intended to reproach the university system for its descent into commercialized education.

But maybe I should call this dream *uchronia*, not utopia: a no-time existing apart from the regimented pace of contemporary life. Because, observing the day-to-day operations of an average program, it's easy to see that the visual arts MFA is conditioned far more by time than by space. Faculties jog between undergraduate and graduate duties, shifting mental gears between the routines of Introduction to Painting and the more nebulous intellectual space of grad-level studio visits. The students, meanwhile, have two years to absorb the conceptual framework and professional codes of contemporary art before they are shunted out into an unregulated industry teeming with competitor-peers. Between critical

issues seminars, visiting artist lectures, teaching assistant duties, organizational meetings with the curator of the end-of-year exhibition, and the preparation of their 2,500- to 3,000-word thesis, they're scheduled within inches of their lives.

I looked up. Dennis Congdon was rubbing the surface of one of Anthony's mural-size, inkjet-print and oil paintings, trying to determine what it was made of. Holly had been quiet for a while, regarding a vertical painting on the north wall: a can of white house paint sitting atop a jumble of soldiers and landscapes, overlaid by a schematic of jutting lines.

"What does that paint can stand for, in that painting?" she asked. Anthony didn't answer.

"Stop squirming! Is there a political implication to this paint can or not?" Still nothing.

"I'll tell you how I read it," she said and approached the painting.

"Holly, tell us!" someone shouted.

"I see this painting as super-American. The notion that we can clean up our mess by keeping the paint fresh. It's a political one-liner to me. There are these 'situations,'"—she gestured toward the jumble of images at the bottom of the canvas—"that's 'all wars' down there, and a structure that implies entrapment, in which we can keep our mess. And then"—up to the top of the canvas again—"the miracle paint can."

A beat of uncomfortable silence passed. Holly backpedaled slightly. "If that isn't in this painting, I should seek help."

Jonathan's paintings, next to last, were brushy abstractions in a light palette. He told the group that he'd been painting representationally last semester, but that this semester he wanted to forget what painting was supposed to be—to start over from scratch.

Dike said, "This may be too early in the conversation, but did you fall under the spell of Raoul de Keyser?"

"Yeah, I tried not to look at him for a few months," said Jonathan of the newly fashionable octogenarian Belgian painter.

David Frazer got up to look at a thick, gray-on-gray painting. A tiny piece of blue masking tape had been casually half-stuck to the surface of the canvas, right near the center.

"Where the hell did that thing come from?" he asked. "I want to rip that little piece of shit off this painting, because that was a *good painting* before you added that."

Over the course of the reviews, I'd noticed that we often spent a minute or two at the start of a session determining what was or wasn't part of the art. Not that we were hoping to arrive at a philosophical definition; simply in the interest of time, we wanted to know what we were contractually obliged to discuss.

So the tape presented a problem. A foreign object in middle of the work of art, the tape took on an outsize, irritating significance. It threw a monkey wrench into the whole art/not-art algorithm we'd been using up to this point. I had a brief, vivid hallucination, no doubt brought on by exhaustion, in which David pulled the piece of tape off Jonathan's painting, and the painting just fell apart—as if the tape were the only thing holding it together in the first place.

Then I wondered what would happen if all of Jonathan's paintings suddenly disappeared—would we talk about the walls? The critique might stop in its tracks, but maybe it would simply turn to the next available object, and then the next, picking up momentum as it did: from the walls to the room, the room to the building, the building to the school, the school to the MFA system, until, if there was enough time, we ultimately encountered the entire economy of art education and our vexed roles within it—the whole art school condition, as David might put it.

I thought about how most aspects of graduate art education are now geared toward the thorough professionalization of the student—but not critique. For all the ways it resembles a focus group, critique does not, in fact, help students refine a sales pitch for their art or give them instructions on how to make it more marketable. It shoots past these goals and bravely heads for the further terrain where art properly begins. It would

also be endless, except for the thirty-five-minute alarms set to keep the thing from getting out of hand.

But then it was suddenly over. As we headed downstairs for the last review, people were chatting amiably, discussing plans for the rest of the week. Lauren showed a suite of bright-fabric assemblages—they looked like geometric abstract paintings from the sixties done up as quilts—and some big inkjet prints of pictures of plants and houses clipped to the wall. To the northwest, a video monitor showed split-screen footage taken out a car window, the image repeated, inverted, and mirrored so that the passing traffic converged at the center of the screen.

"I continue to be interested in the indefiniteness of a lot of the elements, and of the relationships between the elements," said Kevin, "and that you don't know about them. Part of me wants to say, 'Ante up.' Indefiniteness has to become content." The review ended there. People checked their phones, put on their coats, and bustled out of the room for the next class or meeting or train.

2

THE ASSISTANTS

I MET A sociologist at a party once and when I mentioned that I was an art-
ist, he told me about a childhood friend of his, also an artist, who worked
as a studio assistant to a well-known sculptor. "He actually *makes* this guy's
art," said the sociologist, who studied labor movements, with exaggerated
shock. "Do you *know* about that?"

I had to admit that, yes, I knew about that—not about the sociologist's
friend, of course, but about the fact that the art of the well-known sculp-
tor, Jeff Koons, is mostly made by other artists; part of its appeal is that it
requires the labor and expertise of a lot of people to produce. It's no big
secret. There have been documentaries, I said.

The broader point I was acknowledging, or copping to, as it felt like,
was that many artists employ assistants who perform not just the pre-
liminary and auxiliary work of art-making but often the actual, physical
manufacture of the stuff as well. I also had to admit that this wasn't a par-
ticularly big deal, or frowned on in the least among artists outside some
small, purist circles—the kinds of circles where painters who don't grind
their own pigments according to methods dating back to the Renaissance
are considered frauds. Studio assistants, collaborative labor, and industrial
manufacture are all normalized aspects of the mode of contemporary
art production I said, trying to sound more sociological, and it was only

for a brief window of time—from perhaps the mid-nineteenth to the mid-twentieth centuries—that artists were supposed to do everything by themselves. Since then, the labor of the artist has been conceptualized no differently than it has with respect to other creative professionals: you wouldn't expect an architect to lay every brick in a building, I said, using a common analogy.

I left the party feeling weird about the conversation, though—mainly because I'd enjoyed divulging this little factoid about contemporary art, in the way that a hairdresser to the stars might enjoy reporting on the toupees and extensions of various celebrities. Clearly, something still nagged.

"I thought we'd settled that question a long time ago," said my friend George, a painter, when I told him I was thinking about artists and their assistants—that perhaps the normalization of some labor practices around art wasn't so normal after all. I proposed that there was still something slightly un-worklike about art-making, and un-artlike about working, and consequently, that making someone else's art put you into a kind

Figure 2.1

of divided state: performing as labor the same physical and conceptual operations that someone else performs as art.

George didn't buy it, but maybe the difference had to do with experience. George had worked for Peter Halley, a painter who runs a studio as tight and orderly as his clean, geometric paintings, where handpicked, highly skilled assistants perform clearly demarcated tasks to the exacting specifications of the artist. My experience working for an artist had been more nebulous.

For eight weeks, over a summer during college, I'd assisted an artist in his mid-forties who'd moved from New York to live and work near my hometown in California. He had made his name in the early nineties with a series of well-regarded exhibitions, and since then had been not a superstar but certainly a fixture in contemporary art, represented in museum collections and on the biennial circuit, resurfacing every few years to show his latest work. But he'd been quiet for a while.

The terms and terminology of my employment were vague; I floated between being an intern and being an assistant, depending on the context. The summer I worked for him, he was diving into a new multimedia project: animation, software, sculpture, the works—"more like art *plus*," he said, and he was in the very beginning stages of it.

For the first month, the sculptor and I watched movies, read art magazines, and cooked big lunches. A few mornings each week I'd show up at his apartment/studio ready for action. We would brew a big pot of tea, set up at a worktable in the middle of the studio with pens and notepads, and proceed to get nothing done. He told me stories about artists, dealers, and critics he had crossed paths with over the years— people I'd read about in the magazines. Adultery in graduate programs, cutthroat curatorial politics at European festivals, shady deals at blue-chip galleries.

Halfway through the summer, another art student showed up to help; he turned out to be a really good cook, and so our lunches got even more elaborate and often took up entire afternoons. Still, not a lot of progress on the project. During August there were more matinees, trips

to museums, gossip. The other assistant made a model once, I remember that—a little plaster object shaped like a hamburger.

The sculptor did eventually complete the project, but not until long after I'd left. I don't think I ever got paid, but then again, I'm still not sure I did any work.

THE JOB DESCRIPTION of the artist's assistant is as varied as the landscape of contemporary art itself. You could work for a painter and clean brushes, work for a performance artist and archive documentary photographs, work for a found-object sculptor and collect interestingly shaped rocks, or work for a Conceptual artist and teleconference with curators all day. You could work alone with an artist in a moldering loft, come in a few times a week, and get paid in handfuls of cash. Or, you could work forty hours a week in a gleaming state-of-the-art studio with a hundred other assistants, sign a nondisclosure agreement, and get health benefits. Most likely, you will resemble the rest of the American workforce and sit at a desk in front of a computer, sending or receiving e-mail.

A recent scroll through an art-classifieds website revealed the following tasks, aptitudes, prerequisites, and provisos for the studio assistant:

> Coordinating projects with external contractors, which include but are not limited to framers, architects, designers, carpenters, and metalworkers.

> Experienced in making appointments and dealing with sensitive organizational issues with complete confidentiality and discretion. The ability to remain calm under pressure and effectively manage multiple tasks and deadlines.

> Someone who can do almost anything needed in the studio to make it so I can focus on painting is what I need.

> Must like cats.

How many artists have assistants? More than you might think, especially if you throw in those with art-student interns and once-a-month odd-jobbers.

Some artists enlist help as soon as they're able to afford it, going on the (usually correct) assumption that even art-making is subject to economies of scale: more people in the studio means faster production, means more exhibitions, means more money and better career traction. Taking a cue from the now-multinational museums, the studios of in-demand artists have become more like global operations centers, where multiple simultaneous projects are completed by coordinated teams of workers. At the height of the art boom in the mid-2000s, I heard stories about ambitious MFA students hiring their own assistants from the undergraduate labor pool; these subordinates produced work for upcoming gallery shows while their enterprising employers were stuck in critical issues seminars.

Making coffee, sweeping the floor, walking the dog. Bubble-wrapping the sculpture, digitizing the slides, updating the website. All the necessities of the workday—especially those without any real bearing on art-making itself—can be delegated to an assistant, who accepts such chores in the hope that he'll eventually get assigned something more interesting, perhaps educational: assembling stretchers and mixing paints, running the 3-D rendering software, photographing the art before it leaves for the show. Artists often have specific, even borderline-obsessive ways of treating their work materials; a proper initiation into these mysteries requires a commitment from both the artist and the assistant. And while anybody can go to FedEx or pick up sushi for lunch, it takes a certain personality type to make sure that each staple on the back of a ten-foot-long stretched canvas is exactly two inches away from its neighbor and rests at a perfect forty-five degree angle with respect to the stretcher bar. The educational component of being an assistant—which was formerly called apprenticeship—can result in another stipulation often seen in calls for studio labor:

The internship is unpaid but college credit can be arranged.

Beyond the issue of actual preparatory work, there's the social consideration of having assistants: as an artist, do you want people around when

you're having a really bad day in the studio? When you're hungover? I knew a painter whose primary responsibility as an assistant was to keep his employer sober. Willem de Kooning, a solitary worker by nature, preferred to spend the first hours of each day on the menial chores usually delegated to an assistant, even when his paintings were selling for millions.

On the other hand, assistants may serve a primarily social function. The studio can be a lonely place. "You have to love them," one of my professors said about working for artists. "Above all, you have to love them."

A young artist named Christian Sampson worked for the painter Alexis Rockman for years, and his role was ostensibly organizational. "I was sort of like a sous chef," Christian said. At the start of a workday, he laid out Rockman's palette, preparing batches of acrylic and oil paints, solvents, and media to the artist's specifications. Christian learned to prepare colors in dark, medium, and light tints, with varying amounts of oil, turpentine, or drying agent, in anticipation of the needs of a particular work in progress. In addition, he prepared surfaces and kept the artist stocked up on the innumerable components of a functional studio: brushes, soap, paper towels, squeegees, palette knives, paints, oil media, paint thinner.

However, this manual labor was nothing compared with the affective labor he performed for the artist: telling jokes, collecting and recounting art world gossip, providing a running distraction from the tedium of large-scale painting. In moments of exhaustion or when Sampson had run out of material, Rockman was fond of barking at his helper, "That's it? What am I paying you for? You're not my assistant; you're my paid friend!"

But beyond the odd jobs, the prep work, and the companionship, at a certain point the assistant takes on a different role in the studio. Having been successfully trained in the ways of his employer, the assistant moves from a position of support and preparation to one of actual production: executing parts—or wholes—of paintings and sculptures, and in some cases making big decisions about the form and content of finished works. In short, the assistant may come to physically or conceptually make the stuff that will, once it leaves the studio, be known as the artist's art.

And here is where things get tricky—at least as far as the sociologist of labor is concerned. Imagine a painter of enormous Photorealist nudes. He's sitting in the back of his studio, flipping through a magazine, while his assistant is perched high up on a ladder with a paint tray and a brush. Between scans of *Artforum*, the artist directs the assistant to add, perhaps, just a little more of a highlight, please, to the eye of a figure in a work in progress. In this situation, who is making the art?

The answer, by almost universal consent, is clear: the artist is making art, even if he doesn't get so much as a spot of paint on his jeans. The assistant, on the other hand, is merely working; one hopes she's at least making a decent wage for it. But *why* this is the answer is the result of a long and circuitous history.

You could begin with the *bottegas*, where a successful artist of the Renaissance might have employed dozens of apprentices to help with all aspects of his craft. These workshops occupied a place at the center of a community. Pre-adolescents—not necessarily artistically inclined ones, just neighborhood kids who needed work—progressed from simple tasks to more challenging ones: mixing up batches of gypsum and glue for use as a painting ground, then transferring the master's designs onto wooden panels or altar walls, then grinding pigments and making paints, and then, years later, executing parts of actual paintings.[1]

Each workshop was a small business and a school in miniature. In Florence, they predated both the formation of a dedicated guild for artists and an academy of the arts. Each had its own way of doing things, and this proprietary technique, inseparable from the meaning of the art it produced, was sometimes even written down, ensuring the faithful transmission of the artist's method. Ambitious assistants aimed to graduate from service and eventually hang their own shingles in town, competing with their former employers for commissions from churches and nobles, and in turn training the next generation of artists, world without end.

The workshop system also explains the way artistic influence propagated in Renaissance Italy: through imitation. At the heart of the

apprenticeship process was the act of copying. Assistants learned by repro-
ducing the master's drawings, paintings, or sculptures (which, more often
than not, were reproductions of other artists' drawings, paintings, or sculp-
tures) with the aim of perfect fidelity to the boss's style. This practice had
the added benefit of generating a stockpile of reference material, closely
guarded by the workshop, for use in future projects: *You need a horse and
rider, two cherubs, and Our Lady seen in left profile? No problem, Maestro.
I'll pull them from the file.* The Florentine painter Domenico Ghirlandaio
kept bound volumes of drapery studies (drapes at rest, drapes in a gentle
breeze, drapes wrapped austerely around an apostle or opulently around a
wealthy patron) to deploy in his commissions, like Renaissance clip art.

But beyond the creation of these visual reference libraries, the prac-
tice of copying prepared the assistant for executing parts of actual art-
works, according to the master's specifications. Once the assistant's work
was up to snuff, he could be tasked with completing the tedious bits of a
commission: some shrubbery along the road to Calvary, or the wings of
the lesser angels in a Last Judgment. Certain very talented apprentices, it
was said, couldn't help but reveal their employers' limitations by copying
too well — in the way the precocious Raphael once outshone his master
Perugino on an altarpiece job the latter artist was foolish enough to assign
to the former.

By 1610, the Flemish painter Peter Paul Rubens had international-
ized the workshop model, with teams of protégés in his Antwerp studio
executing works for patrons from London to Madrid, while the artist
himself traveled around hobnobbing with potential patrons and, in fact,
performing diplomatic missions for the Spanish Hapsburg court; he was
knighted, twice.

The French Academy in the eighteenth century then centralized it,
linking art training, production, exhibition, and patronage in a mono-
lithic, state-sponsored machine. The most successful artists of the period
maintained extensive studios, with assistants drawn from the ranks of
academy students, to meet the considerable demands of royal and repub-
lican commissions.

As the influence of the French Academy waned and state patronage dried up, so too did the collaborative mode of the workshop. The new, private patron of the arts, drawn from the upper tiers of the bourgeoisie, bought modestly sized pictures for the home. The Salon des Refusés of 1863, an exhibition organized for French artists turned away from the Académie des Beaux-Arts' annual show, marked a watershed in the aesthetics of artistic success. Manet, Whistler, and Cézanne debuted works there, to great public scandal and belated acclaim; in hindsight, it was better to have been rejected from the official Salon of 1863 than accepted by it. With this shift in the structure of patronage, the social coordinates of the artist were dramatically relocated: from the comfortable center of high-cultural life to its adventurous margins. The modern artist—he of the antisocial tendencies and the unique vision—emerged as the paradigmatic hero in the story of art and dominated it for roughly the next hundred years.

In this story, the artist is by definition alone in his creative quest. It wasn't that nineteenth- and early-twentieth-century artists stopped hiring assistants and did everything by themselves, but that the new shape of the market, and the prevailing fashion in self-representation, dictated a less ostentatious display of hired labor. It's hard to imagine, for example, Vincent van Gogh thrashing out a turbulent plein air landscape at Arles while an assistant stood by with a parasol and a carafe of water. Paul Cézanne, who laid the groundwork for twentieth-century painting from a provincial outpost in the south of France, never once had an intern deliver him lunch at his perch opposite Mont Sainte-Victoire. Even Jackson Pollock's revolutionary drip painting method—so readily imitated by others—is the most meaningful when we imagine the Abstract Expressionist all by himself in his Long Island barn, confronting the existential void of the blank canvas.

The myth of the Solitary Genius was precisely that—a myth. But that in no way detracted from its power over our collective imagination. This is how we, as a society, have conceived of the artist for at least the past hundred years. Picasso could hardly have been said to languish in obscurity during his lifetime: he achieved a level of fame and worldly

Figure 2.2

success unparalleled in the visual arts since Rubens. By the middle of his career he had assistants for many aspects of his studio practice—from ceramics to etching to mural painting—and even engaged a private secretary, the indispensable poet-bookkeeper Jaime Sabartés, to orchestrate his demanding schedule. But a certain cognitive dissonance attends the thought of anyone other than Picasso touching brush to canvas; this is anathema to our understanding of what he did and meant.

THE STORY OF contemporary art begins when the direct line between individual and object is interrupted and art-making is opened to a wider range of definitions. This in itself is a phase-shift in art history—a return to the social and collaborative model of art-making most exemplified by the Renaissance and its legacy. But one can't just pick up where Raphael left off: contemporary art is as different from the art of the Renaissance as present-day New York is from fourteenth-century Florence.

Beginning in the early 1960s, a generation of artists reared on the myth of the Solitary Genius and His inimitable style began to move away from the forms of painting and sculpture that marked the apotheosis of modernism and embraced a broader range of materials and processes than had ever been gathered under the heading of art. Donald Judd had immaculate steel sculptures fabricated by the same sorts of metalworkers who built oil tanks and airplane wings. Sol LeWitt gave instructions for mural-size wall drawings and sculptures that could be executed by anybody, anywhere, using whatever materials were at hand. Nancy Holt arranged massive lengths of concrete tubing in a desert in Utah.

The idea was that, in an industrial society where goods are produced through a panoply of technological processes, the limitation of art to just paint on canvas or sculpted wood and metal suggested a real lack of imagination. This more catholic approach to materials—which tended to manifest in cool, impersonal forms derived from said panoply of technological processes—also challenged the primacy of the expressionistic, heroic model of art-making, which had its high point in the art of the forties and fifties. It accomplished this, largely, by proposing a separation between the physical manufacture of art and its meaning. A Picasso painting is what it is because Picasso made it himself, by hand, in a way that no one else (supposedly) could. A Sol LeWitt wall drawing is what it is by virtue of the fact that anybody could physically make it.

Thus, to the most common charge leveled against art since the turn of the twentieth century—my two-year-old could make that!—the contemporary artist might well reply, "Yes, of course, and that's pretty much the point." Your two-year-old might have to learn to weld; but then again, she might not. The idea that the work of art isn't dependent on any particular set of materials or processes leads to situations in which much of the "work" of art can be outsourced to various professionals.

The assistant could be aggregate: a firm of commercial awning manufacturers, an excavation crew, the mass of pedestrians who unwittingly made shoe-print drawings on sheets of paper left in the streets of Amsterdam by Surinamese–Dutch Conceptualist Stanley Brouwn. It

could even be abstract, like the *I Ching* favored by John Cage in his chance-based compositions.

And as the sphere of art practices widens even further beyond the giddily experimental 1960s, the specialization of artistic techniques has become only more pronounced. Rosemarie Trockel mounted exhibitions consisting entirely of machine-knit textiles stretched like paintings. Cai Guo-Qiang exploded 1,300 pounds of gunpowder in the Gobi Desert. Damien Hirst engaged the services of fabricators and scientists to create his dazzlingly macabre mixed-media sculptures: a tiger shark or a cow preserved in formaldehyde in glass vitrines. Applying a criterion of mastery to these artists would mean insisting that Trockel be a master weaver, Cai a munitions expert, and Hirst a licensed shark embalmer.

Even when they return to more traditional forms, like painting or sculpture, artists must acknowledge the deconstruction of the category of manual skill, which has accompanied art since the mid-twentieth century, and the reality that the work of art is now an aesthetic commodity traded on the global market. In a nod to both phenomena at once, the prominent portraitist Kehinde Wiley recently set up a studio in Beijing, complete with a team of assistants—playfully "offshoring" his art production and placing it near one of the biggest emerging contemporary art markets of the past twenty years.[2]

Where does this leave the studio assistant? What does she stand to learn from her boss? The circuit between labor, skill acquisition, and influence that operated in the workshop system of the Renaissance has been disrupted. A young artist working for an older one will certainly learn particular techniques, but these are often so specific to an artist's practice that they're almost impossible for an assistant to adapt for her own work. In a field broad enough to encompass giant concrete tunnels, Photorealist paintings, and cows in boxes, an assistant who straightforwardly emulates his employer's art is more likely to be written off as a copycat than lauded as a successor.

Assistantships do create lines of succession: in the history of art, who worked for whom is as important as who taught whom. But absent the

direct transmission of a techne, do these lines do anything other than perpetuate a certain prestige? What, at the end of the day, is being handed off from generation to generation?

THE VIDEO ARTIST Karen Leo, who supported herself as an artist's assistant for most of her twenties, divides holders of the job into two groups. First there are the administrators: the schedule-keepers, e-mail-responders, and supply-orderers, who make sure the studio runs smoothly and profession-ally. Then there are the stuff-makers, who are covered in plaster and wood shaving or flecked with paint.

Leo first made stuff for a former professor from the School of Visual Arts in New York; then for an older classmate, the sculptor Toland Grinnell; and then for the multimedia artist Matthew Ritchie. She assisted Ritchie for ten years; mainly, she cut out the huge, massively complicated PVC board sculptures that are Ritchie's signature works—day after day, inch by painstaking inch, with a utility knife.

At the same time, Leo moonlighted in the studios of other artists. She edited a video for Conceptual artist Barbara Bloom and did installation work for the sculptor E.V. Day. In a brief departure from stuff-making, Leo was line producer for Carrie Mae Weems on a video project for the Museum of Modern Art. These freelance gigs allowed her to sample different artists' ways of working: were they planners or improvisers? Delegators or controllers? Freelancing was also economically unavoid-able, for someone whose job skills were at once specialized, various, and almost impossible to apply outside the art world. "It's a very rarefied thing to get yourself into, being an artist," she said.

When I asked her what she'd learned from assisting people, or how she'd learned it, Leo said it all came down to conversation—what you talk about in the studio, with your employer or your fellow assistants, while you're performing the repetitive and often (frankly) mindless labor of mak-ing stuff. What you talk about is art: what it is, how it works, what makes it good or bad; you can assemble a pretty comprehensive theoretical model of contemporary art in the course of an eight-hour day with a glue gun.

Of course, *who* you talk to is equally important, and a mindful employer will be sure to introduce his assistant to the critics, curators, and dealers who may help her along on the path to an art career.

Another way to put it is that the educational component of artistic apprenticeship is now social, professional, and conceptual rather than technical. The assistant isn't there to learn the finer points of a craft but to absorb the weltanschauung of the artist, from her aesthetic philosophy to how she talks to important people on the phone. Tips about paint handling or Photoshop are simply perks.

This information is transmitted through performance — the artist being herself — and only rarely arranged into a formal lesson; the assistant is likely to gain it through discreet, stealthy observation. The by-product of this observation is the rich anecdotal culture of studio assistant lore, full of egomaniacal ranting, drunken mayhem, psychological victimization, nervous breakdowns, theft, and lawsuits. (No one wants to hear about the model employers who treat their subordinates with generosity and respect.)

These stories get swapped at parties and bars by young artists in a kind of servants' hall gossip and range from painful but endearing accounts of personal foibles to full-blown horror stories of abuse and humiliation: from the artist so sensitive to noise that he wouldn't let his assistants chew gum to the artist who punished her helper by locking him in the studio overnight.

This is my favorite: An assistant was offered a generous Christmas bonus, one of his employer's very own paintings, easily worth tens of thousands of dollars. But there was a catch — the assistant had to make the painting himself, start to finish, on his own time. The artist would then come in at the end, scribble his signature, and voilà, Merry Christmas.

The tradition of haughty bosses and underappreciated assistants goes back to the *bottegas*: as long as the West has kept track of its artists, they've been represented as pricks. The shameless sixteenth-century gossipmonger Giorgio Vasari says, in his *Lives of the Artists*, that Michelangelo was hardly a model employer. He sent for half a dozen of the best fresco painters in Florence to help him do the Sistine Chapel. When they arrived in

Rome and showed him their work, he was so disappointed that he locked himself in the chapel until they got the hint and shuffled back home, unpaid.

The experience of being up close and personal with the creative act can severely test the faith of even the most devout believer in contemporary art. In 1971, performance artist Chris Burden asked a friend to assist him in the realization of a piece by shooting him in the arm. The German artist Martin Kippenberger, for whom the entire practice of being an artist was a form of high comedy, once commanded his assistant to make a series of paintings on huge canvases based on his specifications. Once the assistant was finished, Kippenberger crumpled up the paintings and crammed them into a Dumpster. The Dumpster was later shown in his retrospective at the San Francisco Museum of Modern Art.

The artist Cameron Martin worked for Nam June Paik on and off for about three years in the late 1990s; he met the legendary Fluxus artist a grand total of two times during that period. Paik had suffered a stroke in 1996, and his studio pretty much ran itself in its final years, producing the television-monitor and neon assemblages that had become his trademark. A group of studio managers administered different aspects of the artist's work and oversaw teams of assistants in shops scattered around SoHo: there was the robotics shop, the video editing shop, and the sculpture shop. Cameron wasn't sure exactly how many branches of the Nam Jun Paik studio there were.

He worked in the sculpture shop, hardwiring TV monitors into big welded steel armatures. A few blocks away, people he rarely met, but presumably young artists like himself, produced the jittery, seizure-inducing videotape loops that eventually played on the monitors when the sculptures were finished. Cameron remembered a day when a European collector was scheduled to visit Paik's studio in the afternoon, all set to buy one. The trouble was that the studio hadn't built it yet. They went into crisis mode and completed the sculpture just in time for the visit—which did indeed lead to purchase. Paik never laid eyes on the piece.

■ ■

SOMETIMES SEEING HOW the contemporary art sausage gets made can turn a person off from the entire meal. Audrey Robinson is a fashion designer, but considered being an artist. She had been to art school in Montreal, where she did guerrilla performances with a friend in public spaces around the city, but in the fall of 2002 she was living in Williamsburg and working in a cafe. One day she replied to a message on Friendster, then a social media site, from the artist Vanessa Beecroft, who was looking for an assistant.

The Italian-born Beecroft became famous in the early 1990s, at a time when the art world was revisiting the then-moribund genre of performance art. Early on, Beecroft had developed her signature work, which she repeated and elaborated on over the next twenty years. A group of people, usually women, usually seminude, pose more or less motionless in an exhibition space for a couple of hours. They're instructed to stand as still as possible—sitting or lying down for short rest periods if need be—and to refrain from speaking or in any way engaging one another or their audience. The performers are dressed and styled differently for each piece; clothes, hair, and makeup are the main variables, which usually change in reference to the location of the work. *Vb08*, Beecroft's first stateside performance in 1993, had a red, white, and blue theme: ten women in red pigtailed wigs, tan sweaters, and blue or white panties stood motionless at the PS1 museum in Queens. Three years later, *vb16* opened at Deitch Projects in Manhattan: this performance featured a dozen women, with blonde bobbed wigs, dowdy underwear, and gold high heels.

In 1999, Beecroft changed up her formula and started displaying men. She arranged the loan of fifteen U.S. Navy SEALs in crisp uniform whites from the nearby Naval Special Warfare Center and had them stand at attention in a gallery at the San Diego Museum of Contemporary Art. For *vb45* in 2001, Beecroft's largest performance up to that point, about forty dyed-blonde women with shaved genitals and thigh-high, black leather Helmut Lang boots inaugurated the new Vienna Kunsthalle building by standing, sitting, and finally lying down on the floor of the museum's atrium before an audience of VIPs.

Reception to Beecroft's work has always been mixed. She seems to take up the intersecting art historical themes of gender, performance, and labor only to tie them in a hopeless ethical knot. Was the artist highlighting the objectification of women within the culture industry, or in fact merely objectifying them? Did her work reinvigorate the anti-market ethos of 1960s Conceptualism or the politicization of the female body accomplished in 1970s feminist performance art, or did it merely recycle these ideas as promotional events? What to make of Beecroft's public battle with exercise bulimia and the almost paternalistic form of control she wielded over her conspicuously model-thin performers? What to do with the spectacle of a dozen nude or seminude women slowly collapsing to the floor of a museum rotunda, in front of an audience of fully-dressed arts professionals and museum trustees? "There may not be any easy resolution of the feelings and opinions that Ms. Beecroft's work arouses, and that may be the point," demurred Roberta Smith of the *New York Times* in 1998.[3] In 2001, Los Angeles critic Bruce Hainley wondered whether she was "the Leni Riefenstahl of performance art."[4] A friend of mine was even glibber, underlining what he saw as the only concrete development in her work: as Beecroft got more and more famous, her models looked more and more expensive.

In 2002, having recently completed performances at the Peggy Guggenheim Collection in Venice (white women, nude, flesh-colored stockings pulled over their heads, arranged in front of famous Surrealist paintings) and the Palazzo Ducale in Genoa (black women, black string bikinis, Manolo Blahniks, white fur rug), Beecroft set to work on a new project for her New York dealer, Jeffrey Deitch, to exhibit at the 2004 Armory Show. It would be something of a departure for the artist: a series of paintings.

On the day she met Beecroft, Audrey recalls, there was little in the way of an actual interview. She had hitched a ride out to Long Island, where Beecroft and her family had just bought a mid-century modernist house located inside a nature conservancy. Audrey and Beecroft sat in a

sun-filled studio, drank seltzer, and made small talk. The modest portfolio of watercolors Audrey had brought with her to demonstrate her painting abilities sat unopened, and unmentioned, beside her. "We met, and we talked a little, and she just asked, 'When can you start?'" A few days later Audrey was hired. She spent the next seven or eight months painting Vanessa Beecroft's paintings.

Early in her career, Beecroft had exhibited a few small watercolors: breezy images of figures, faces, pieces of clothing that looked like fashion designers' sketches by way of exuberant children's doodles. It's easy to see the continuity between these pictures and the tableaux-vivants that would later make her famous. In a recent interview, Beecroft recalled, "When I didn't have any means, I did watercolors that were psychological pictures, then I used the girls because I had a problem with technique."[5] Shortly before Audrey arrived, Beecroft had started on a series of paintings in a similar vein. Flattened, cartoony faces with shocked eyes and strag- gly hair float on bare white grounds; some resemble the artist. They're a far cry from the physical perfection of Beecroft's live models, and it's entirely unclear whether the problems with technique in the paintings are affected or genuine—and whether the answer to that question ever mattered to the artist.

Audrey was first instructed to pick up where Beecroft left off: she was given a photograph, the close-cropped face of a woman, and asked to make a painting from it. The woman turned out to be Beecroft's younger sister, Jennifer, who had been the artist's muse in previous works. Audrey set to work building up the structure of Jennifer's face, developing the tones and texture of skin and hair, trying to tweak the proportions and angles and make everything a bit more anatomically plausible.

Vanessa didn't like Audrey's first attempts. "She thought they were too realistic, too much from the photograph," Audrey said. The photo- graph vanished. Audrey began working on other paintings of women in a looser, more expressionistic manner. These met with greater approval. As the weeks went on, these were followed by paintings of other women's

faces. Sometimes Audrey would paint by herself, and sometimes she and Beecroft would paint together. Beecroft gave her assistant very few instructions about what to do, but reacted strongly to decisions that Audrey made. After a while, Audrey began to see that perhaps the criteria for these paintings were not fully consistent.

"Sometimes Vanessa would come in and say, 'I think her hair color should be darker,'" Audrey recalled, "and so I would change it. Or she would say, 'She should be more blonde,' and I would change it back." The paintings got thicker and thinner, the faces more and less realistic. Their subjects began to look like Botticellis, idyllically beautiful, before they were painted out and started again. It felt a bit like they were painting in circles.

At one point, Beecroft decided that the paintings should correspond to the four seasons. Audrey painted one woman's lips a wintry, bluish gray; another's hair in russet reds and deep autumnal oranges. This idea was eventually scrapped too. "I was like the hair and makeup stylist for the paintings," she said.

Halfway through her time with Beecroft, Audrey came to realize that changing the paintings constantly was the whole point. This was where Beecroft's instincts as an artist lay, and this defined the essence of her craft: she styled and arranged women. Beecroft had once referred to the women in her performances as "material, in an almost pure state."[6] The painted women were material as well, to be made softer or harder, blonder or darker, by Audrey. And Audrey, too, was a kind of raw material: she had signed up to be an assistant, but instead she found herself in the middle of an unexpected six-month performance piece, with an audience of one.

Her insight into Beecroft's work was that the pleasure of painting could be experienced by proxy. "She liked the process," Audrey said, "but she didn't necessarily need to do it herself."

The painting project came to an abrupt end following a studio visit from Jeffrey Deitch. After viewing the work, he decided that, in retrospect, maybe paintings were not the way Beecroft should go for the

upcoming Armory art fair. Instead, he suggested, perhaps she should try to make a sculpture? Audrey recalls that he had a very detailed idea of this: Vanessa's sister, life-size, cast in resin, on her knees on a desk — "like a guard dog," Audrey remembers him saying — with a real security guard sitting at the desk.

But this project was ultimately destined for another assistant. Audrey had no real background as a sculptor, and she sensed it was time for her to move on; she'd had enough painting to last her a lifetime. When she told Beecroft she was leaving, Audrey recalls that the artist was sweet, concerned, a bit regretful. It was never clear what, if anything, became of the dozens of half-finished paintings she had worked on that year and left lying around the studio. In March 2004, Vanessa Beecroft's inaugural sculpture, *Sister Sculpture*, debuted at the Armory Show. It portrayed the artist's sister, life-size, cast in resin, on her knees on a desk in the booth.

■ ▪

MOST STORIES ABOUT artists and their assistants wrap a protective layer of humor around a nub of anxiety; if you unwrap them, you find the question of authenticity at their tiny, fragile core. When are artists delegating nonessential aspects of their work to capable assistants, and when are they phoning it in? The Solitary Genius dies hard. Despite centuries of historical precedent, the reality of art's industrial or even simply collaborative dimension still sits uneasily with our cherished (sometimes unconscious) beliefs about its relationship to an individual. Even Andy Warhol, whose freewheeling Factory is largely responsible for how we think about the artist's studio today, occasionally had to retreat from his cavalier position on the role of the artist. In 1969, Warhol told an interviewer that he never actually made any of his paintings anymore — his assistant, Brigid Polk, did. The line got picked up in a German newspaper, inciting a minor flap among German Warhol collectors, who demanded to know whose paintings they actually owned. As it happened, nobody really wanted a Brigid

Polk. Warhol was forced to issue a retraction: Just kidding! He made his own paintings, after all.[7]

In other instances, conflicts arise at the intersection of ego and terminology—especially where the historical record is concerned. When Romare Bearden, the prolific Harlem modernist, was scheduled for a posthumous retrospective in 2003 at the National Gallery of Art in Washington, D.C., his former assistant André Thibault enlisted the services of a lawyer to ensure he received credit in the show. Thibault claimed that he had collaborated with Bearden in the completion of twenty-two works during the last months of the artist's life. The institution and the artist's foundation begged to differ: Thibault may have assisted Bearden, they claimed, but the two were never collaborators.[8]

The propriety of someone else's labor in an artist's work is often decided on a case-by-case basis. In 1997, the Museum of Modern Art mounted an exhibition of Willem de Kooning's late paintings. The artist, who passed away while the show was up, had worked through the 1980s despite the mounting effects of Alzheimer's disease and a lifetime of alcoholism. His spare, minimal paintings from this era, which differed greatly from the earlier masterpieces of his long and storied career, had been exhibited before but remained a source of skepticism among critics and historians. Was this the late style of a protean master in the process of reinventing himself yet again or the doodles of a once-great talent now wasted by disease?

In an essay accompanying the exhibition, curator Robert Storr argued vehemently for the masterpiece interpretation and against the doodles theory. A lot rested on Storr's defense, in terms of not just the monetary value of the works on display but also our understanding of the artist's legacy.

The case hinged, in part, on the role of de Kooning's assistants. How much did they do for the artist in those dim final years when he was struggling to paint, despite chronic anxiety and memory loss? Did they not, perhaps, assist him a little too much? Storr charted the routines of the de Kooning studio with the fastidiousness of a forensic anthropologist in an

effort to rebut the "ill-informed speculation that has tainted the authenticity of these paintings."[9] When the artist struggled with depression in the late 1970s, his once estranged but recently returned wife, the painter Elaine de Kooning, sacked Willem's current assistant (whose drinking had enabled de Kooning's own) and brought a new group of young artists to the studio. Her express purpose was to enliven the atmosphere and encourage him to work. (This in itself was a small revelation, given that in a 1983 book on the artist, art historian Harry Gaugh made much of the "silence" of de Kooning's studio in the early eighties—suggesting that the aging artist persevered in his legendary solitude).[10]

De Kooning's assistants performed the routine studio maintenance that the artist once relished doing himself. They washed the brushes and did all the usual prep work. They even devised a motorized easel that would allow him to rotate his large canvases without physical strain. For Storr, though, the most significant aspect of the assistants' work, which required a step-by-step explication in his essay, was their use of an overhead projector. For the detractors of de Kooning's late work, this device was a smoking gun. Each day the assistants would project images of earlier black-and-white de Kooning drawings onto blank canvases and trace some of their contours with a first coat of charcoal and oil paint—thereby allowing the artist to begin his new paintings using older visual ideas as templates.

In fact, neither the projection nor the charcoal sketching nor the underpainting is at all shocking compared with the techniques and practices habitually used in artists' studios from the fourteenth century to the twenty-first. But in the case of an aging, once-godlike Abstract Expressionist, one of the last icons of American art's rugged individualism, these prosaic details hit a sore spot. Perhaps sensitive himself, Storr made a point of delimiting the assistants' role to a space literally and metaphorically outside the proper domain of the artist. He wrote that they did the projecting and underpainting in a downstairs office, outside the studio. The show at the MoMA was well received, and the art world more or less agreed with Storr that, in the case of late de Koonings, the

assistants were merely preparing each work "before bringing the canvas up to the studio, where the artist would take over."[11]

SOME ARTISTS HAVE made a career out of inverting the notion of artistic individuality as spectacularly as possibly, mining the diminishing store of frisson produced by its repeated demystification. The artist and musician Sean Greathead, the childhood friend of the sociologist I met at the party, works for the wildly successful multimedia artist Jeff Koons. Koons is the closest thing to a household name that contemporary art has produced since Warhol, who very much provided the template for Koons's career.

Koons is probably most famous for his forty-three-foot-tall topiary West Highland terrier, titled *Puppy*, which now guards the entrance to the Guggenheim Museum in Bilbao, Spain. Through their painstaking re-creations of commonplace American objects, Koons's precision-fabricated sculptures and immaculate photorealistic paintings present a vision of middle-class values elevated to the chilly heights of luxury. A Mylar balloon in the shape of a heart is blown up to the size of a car and fashioned in mirrored stainless steel (*Sacred Heart*, 1997). A giant plastic toy in the shape of peg-legged pirate hovers in space in front of the Liberty Bell (*Peg Leg Liberty Bell*, 2008). In 1981, Koons encased a gleaming vacuum cleaner in a Plexiglas box and lit it with cold rows of fluorescent tubes—a piece that sums up Koons's ambivalent relationship to his subject matter: it's as if he isn't sure whether he's glorifying these humdrum icons or utterly sucking the life out of them.

Hearing Koons talk about his work is similarly vexing. A 2009 PBS documentary segment about life in his studio in Chelsea begins with the voice of the artist—placid, unhurried, a bit folksy—meandering through the themes of his art: banality, fantasy, comfort.[12] Meanwhile, we glide through Koons's enormous Chelsea studio. It looks nothing like our conventional image of an artist's atelier: no ratty armchair, pile of oily rags, or clay-crusted workbench. Rather, it's clean and orderly; we see computers, office chairs, welding booths, industrial shelving units laden with long

rows of identical paint cans, and smooth gray concrete floors. It could be the production office of some niche manufacturing company, perhaps one that makes high-end espresso machines or garden statuary.

The main thing is that the immaculate space is bustling with people: maybe a hundred assistants are busily making Jeff Koonses, like elves in Santa's workshop. We see them polishing cast aluminum sculptures and spray-painting them in a plastic-lined room, mixing oil paints on a glass palette to match the vivid hues of a digitally printed collage, transferring these digital images onto enormous, colorful canvases inch by careful inch. Some wear dust masks, respirators, goggles, even white Tyvek suits, but a few glimpses of pierced noses and tattooed arms beneath shirt-sleeves remind us that these young people are artists, after all, not lab technicians. The camera continues its pan into a cluttered workroom, where a sculpture fashioned after an inflatable lobster sits prominently on a large wheeled cart, and behind the lobster, for a duration of about three seconds, there's Sean working at a computer.

Sean is a soft-spoken punk rocker, modest about his music and art. In college he studied painting and a bit of digital media; those skills, plus the informal career network of Atlanta artists transplanted to New York, were enough to land him some commercial illustration work. He freelanced at *Forbes* and designed online slideshows for its website. They'd say, we need a picture of a clock, and Sean would make one in Adobe Illustrator. In the early 2000s, he met an art director at Topps, the iconic trading card and sticker company based in New York, and was commissioned to make paintings for two of its canonical card series: Garbage Pail Kids and Wacky Packages.

Sean had a run of hits with his designs for Orangutina orange juice, Spittles candies, and DeadBull energy drink. Hill Billy, his most lasting contribution to the Garbage Pail Kids series, is a barefoot cherub in cover-alls, who grins idiotically at the viewer with enormous, malformed teeth. Flies circle his oversize head; he holds a cardboard sign reading SMILE and sprawls in front of a rickety wooden fence set in a grassy pasture. The card is now somewhat rare—I saw one online for ninety dollars—and

Sean has been asked to sign a few for collectors. "I had very minor celebrity for a minute," he said. This was all fine and good, but when Sean heard about an opening at Jeff Koons's studio in 2004—an opportunity to do real art for a real artist—he took it.

Koons's studio is one of the biggest employers of studio assistants in New York. If artists' studios were brokerage firms, Koons's would be Goldman Sachs. Most of his staffers come from top-notch art schools— ironically, many are graduates of the kinds of conservative institutions in which an artist attempting Koons-esque conceptual hijinks would be thrown out on his ear. A lot of employees at the Koons painting department, for instance, were trained at the New York Academy of Art, a school that specializes in traditional realist oil painting with an emphasis on classical technique and materials. The artist doesn't need people with particularly sophisticated takes on theory or the neo-avant-garde; he needs people with really good painting chops.

The studio manager who reviewed Sean's portfolio liked his stuff— somehow Koons and the Garbage Pail Kids are not that far off in spirit— and Sean got the coveted job, along with health insurance and a new employee handbook.

In smaller studio situations, the benefit of working for an artist is that you're in close contact with him or her, and thus, that you have unfettered access to the nitty-gritty details of the trade. In addition, you hope, this workplace intimacy lends the artist to take an interest in your artistic and professional development. Plenty of artists' assistants have parlayed a fairly low-paying (sometimes next-to-no-paying) job into the beginning of their own bona fide art careers. Some artists choose to become assistants instead of attending high-priced MFA programs; the assistantship functions para-academically, along the lines of an unaccredited work-study program.

This isn't necessarily the case in the big studios. When Sean came to work for Koons, he didn't meet the man himself until a few weeks into the job, and he primarily dealt with with his co-workers and various studio managers. Impersonality, however, was made up for by reliability: Sean

was fairly sure he'd still have a job in two months, which is more than many artists' assistants can say.

This reliability is a function of the artist's market. Koons's work has been a fixture at auction for decades, and the artist operates at a level of the art world that buffers him against sudden catastrophic meltdowns. Enough people and institutions have now invested in his work that utter ruination, though certainly not impossible, is at least unlikely. Consequently, his studio apparatus is insulated against sudden swerves. When Sean started, in 2004, Koons employed about fifty people. The staff ballooned during the peak of the art boom—when Koons's sculpture *Hanging Heart* broke the auction record for a work by a living artist, at $23.6 million—and has since leveled off at about 120 people, post–crash of 2008.

Sean ended up in the sculpture painting department (as distinct from the sculpture department, or the much larger painting department); as the name suggests, he and his colleagues were responsible for applying paint to sculpture. But Sean's particular job was confined to the computer. In the Koons studio methodology, most things began with a digital source. In the case of paintings, this meant a Photoshop collage that could be blown up onto a canvas through a process of projection, tracing, and color matching. For sculptures, the staff worked from a composite image produced using a 3-D rendering program. A sculpture of an inflatable cartoon lobster, for example, could be scaled up on the computer in order to generate a series of molds for use in the casting process—which was outsourced to off-site fabricators. When the raw aluminum lobster returned from the foundry, the boys in sculpture painting were responsible for devising a plan to spray-paint it so that it perfectly match the plastic original.

This was where Sean came in, sort of. His job was to transform the original digital lobster file, for example, into a series of vectored shapes, which became templates used to guide a plotter, which produced vinyl stencils, which were applied to the sculpture and carefully masked off with tape. This ensured that whoever actually pulled the trigger on the

spray-paint gun got every scale, spot, claw, and eyeball in exactly the right place.

Despite the relative consistency in this phase of his oeuvre, a 2001 Koons is subtly different from a 2011 one: the paintings become more complex and fragmentary over the decade, and the sculptures evolve from single objects and monochromed shapes to colorful, multipart arrangements. I asked Sean if he'd noticed the difference, as he sat there at the computer every day for seven years working on color separations and vector graphics. "It's kind of funny sometimes—when you're focused so much on one tiny part, you lose track of what it actually is you're working on." In other words: not so much. He did say that he once spent weeks at the computer vectorizing a picture of a vagina before he realized what he was working on; he was zoomed in so far that it was just a bunch of abstract shapes.

"PEOPLE THINK I have a large factory that just knocks out work," Koons has said, by way of minimizing the role of industrialization in his studio. "I do have a lot of people that work with me, but we make very few paintings a year because it takes a long time to make each one."[13] The nod to Warhol is implicit. After all, it was Warhol's Factory, more than any other development in contemporary art, that most radically reconfigured the artist's studio in the popular imagination. Warhol was unashamed about playing up the glib, mechanized aspects of his art. "Making money is art. And working is art. And good business is the best art," he claimed, and flaunted the idea that the Factory churned out Warhols like cheap cars off an assembly line.

The reality was quite different. The Factory, which the artist started while still living with his mother on the Upper East Side, was more like a piece of experimental living theater than an art studio. It was a space where Warhol's coterie (he called them "superstars" rather than workers) enacted a countercultural utopia of sexual freedom behind the blank, productivist symbolism of the place's name. Warhol, a working-class son of Pittsburgh at the tail end of the steel industry, generally employed only

one or two assistants at a time — usually at below-minimum wage. Others were contracted on a per-project basis, such as the young men hired from the St. Marks Baths to urinate on prepared canvases for his late 1970s *Oxidation* paintings.[14] The assistants might help to churn out batches of silk-screen prints, but Warhol himself was much closer to the production line than he professed to be. Even his famously impersonal films — the eight-hour-long *Empire*, the interminable *Sleep* — belie a rigorously personal approach to art-making on par with the most existential of Abstract Expressionist head trips. The poet John Giorno, whom we see sleeping in *Sleep*, recalls that Warhol himself, wired on amphetamines, wound the crank on the 16 mm Bolex camera every twenty-eight seconds for the entire five hours and twenty minutes of the take.[15]

In many ways, Koons has taken Warhol at face value: though a far cry from General Motors or even Martha Stewart Inc., Koons's studio is more like a factory than the Factory ever was. Warhol's studio was incorporated as a legal business entity — Andy Warhol Enterprises — only in 1974, ten years after the Factory first opened; in contrast, Jeff Koons LLC has aggressively pursued copyright infringement and intellectual property disputes concerning the artist's work and requires its employees to sign nondisclosure agreements about the work they perform for the company.

Figure 2.3

Sean was allowed to tell me in general terms what he did for Koons, but not which particular projects he had a hand in: the example of the lobster sculpture is pure conjecture.

The transgressive agenda underpinning Warhol's pseudo-industrialism has been entirely displaced within the earnest post-Fordism of the Koons model. On the whole, Koons's work is high quality art produced under decent, if dull, conditions; by all accounts, he's a model employer. Sean, who plays in two bands at the moment and still finds a little time to paint, seems genuinely happy with his assistant job. Vectorizing computer graphics five days a week, from 8 to 5, is a little repetitive, he admits. But then again, he's able to pay rent on an apartment in Crown Heights that he lives in by himself. He also has health benefits, a genuine rarity in the primarily freelance world of assisting. There's a certain amount of competitiveness and gossip among the staff, but also friendship, camaraderie, even love: Sean counted a dozen couples who had met on the job since he started working there seven years ago. He can see gallery shows in Chelsea on his lunch break, and the studio has a lively soccer league: almost a game every day. When he first started, he'd heard rumors that some of the staff at Matthew Barney's studio (another of the city's megastudios) wanted to challenge the Koons team to a football game—a nice idea, but the wrong sport. "If it was soccer, I'm sure we could kick their asses."

■ ■

In October 2011, Metro Pictures Gallery in Chelsea mounted an exhibition by the French artist Claire Fontaine. Titled *Working Together*, the show presented a sort of greatest hits collection of contemporary art forms—text paintings, found-object sculptures, prints, videos, neon—exploring the politics of collaboration. In one room, a series of monochrome paintings with silk-screened texts reproduced portions of an interview between the fashion designer Marc Jacobs and the artist Richard Prince, who had recently collaborated on a series of handbag designs for Louis

Figure 2.4

Vuitton, where Jacobs was the creative director. In the interview, Jacobs and Prince chat about their mutual appreciation, their love of collectable objects, and being friends with Jay-Z. In another room, a video projected onto an enormous wall shows the British poet Douglas Park reading an essay by the Italian philosopher Giorgio Agamben. The video is both tedious and riveting. The essay he reads, called "The Assistants," is about Walter Benjamin and Franz Kafka.

The exhibition's conspicuous parade of names, from Agamben to Jay-Z, leads the viewer in a roundabout way back to Fontaine herself—or, rather, itself, as the work in the show was actually made by a group of artists rather than a single individual. Claire Fontaine, named after a French stationery brand, is a "collective artist," according to the exhibition's press release. It is reported to consist of two individuals, one Scottish and one French, who give interviews and write essays but remain officially nameless. In one of these interviews, they described Claire Fontaine as

an organization "composed only of assistants" and whose "management is an empty center."[16]

The collective's idea that the artist is a figurehead, a blank page of sorts, cast a different light on the way we treat proper names in art and industry. Who is Marc Jacobs, and who makes his bags? Whose labor goes into them, and, if we buy one, whom are we remunerating?

These questions are relatively easy to answer when applied to a fashion designer. As a society, we're comfortable with the idea that Marc Jacobs doesn't sew every stitch on each product bearing his name (or Louis Vuitton's), and that even that a lot of Marc Jacobs clothes and accessories are probably not designed by the man himself but rather by various people in his employ; after all, the name "Marc Jacobs" belongs equally to a person, a corporation, hundreds of retail stores, and millions and millions of individual shirts, jackets, dresses, and bags.

When asked of artists, the answers to these questions aren't as clear-cut. Artists, even high-volume producers like Koons and Damien Hirst, have corporate structures so small as to appear essentially monadic when placed against those of fashion designers or record moguls. As a consequence, it's harder to square the appearance of individual authority with the reality of collaborative labor that underpins most contemporary artists' work—even when the artist is essentially shoving our noses in that fact. We're less comfortable with the thought that the words "Jeff Koons" may designate an artistic brand, first, and a guy from Pennsylvania who makes art, second. We're still in the habit of relegating the assistant to the back room, out of sight and mind.

But this may change. In a time when many prominent artists seem awfully managerial with respect to their own work, projects like Claire Fontaine suggest a shift in symbolic allegiances. Meanwhile, a welter of art-activist projects have sprung up in the past decade to examine actual conditions of labor within the billion-dollar pyramid of the art industry.

Working Artists and the Greater Economy, W.A.G.E. for short, advocates for the establishment of a formalized artist fee schedule at nonprofit

institutions. The group's goal is a reality check on the notion that artists included in prominent exhibitions are "paid" in the form of exposure; if your work is in a big museum show, their argument runs, the museum should at least foot the bill for installing it.

Others, like Arts + Labor and the Precarious Workers Brigade, address the other multiple forms of labor required to circulate art and ideas through the culture industry. What they find, not surprisingly, is that many people who fill jobs in the art world (art handler, gallery receptionist, preparator) are themselves artists, critics, art historians, and so on—and that many consider their work to be a temporary stopover on their road to professional autonomy.

A few months before the opening of the Claire Fontaine show, a young artist in New York named Chris Kasper published "An Open Letter to Labor Servicing the Culture Industry" in an online magazine called *Dis*.[17] Kasper narrated his travails in various art-related jobs, and the anxiety of working freelance for dismally low wages with zero job security—a familiar story in the era of distressing workplace neologisms like "flextime" and "perma-temp." He calls for a time-honored solution to these problems: unionization. His list of low-paying art-world occupations is nearly exhaustive, except that it leaves out the category of the artist's assistant.

What would a union of artists' assistants mean? Perhaps an end to uncompensated dog walking and compulsory ego stroking, as well as the abuses, trivial and severe, that ornery artists inflict on their hapless staff. But it could also mean an end to the unofficial career training, art education, and extravagant lunches that constitute the positive aspects of this entirely unregulated work situation.

It's a theoretical question for the moment. The art industry isn't liable to see a return of the guild system, and, unlike its close relative the film industry, it hasn't yet developed its own modern forms of organization. What's commonplace in Hollywood is anathema in Chelsea, and a revolution in art industry labor isn't likely to begin with the artists' assistant.

But again, imagine a painter of enormous Photorealist nudes. He's sitting in the back of his studio, flipping through a magazine, while his assistant is perched high up on a ladder with a paint tray and a brush. Between scans of *Artforum*, the artist directs the assistant to add, perhaps, just a little more of a highlight, please, to the eye of a figure in a work in progress. What if the assistant decided to throw down the brush and walk out? After all, she's actually doing the work.

3

MILWAUKEE AS MODEL

IN THE LATE 1920s, a Kansas-born critic named Thomas Craven mounted a campaign against the influx of modern art from Europe. He urged American artists to "throw off the European yoke, to rebel against the little groups of merchants and esoteric idealists who control the fashions and the markets in American art" and to forge their own, properly nativist vision.[1] He championed a group of painters from the heartland—Thomas Hart Benton, John Steuart Curry, Grant Wood—who depicted traditional scenes of rural American life: rolling prairie landscapes, farmers toiling alongside their livestock, and honest folk walking small-town streets. Their paintings were like tall pitchers of lemonade for an art-going public parched by the Great Depression.

Craven was a man of strong passions, and most of them were negative. He was not only anti-European but also anti-Semitic, anti–woman artist, anti-photography, and anti-abstraction as well—the kind of advocate an art movement is unlucky enough to have. For Craven, the Regionalists (as these artists became known) had "taken art from the hothouse to the open air, away from the tender nursing of Bohemians and playboys, and . . . placed it within reach of the people."[2] And because these Bohemians and playboys, merchants and esoteric idealists, all tended to live in one particular city, Regionalism constituted the first critique of New York as the center of the American art world.

It was just the beginning: subsequent decades would see the critique renewed, with different political aims and competing visions of how artists might otherwise distribute themselves geographically around the country. And over the course of eighty-five years, the landscape of American art has certainly changed. Between art education in the university system, the propagation of art culture through the digital media, and the well-documented capacity of contemporary art as a tool for urban renewal, art is embedded in the mainstream like no other time in history. The country now boasts myriad enclaves of art activity, pockets of vigorous production emerging around the multiplying nodes of the contemporary art network. Show me a college town with an old bank building and a bunch of empty warehouses, and I'll show you an exhibition center and a local scene waiting to happen.

But despite a history of proclamations to the contrary, the truly local turn in American art seems always *just about to* occur. By and large, ambitious artists still move to the market centers of the art world — and if they don't, they worry that they should.

It's no great mystery why: once there, they have distinct professional advantages over their peers in smaller art centers. In an industry still largely committed to doing its business face-to-face (in physical spaces, and with, for the most part, physical objects), they have easier access to the centers' commercial gallery system, nonprofit institutions, and arts media. By and large, these structures still dictate value in contemporary art to the rest of the country; an artist from elsewhere may need to move to, and succeed in, New York or Los Angeles before she's taken seriously at home.

The benefits don't end with the strictly professional. Artists in the major arts hubs exist in larger creative communities with more durable support structures and enjoy greater opportunities for critical dialogue. They're less subject to the whims of the relatively small group of critics, curators, and dealers who determine what gets shown in a smaller art scene.

The only downside is that they pay for it. And as the market centers reach potentially terminal levels of costliness, it may finally be time for

everyone to consider this alternative arrangement: distributed, small-scale art communities whose cost of living doesn't drive artists into bankruptcy—but at the same time allows them to achieve visibility in, and interface productively with, the massive complex of ideas, institutions, and markets that constitute the contemporary art world. In theory, this has been possible since before New York took the mantle of world art capital away from Paris, but practice is always trickier than theory.

I WAS THINKING about this as I flew into Milwaukee. I'd scheduled a long weekend there in the fall of 2012 to investigate precisely such an example of ambitious, locally oriented art production, or something approximating it. My hopes were high.

Milwaukee has roughly the same degree of art infrastructure as a dozen other American cities. It has two college-level fine arts programs; a mid-size museum; an art-education nonprofit, the Walker's Point Center for the Arts; and a small contemporary art *kunsthalle*, the University of Wisconsin–Milwaukee's Institute of Visual Arts. A handful of commercial galleries cater to the occasional local collector, and smaller artist-run spaces offer exhibition opportunities for local artists, though not much in the way of sales.

While the city is number one in American beer-making, it has never cut much of a figure as an art town. But Milwaukee had been in the back of my mind since 2006, when a group of young artists decided, against all conventional wisdom, to hold an art fair there.

It was a banner year for the international art fair in 2006. Cities like London, Moscow, Dubai, and Palm Beach had recently joined the circuit, and fairs in Shanghai, Abu Dhabi, and Berlin were in the works. The old stalwarts were expanding, accruing smaller satellite fairs and then satellites of the satellites so that visitors to Art Basel Miami Beach in December could also explore NADA, Scope, Pulse, and Aqua by wandering from convention center to hotel to warehouse to tent city, taking in that season's art offerings while sampling free promotional cocktails in a state of sun-soaked distraction.

Top: "Airwalk" sequence from *The Secret Choreographer* "Blue Tape." January, 1999.
Bottom: "Spindle" move from the same tape.
(Hermetic Archive)

72

Figure 3.1

Seen from afar, the Milwaukee International Art Fair looked a lot like a put-on. Forgoing the luxury-tourism cache of most fairs, it was scheduled for an October weekend at the Falcon Bowl, a beer hall/bowling alley/home of the fraternal order of Polish Falcons of America, Nest 725, in the neighborhood of Riverwest. The name of the fair was slyly self-deprecating (*International?*) and funny even on a phonetic level,

containing that terminal "key" that one comedian or other called the most humorous sound to the anglophone ear, especially when found in a place-name; Milwaukee shares this with Albuquerque, where Bugs Bunny took his famous wrong turn.

As it happened, the funniest thing about the Milwaukee International Art Fair was that it really was an art fair — small but real — and an international one at that. Visitors could sample the wares of a concise selection of galleries from Switzerland, Canada, and Puerto Rico, not to mention Los Angeles, Miami, and Chicago. The eminently cool New York gallery Gavin Brown's Enterprise participated, as did the venerable nonprofit exhibition space White Columns. White Columns curator Matthew Higgs included a paean to the experience in his "Best of 2006" wrap-up article in the December *Artforum*. "The Milwaukee International proposed a viable, self-sustaining model of culture, one that was rooted not in social or economic one-upmanship but in the pleasures of self-determination, friendship, and cooperation," he wrote. A little art was sold, most participants broke even, and some people actually made money.

The Milwaukee International had been a triumph of shoestring event planning. The organizers charged galleries $150 for a booth (compared with $30,000 to $50,000 for a space at New York's Armory Show), used the entry fees to rent the Falcon Bowl, and housed visiting art dealers and artists in their or their friends' apartments. Good luck helped too: earlier that year, the Art Chicago fair had imploded after a last-minute labor dispute. When a 25,000-square-foot tent spectacularly failed to materialize in Grant Park by the scheduled opening, the Art Chicago people were left with a whole lot of suddenly useless freestanding walls. They donated them to the Milwaukee kids, five or six local artists, who unloaded them off a flatbed into the Bowl with the help of the two truck drivers.

Though the Milwaukee International group's fair-making ended in the wake of a downturn in the art market a few years later, their campaign had the effect of substantially raising the profile of the city and its small cadre of contemporary artists. People started showing up to see what the fuss was about. Artists came from out of town to make shows.

Journalists checked in to dig the scene. Six years later, the question was, if Milwaukee truly is a model of a small, self-sustaining contemporary art center, does the model actually work?

I VISITED THE city a few days after Hurricane Sandy hit the East Coast. In Brooklyn, the neighborhoods of Dumbo, Sunset Park, Gowanus, and Red Hook were underwater; the Rockaways were underwater and on fire. The lights were out in Lower Manhattan, and water filled the basements of Chelsea galleries between Tenth Avenue and the West Side Highway, doing serious damage to a lot of artwork. This was devastating for the artists and for the dealers without insurance, but with peoples' houses burned to the ground, it was hard to get too upset over some *contemporary art*, everyone pointed out. On the way to Newark airport, I passed long lines of cars on the roadside waiting for gas.

The Milwaukee airport, though, was a tranquil vision of normality. At the car rental place, they gave me a bottle of water and directions into town, where I soon located Milwaukee's hippest (and practically its only) contemporary art gallery, the Green Gallery, and its proprietor, John Riepenhoff.

The Green Gallery is a wedge-shaped, single-story brick building that sits a few blocks from the lake on North Farwell Avenue. It has a small paved lot out front, with a carport and a big, blank, kelly green rectangle as a sign. The building might have been a gas station or a dry cleaner's shop in a previous life.

John met me inside the door, wearing an orange camouflage Green Bay Packers hat, a white shirt with a pink and turquoise geometric motif, and white jeans. He's in his early thirties and has long, very fine, straight blond hair and rectangular metal glasses with thick frames. Behind the desk, a young intern named Madeleine was listening to NPR. Obama was campaigning in Green Bay, and he'd just gotten the endorsement of Packers safety Charles Woodson; this was a coup for the incumbent in the Republican-controlled swing state. "We have this awful governor, Scott Walker," John explained.

Over the past few years, John had been making sculptures called "Art Stands": pairs of mannequin legs, dressed in jeans and sneakers (usually his own) that hold up paintings or sculptures by other artists. They're perfect portraits of the artist as social facilitator, small-time impresario, and, in many instances, tireless schlepper for his friends and colleagues. He's a walking reminder of the first thing you need to get a small art scene off the ground: a really enthusiastic booster.

John grew up in Wauwatosa, a Milwaukee suburb, where his father was a sports editor for a newspaper. He studied art at the University of Wisconsin–Madison and after graduating met brothers Tyson and Scott Reeder, both artists who'd recently moved to the city to participate in an Internet television venture. Later, they'd all work together on the Milwaukee International and a host of other Milwaukee-centric art activities, but at first John worked for the Reeders as a studio assistant.

The first location of the Green Gallery, an attic on East Clarke Street opposite the Falcon Bowl, had sky-blue walls, ceiling, and floor; John decided to leave it as is, liking the cognitive dissonance the combination of the color and the name of the gallery produced in its visitors. Because the gallery wasn't a moneymaking proposition—he supported himself by doing art direction and prop master work on local films—he was free to develop his program at his own pace. He was also under no obligation to work with people he didn't like. "I try to put people who are interesting and nice into the gallery and see what they do," he said.

He invited a group of decorative artists specializing in faux-finishing to paint murals on the gallery's walls. He hosted the sixth annual Umali Awards, an absurdist presentation by local artist and professor Renato Umali honoring winners in categories like "Most Frequented Restaurant" and "Most Famous Person Spoken To." He gave an exhibition to Thurman O'Herlihy, a gifted nine-year-old from rural Wisconsin. Sometimes he found interesting, nice people who would never in a million years think of themselves as contemporary artists and tried to convince them that they were and that they should do a show at his gallery. This sometimes backfired, he said—"but making public mistakes is good for everybody."

The gallery moved into a larger space in a building on East Center Street in 2005. The new location also featured Club Nutz, an open-mic comedy club devised by the Reeders that served as a convenient if limited-capacity venue for after-parties. The room, into which everybody crammed to drink beer and take turns telling bad jokes, was the size of a broom closet, with a fake-brick backdrop and a microphone.

In 2009 John brought in his cousin, Jake Palmert, as a business part-ner and opened a second space; we were standing in it. It looked more like a proper gallery than the old one did, and they treated it as such: a commercial enterprise, doing business both in town and on the art fair circuit, that would also facilitate an intellectual exchange between local and international art.

The nice thing about a small scene is how manageable it is: there's usually just one of everything. But that's the terrible thing too. The Milwaukee art scene had suffered a major loss that July, when the artists' building on East Center Street burned down. The fire began in the auto shop on the ground floor and took out sixteen artists' live/work spaces and five galleries, among them the Green. The arts community rallied, arranging donation programs with local businesses, temporary apartments and dorm rooms, and fundraisers for the victims of the fire. John, who had almost been at the point of being able to live off the gallery, started saying yes to film jobs again.

■ ▪

GRANT WOOD'S AMERICAN GOTHIC (1930) is the most iconic product of the Regionalist movement, and it certainly cracks the top five of famous twentieth-century American paintings: the cue ball–bald farmer with the pitchfork, his dour wife, sister, or daughter—you've seen it. Looking at it, you may suspect that Wood held a more dialectical vision of the rela-tionship between Bohemia and Main Street than Thomas Craven did; American Gothic, with its perfect deadpan tone, seems not so much like corn as pure, homespun camp.

Also unlike Craven, who launched most of his fuming anti-coastal polemics from the comfort and convenience of Greenwich Village, Wood thought that artists should *actually* live in other parts of the country. He himself preferred the Midwest and taught at the state college in Iowa City. In his 1935 statement "Revolt Against the City," the painter rested his case for regionalism on the psycho-geography of American art.

The East Coast was in the thrall of "the colonial spirit . . . basically an imitative spirit," he wrote. Culturally, it was fated to proceed along tracks laid down by Europe and to fail to grasp what was "new, original, and alive in the truly American spirit."[3] Therefore, artists living elsewhere in the United States could save themselves a lot of hassle and stay right where they were:

> The artist no longer finds it necessary to migrate even to
> New York, or to seek out any great metropolis. No longer is it
> necessary for him to suffer the confusing cosmopolitanism,
> the noise, the too-intimate gregariousness of the large city.
> True, he may travel, he may observe, he may study in various
> environments . . . but this need be little more than incidental
> to an educative process that centers in his home region.[4]

Wood outlined a plan for the development of regional art centers through federally funded art schools, with annual regional exhibitions and collaborative public works to spread the joy of art to the people. He thought that a place should celebrate its local artists the way it did the high school football team.

The sentiment would surely pass muster with Sara Daleiden, a young Milwaukee artist and art-community advocate. We were in a bar. I ordered a Riverwest Stein, made by the nearby Lakefront Brewery, and Sara wondered aloud: "Could you get people to invest in local artists the way they invest in local beer? Look at what's on tap: all these nuances of Wisconsin that you're buying. I'm trying to translate that idea into art."

John Riepenhoff showed up, and the two immediately fell into an animated discussion about art promotion. They sounded a bit like lobbyists

for an under-recognized industry—the U.S. goat meat industry, perhaps, brainstorming how to get people to eat more goatburgers.

"I think there could be a shift toward wanting to consume regional ideas," John ventured. After all, artists and audiences in a place experience the same seasons and navigate the same landscape as they go about their business. This, too, echoed a Grant Woodism: that the physical geography of place would invariably impress its unique characteristics on those most sensitive of seismic registers: its artists. I wondered what this meant for the artists of Milwaukee, situated between three rivers and subject to the massive weather generator of Lake Michigan. Is lake-effect precipitation conceptually encoded in their art?

Earlier that the evening, Sara had hosted a workshop on fundraising for artists in conjunction with a show she'd organized at the Milwaukee Institute of Art and Design. She walked her small audience through the steps of finding and applying for grants, writing convincing project proposals, and forming nonprofit organizations. Halfway through the talk I realized that Daleiden isn't an artist who fundraises in order to make her art; fundraising pretty much *is* her art. She has turned her grant-writing practice into an artistic practice: a poetics of initiative building, cover letters, project narratives, fiscal accountability reportage, and budget summaries.

She called this "institutional mimicry" and considered it a handy tool for artists in a place like Milwaukee. You have to speak a language that people understand if you want them to take you seriously and give you money.

For example, Sara heads up the advisory board of a group dedicated to the preservation of a local public artwork called *Blue Dress Park*. The group also includes John, several community representatives, members of Milwaukee's Municipal Land Use Center, and the artist Paul Druecke, who created the park. The board, the Friends of Blue Dress Park, had a meeting that weekend in Chicago.

Blue Dress Park itself is a superfluous wedge of concrete on the dividing line between the neighborhoods of Riverwest and Brewers Hill, next

to a bridge overlooking the parking lot of the Lakefront Brewery: a thick-
ened sidewalk, really, about as big as a basketball court, a minor accident
of urban planning made even more conspicuous through the addition of
a knee-high iron railing along its perimeter. Druecke didn't alter it in any
way; he just decided it was a park, gave it a name, and sent out invitations
to a christening party. Grant Wood might have endorsed the gesture as
"a utilization of the materials of our own American scene," had he been
willing to consider an unadorned patch of city concrete a work of art.[5]

Blue Dress Park seemed like simplistic piece of art until I actually
thought about it. As it is in most American cities, contemporary art in
Milwaukee is intrinsically bound up with gentrification; judging by the
tendency of exhibition spaces to spring up in disused industrial zones
or low-income neighborhoods just before the cafes and clothing stores
do, you could say that the current civic function of art is to kick-start the
process. And gentrification is as much about names as actual changes

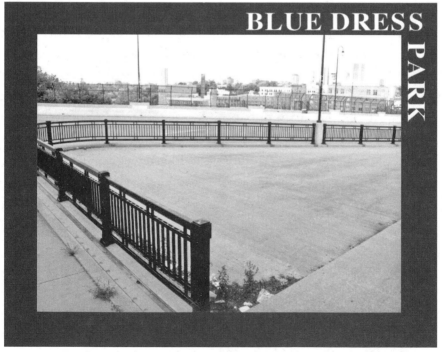

Figure 3.2

to the urban landscape. As Druecke was beginning his project in 2000, residents of Brewers Hill were battling a proposed condo development. They worried that it would clash with the historical character of the neighborhood: the old beer barons' mansions and Greek Revival and Italianate homes that the National Historic Register identifies as Brewers Hill's architectural contribution to the country. In a further affront to the community, the name of the proposed development was Brewers Hill Commons.

But then again, the name Brewers Hill only really emerged in the 1980s. Before that, the area was more commonly considered the southern end of Harambee—a neighborhood that had come to be called Harambee a decade earlier, when some of the area's African American residents adopted a Swahili word meaning "pulling together" as a rallying cry for grassroots urban renewal. The differentiation between Harambee and Brewers Hill occurred at about the same time that a new influx of residents—primarily white people who dug buying and renovating dilapidated historic houses—took an interest in the area and the demographics of the neighborhood shifted.

So Druecke's act of designation, however wan, was just the most recent in a very long chain. It stretched all the way back to the Algonquian and Siouan peoples who'd lived in the area before waves of French Canadian traders, missionaries, and soldiers showed up, garbled a few of their place-names, and eventually ended up with the name *Milwaukee*. And in the context of present-day gentrification, naming something *art* has serious implications. I suspected that the slightness of Druecke's intervention pointed to a certain scruple about this fact: a desire to tread the city with the lightest possible footprint.

On the tenth anniversary of the christening, the Friends of Blue Dress Park hosted a bratwurst cookout there. They covered the concrete wedge in red-and-white plastic gingham tablecloths, like a giant picnic blanket. Milwaukee's lone art journalist, Mary Louise Schumacher of the *Journal Sentinel*, blogged about the event: "The crowd may have been modest, but a steady stream of Milwaukeeans showed up, umbrellas hoisted overhead, to have a nibble, catch up with art- and architecture-world chums

and to support the inauguration of a new group that wants to create value in marginal spaces, in ill-advised bits of urban design."[6] The lesson here was that you can begin something as an art project and end up being a pillar of the community.

JOHN HAD OFFERED me a spare room in a two-story industrial building on the northeast corner of Riverwest that he uses to put up visiting artists. The building housed three artists who'd lost their spaces in the East Center Street fire. They had divided the garage space on the ground floor into studios and converted the office space upstairs into an apartment. Alec Regan and Brittany Ellenz, one half of the art collective American Fantasy Classics, directed me to a cornucopia of toiletries in the hall closet: bins full of individually wrapped bars of soap, cardboard boxes overflowing with toothbrushes and sample-size tubes of toothpaste, racks of shampoos, conditioners, and lotions, all donated after the fire.

■ ▨

BY THE 1960s, art in the United States was, charitably speaking, a two- or three-city game. Los Angeles and Chicago were in it, but only barely; New York had held the lead since the end of World War II. The Abstract Expressionists had put the city on the world stage, and it no longer followed developments in art unfolding abroad—many key European artists lived there, anyway, having fled to the States before or during the war. New York was the place where innovation happened, and it was only a matter of time before innovation got around to transforming the idea of place.

Following the progress of Abstract Expressionism (and its various painterly and sculptural offshoots) into something like American art's house style, younger artists needed a new direction. Rather than attempting to progress within the categories of painting or sculpture, they turned their thoughts toward the categories themselves: Why so few? What else could an artwork be? Conceptual art, as one answer among many to that question, proposed a model of art-making that would have serious

repercussions for the relationship between the artist and geographical space.

Ideas, as works of art, were inherently more portable than paintings or sculptures. And while paintings and sculptures *did* travel all the time (in fact, the CIA funded several touring exhibitions of Abstract Expressionist art in the 1950s, conceived as cold war demonstrations of American cultural values), ideas could zip through a host of distribution systems at a fraction of the time or cost.[7]

Conceptual art spokesman and dealer Seth Siegelaub pioneered new exhibition strategies for the work of artists he represented. He arranged shows that existed only as books, posters, or calendars; collections of statements, proposals, and drawings reproduced by Xerox copy; art actions that occurred at remote locations and were then publicized via mail. For an exhibition at Simon Fraser University in British Columbia, he organized a symposium as a conference call between the audience in Burnaby and the artists in New York.

If Abstract Expressionism had been all about presence—standing directly in front of a painting where the artist had once stood and experiencing it—Conceptual art cultivated an equally strong aesthetic of distance. Artists in New York sent instructions to have sculptures constructed in Düsseldorf or Zurich or simply sent their concepts out into the informational ether via phone or fax. This mobility fostered faster exchanges between artists in different areas and a greater parallel processing of artistic ideas. By the standards of the digital revolution, it was all about as fast and efficient as the Pony Express. But Conceptual art went a long way toward shortening the lag time between the established centers of the avant-garde and emerging ones.

The next logical question was, if the art could be conceived in one place and manifested somewhere else, why were artists still hanging around SoHo? In 1969, Siegelaub felt that the information revolution had created conditions such that artists could live anywhere in the world, participating in the most up-to-the-minute dialogues in their field. "I think it's now getting to the point where a man can live in Africa and make great art," he remarked.[8]

In that sentence, *man* and *Africa* tell us something about the chauvinism and provincialism of the art world in late-1960s New York: what was counterfactual and speculative for Siegelaub is now commonplace, and art's dialogues now include more participants in more places than were conceivable in 1969. The interesting thing, though, is how different his version of relocation is from Grant Wood's. Rather than imagining the artist as a thinker of and through place, shunning the metropolis and creating for a local audience, Siegelaub, and the worldview of Conceptual art, envisioned her as something like a telecommuting worker.

DAVID ROBBINS, MILWAUKEE'S resident media guru and former 1980s quasi–art star, is a staunch believer that the Siegelaubian moment has finally arrived—albeit forty-odd years after the fact. "When I moved to New York in 1979, a long-standing phase of culture and society was still in place where, if you wanted the New York information, you moved to New York," he said. "Today I wouldn't have to do that. Courtesy of the Internet, I have access to much of the same information a New Yorker has, and at exactly the same time. Do I have 100 percent of the New York information? No, I have 70 percent—but the remaining 30 percent is basically who sat next to who at dinner."

We sat in the front room of his house, the window of which would have looked out onto a placid residential street in Shorewood, the closest of the city's string of northerly suburbs—except that the blinds were drawn tightly shut to keep the glare off the enormous monitor of the desktop computer where he makes his art. A digital video camera on a tripod pointed up at the ceiling, and the closet was overfull with the empty boxes and foam packing forms of video and audio components.

When Robbins did move to New York, he fell in step with a generation of artists crossbreeding entertainment strategies with Conceptual art. He worked for Andy Warhol for a while. Robbins's most famous piece of art is a work from 1986 called *Talent*: eighteen framed black-and-white publicity shots of his downtown cohort, including fresh-faced ingénues like Cindy Sherman and Jeff Koons. He returned to Wisconsin when his parents fell ill, and stayed.

Robbins doesn't teach in the city, and he professes no interest in influencing the course of its visual art. Nevertheless, he hovers quite conspicuously behind the scenes. The art discourse of Milwaukee, and the work of its young artists, are both deeply Robbinsian. For example, I heard the words *platform*, *platforming*, and even the unusual *platformist* from at least six different people during my three days in Milwaukee. I wondered why this bit of art-speak was so popular and eventually traced it back to Robbins's 2009 book *High Entertainment*, which provides a kind of blueprint for the cross-promotional art practices I'd observed—John's "Art Stands" and the public art advocacy of the Friends of Blue Dress Park:

> A platform is a context, medium, or venue for the presentation of people, events, objects, or information . . . The one who innovates the platform and works actively with it as a medium for the presentation of others is a "platformist." The platformist is a kind of artist—an artist at presenting others.

Robbins is supportive of Milwaukee's younger artists but somewhat skeptical that contemporary art should be the ultimate goal of everything. Lately, he's taken to making quirky online advertisements for things he likes, such as the work of other artists or abstract values like beauty. He encourages his unofficial protégés to look outside the category of art for new things to do; this, paradoxically, is what artists are supposed to do anyway.

I got the impression that any sense of alienation Robbins felt living here was balanced by the satisfaction he took in being a unique feature in its cultural landscape. Walking outside his house to say goodbye, he gestured at the nice cars and manicured lawns of the houses next to his and told me, gleefully, that *not one* of the other people living on his block was an artist.

FOR OTHER LOCAL artists, life as a displaced avant-gardist is a less comfortable fit. The performance artist and videographer Kim Miller talked about the challenges of working in nontraditional media in a city where, for much of the population, art still means painting or sculpture.

"I grew up here and got out," she said. Miller attended Cooper Union in New York and then worked with an all-women performance art group, since disbanded. Like Robbins, Miller returned to Milwaukee when her father got sick, and she now teaches in both of the city's college-level art programs. She and her sister live in a stately, narrow two-story home on a wide, tree-lined street. "It's a nice reason to be here," she said.

Her daughter, Lillie, poked her head through the door and observed us. Miller suggested we watch some of her videos in the kitchen. "And then"—looking at Lillie—"we can watch *Pirates of the Caribbean*."

We watched *Quincy Jones Experience*, a piece from 2008. In the video, Miller is behind the wheel of a car holding a microphone; a slice of silvery-green suburbia scrolls past outside the window. She says that she's been "going through some things" and that she has discovered a new coping mechanism. She tells a rambling story about Quincy Jones and the nervous breakdown the musician suffered after the success of Michael Jackson's *Thriller* in 1982, his unsuccessful attempts to recuperate at Marlon Brando's estate in Tahiti, and his eventual discovery that the sleep-aid drug Halcyon was responsible for his paranoia and hallucinations. The coping mechanism that Miller's character has discovered is never identified, other than that it "has to do with the simultaneous acknowledgment of the front and back of the head."

In the next video, Miller is pulling a pair of tan pantyhose over her head, bank robber style, and then pulling them off again. With the hose on, she threatens the viewer: "Don't say a fucking word" and "Deal with it, cocksucker." When she takes them off, she smiles and issues platitudes: "It's all about choices. You're in control" and "You're doing great."

I told Miller about an art opening I'd been to the night before. "I think—don't be offended—that it's easy to come from outside and romanticize something," she said. "It's a very specific scene and has a very specific demographic. This is a very diverse city . . . Friends of mine that are not white don't want to go to things like that. Maybe that's not just specific to Milwaukee."

Figure 3.3

And then, "Sorry, I feel like I'm bumming out on this! Because it's such a small scene, it's also so hard to say this, because you're probably seen as disrespecting a few people and their really hard work. They work twenty-four hours a day on these things. Someone like John Riepenhoff is a really hard worker, and I totally respect that."

■ ■

FREDRICK LAYTON, AN English American meatpacker, built a public art gallery in 1888 to display his recently acquired collection of European and American paintings. He put an art school in the basement. This got the ball rolling for art appreciation in Milwaukee.

The Layton Gallery eventually grew into the Milwaukee Art Museum, which over the years has received major gifts from benefactors of many stripes: Richard and Erna Flagg, a tanner and his wife originally from Frankfurt, Germany (Renaissance, Medieval, and Haitian art); René von Schleinitz, the secretary of a large mining

equipment company (19th-century German and Austrian painting and decorative arts); Maurice and Esther Leah Ritz, an accountant and the first female president of the Milwaukee Jewish Federation (German Expressionist art); Anthony Petullo, a retired Milwaukee businessman (outsider and self-taught art from America and Europe); and Mrs. Harry L. Bradley, wife of a factory automation magnate and cofounder of his right-wing philanthropic foundation (European and American paintings, prints, watercolors, and sculpture, late nineteenth century to the early 1970s).

The museum struck me as somewhat detached from the city's local art production—but no more so than most regional museums, even those devoted exclusively to contemporary art. Its contemporary programming is primarily drawn from the same traveling pool of prominent figures whose work graces the walls of comparable institutions from San Diego to Boston. By and large, local art is the domain of educational initiatives and juried exhibitions.

The relative absence of an art infrastructure in Milwaukee means that artists can play a bigger role in determining how things are going to go; in this respect, the scene is wide open to change in a way that places like New York, or even Chicago, haven't been for generations. But a lack of relevant institutions also means a lack of institutional memory: details fall through the cracks, and it comes down to the artists themselves to perform the archival work usually managed by museums and the more dedicated private collectors. Art history is a DIY operation.

Nicholas Frank, another organizer of the Milwaukee International Art Fair, ran a gallery called the Hermetic from 1993 to 2001. During that time, he witnessed the coalescence and disintegration of a vibrant art scene around UWM's experimental film program and the artists it brought to town—a recent Golden Age that already seems like ancient history, complete with a register of now-defunct art and performance venues: Metropolitan, The General Store, Jody Monroe Gallery, Hotcakes, the Bamboo Theater, Pumpkin World, Rust Spot, Darling Hall. Frank, David Robbins, and a filmmaker named Jennifer Montgomery began

work on a documentary about it, called *The Milwaukee Moment*, just as the scene started to break apart.

Since then, Nicholas has embraced more skewed forms of documentation. Sitting in his kitchen in Riverwest, he showed me framed book pages from a project called *The Nicholas Frank Biography*. In reverent, inflated prose, the biography details key moments from his artistic career, some based on real events and others manufactured as fodder for the project. "Frank's subsequent campaign to export a case of New Milwaukee beer into outer space failed, of course, due to the ridiculousness of the proposition," reads one excerpt. Another tells the story of the Secret Choreographer, an anonymous guerrilla artist (Frank, dressed in a balaclava and leotard) who breaks into galleries after hours to dance around other artists' work.

The project is exuberant, inspired, and utterly grim in its predictions about the eventual fate of art made in peripheral places. "I did this because at one point I was sitting in my studio, totally abject about the fact that I live in Milwaukee and that I have great ambitions, but I will never be recognized as an artist in any substantial capacity," he said. "I thought, 'This is beyond my reach, so I'm going to make it myself. I'm going to preempt posterity.'"

Frank asked if I'd like to see the studio. We got up from the table, walked about eight feet to the back of the kitchen, and stood in front of a door. He reached into a cardboard box and held out what I thought were two plastic sandwich bags.

"I want to give you the opportunity to fully explore," he said. "So it's standard operating procedure to put these booties on."

My shoes protected, Frank opened the door on a room about the size of a generous hotel bathroom. The floor was covered wall-to-wall with wooden panels wrapped in paint-smeared and footprinted canvas, which fit snugly next to one another like tatami mats. On top of these were a bunch of fifteen-by-sixteen-inch canvases, open tubes of paint, thinner-soaked rags, and brushes. He explained that the floor was both a palette for the small paintings and a painting itself.

For Frank, an artist's studio is a narrative space. The ultimate artistic localism is the localism of the studio. The studio is a continuum in which the products of artistic work are completely present and alive—unlike the dim phantoms of themselves they become when you take them out of the studio and exhibit them, or read about them and see their pictures in an art magazine. "When you pull the objects out, you kind of fuck with the program," he said. "Like history does. History is an oversimplification of activity."

Appropriately, the most prominent benefactor of Milwaukee's artist-organized contemporary art scene was neither a beer baron nor an industrialist, but instead a reclusive sculptor who lived in the suburbs. Over her lifetime, Mary Nohl transformed her family's former summer cottage in Fox Point into what German avant-gardist Kurt Schwitters would have recognized as a *Merzbau* and Soviet-born Conceptualist Ilya Kabakov would call a "Total Installation": a complete artistic environment

Figure 3.4

incorporating her concrete and driftwood sculptures, paintings, ceramics, murals, jewelry, found objects, and prints into a living work of art.

The neighbors, however, hated it; Nohl was subject to a lot of local harassment during her life. Her sculptures were vandalized or set on fire, and her cottage was known in Fox Point as "the Witch's House." People were fond of shooting out its windows. Despite this treatment, Nohl, the eccentric daughter of a prominent Milwaukee family, left $9.6 million dollars to the Greater Milwaukee Foundation after her death in 2001.

This money endowed the Nohl Fellowship, awarded yearly to emerging and established artists from the area. The emerging artists get five thousand dollars and the established ones fifteen thousand. Polly Morris, a former dance company organizer, oversees the selection of grant recipients through the Bradley Family Foundation. "Inevitably over time you come to know a ton of artists, young and old, many of whom hate you when you do something like this," she told me.

In 2011, American Fantasy Classics, my hosts in the loft in Riverwest, received the fellowship as a collaborative entity. They funneled the entire purse into an ambitious installation for the show at the Institute of Visual Arts celebrating the grant winners. ("We spent the last dollar on the day of the opening," Alec said.)

Their piece, *The Streets of New Milwaukee*, was a life-size, walk-in diorama of a seedy-looking city block. Viewers strolled down a central aisle floored with concrete squares and terminating in a chain-link fence at one end of the gallery. Ramshackle storefronts and stalls, painted to look like graffitied brickwork or stone, lined the darkened room. Rickety signs promised dubious entertainments: Video Club, Waffle Plaza. I opened a door beneath a neon sign reading DUNK onto a tiny brick-walled room with a microphone stand in it. Windows revealed artfully dingy cubicles crammed with bits of street detritus, and an illuminated billboard displayed ads for cell phones.

The installation riffed on a beloved local attraction: the Streets of Old Milwaukee, a diorama at the Milwaukee Public Museum replicating a turn-of-the-century cityscape: cobbled streets and gas lamps,

an apothecary's shop, and a brew pub complete with a mustachioed mannequin bartender in sleeve garters. The look of AFC's version was modeled on the background from *Streets of Rage,* a scrolling martial arts videogame from the mid-1990s.

I didn't get the name American Fantasy Classics until I looked at a Milwaukee online Yellow Pages and saw listings for businesses like Absolute Custom Extrusions, Glam Star Industries, and American Muscle Car Gearheads. The group, which assembled a few years ago when its four members were undergrads at the Milwaukee Institute of Art and Design, operates like an autonomous team of studio assistants: they invite an artist to do a project and then put themselves to work in realizing it. They collaborated with Portland, Oregon, digital artist Brenna Murphy to convert the psychedelic abstract forms and organic textures of her website into a low-fi floor sculpture, ludicrously made out of painted wooden polygons, gourds, sand, rocks, ceramic vases, cast fried eggs, and jalapeño peppers.

During my visit, the group was in a transitory state. Alec and Brittany would continue to operate in Milwaukee, but the other half of AFC was headed south: Liza Pflughoft had already moved down to Texas for graduate school, and her boyfriend, Oliver Sweet, planned to join her. I asked them if they anticipated any problems collaborating over such a long distance, and they laughed. Most of the time they never even meet the artists they work with—the project usually happens over e-mail. So why would it matter that they'll be living in different cities?

■ ▓

IN 1996, FRENCH critic Nicolas Bourriaud looked at a collection of art practices that had emerged in the nineties but harkened back to the art of the sixties. These forms riffed on the participatory qualities of performance art, the prankish multimedia experimentalism of the Fluxus movement, and Conceptualism's emphasis on ideas over materials. New York–based Thai artist Rirkrit Tiravanija set up a makeshift kitchen in a

gallery and prepared meals for viewers. Visitors to a show by Dominique Gonzalez-Foerster could make an appointment to have their life story recorded by the artist. Maurizio Cattelan made an elaborate costume for his Paris dealer, resembling something between a pink rabbit and a giant furry penis, and challenged him to go about his business for the duration of the exhibition while wearing it.

Bourriaud homed in on the common element in these types of projects and their philosophical core: they all focused on the social space in which our encounters with art take place. He coined the term Relational Aesthetics to describe the way these artists emphasized dynamic interpersonal exchange over the solitary contemplation of art objects. "Artistic practice appears these days to be a rich loam for social experiments, like a space partly protected from the uniformity of behavioral patterns," he observed—perhaps the antidote to consumer culture's programmed numbness was through contemporary art.

Relational Aesthetics was part of a period in art and culture obsessed with motion and the pressures of globalization. In an extension of the Conceptualist model, the artist—not the work of art—moved from place to place, interfacing with curators and institutions and making things happen on an international circuit of biennials, triennials, and art festivals. (Briefly, Milwaukee itself constituted a minor stop on this busy circuit: a curator at the Institute of Visual Art named Peter Doroshenko invited many Bourriaud luminaries to stop in and make shows there.) The form bloomed in the pre-9/11 golden age of hassle-free commercial air travel and thoroughly tweaked the traditional models of centers and margins in art: the artist could *be* anywhere, provided she never stopped moving.

Later, Bourriaud evolved these ideas into a manifesto of sorts, which he titled "The Altermodern" and published on the occasion of the Triennial at Tate Britain in 2009. Travel, real and metaphorical, abounded in his text. "Our daily lives consist of journeys in a chaotic and teeming universe," he wrote, and compared the artist to the pilgrim, "the prototype of the contemporary traveller whose passage through signs

and formats refers to a contemporary experience of mobility, travel and transpassing."[9]

This somewhat glamorous aesthetic of perpetual motion is nearly inverse to that of the present-day Milwaukee scene, where travel is more likely to mean red-eyes and couch-surfing than international flight and hotels comped by museums; less about maintaining a presence on a global art circuit than about moving back home to take care of your parents. Nevertheless, the Relational Aesthetics flavor is present in the work and ideas of many of the city's artists. No one cited it to me as an explicit point of reference, though it was clear that other spectators have made the connection. "We didn't know anything about that as we were building our scene here . . . We were entertained by that framing of things," Riepenhoff told me, recalling all the times he'd gotten an earful about Bourriaud and his theories.

THAT NIGHT, AMERICAN Fantasy Classics was gearing up for a recently inaugurated Halloween tradition called the Ghost Show: a one-night exhibition, costume party, and concert held in several Riverwest art spaces. This would be the third Ghost Show—technically, it would be *00000 Ghost $how III*, as the exhibition was billed on its flyers and Facebook event page. The Reeders were up from Chicago and would be performing in a band.

John arrived at the loft, and we went to pick up his cousin and business partner, Jake Palmert, who had just arrived from New York, where he works as the director of a gallery on the Lower East Side. Since downtown New York was still dark, and largely wet, he'd decided to head back to Milwaukee for the weekend. We drove over to Imagination Giants, a ground-floor exhibition space on a residential block in Riverwest.

The main gallery was dimly lit, as befitting the occult theme of *00000 Ghost $how III*. A gorilla mask mounted on a tripod faced out the front window, and the rest of the room was sparsely hung with spooky artworks: a red cloth mask pinned to the wall next to an ominous photograph of a house, a TV monitor playing jittery footage of Glenn Beck. Down a

narrow flight of stairs, a basement with wooden palettes piled into a corner housed a few more monitors and photographs.

Most of the costumed crowd was gathered in the darkened rear gallery on the first floor, where the Ghosts were performing fuzzy psych-rock numbers behind a floor sculpture of a pentagram. True to their name, the band was garbed in white sheets with big cut-out eyeholes; one Ghost crouched behind a sampler and triggered haunted-house sound effects. A light machine threw oscillating patterns of stars onto the walls of the room. During their finale, some of the Ghosts rushed out of the room under cover of a fog machine and magically reappeared outside the window in the back of the room, waving.

I met Tim Stoelting, one of the proprietors of Imagination Giants. A thin guy in a tinfoil hat and a gas station attendant's shirt, Tim was telling John about a new drug called *krokodil*, an easily manufactured but deadly opioid currently decimating the addict population of Russia. "It eats your skin," he said.

"Is it called 'crocodile' in English or Russian?" asked John.

I thought about Kim Miller's gentle critique of the insularity of the Milwaukee scene. John and Jake of the Green Gallery, the Reeders and their circle, and the younger network of student-gallerists doing the Ghost Show formed a close-knit network. Despite the fact that they seemed like nice people—nice *guys*, for the most part—they had their own set of preferences, prohibitions, and assumptions. These reinforced modes of behavior and art production that you had to adopt if you wanted to be in the group. However inclusive they intended to be, if you didn't like their brand of jokes, or didn't think that art and jokes should even remotely go together, then the city could probably be a small place indeed.

John and I left and walked halfway down the block to the smallest of the Ghost Show's exhibition sites, and a perfect icon of the city's signature, deadpan riff on post-globalization contemporary art: 516-TJK, a "mobile project space" in the guise of a 1996 Honda Accord. Julio Cordova, its owner and proprietor, was dressed in a black hoodie and black-and-white skeleton makeup. He popped the trunk to reveal a sculpture by an artist named Carly Huibregtse: a crumpled digital print on vinyl of a magazine-

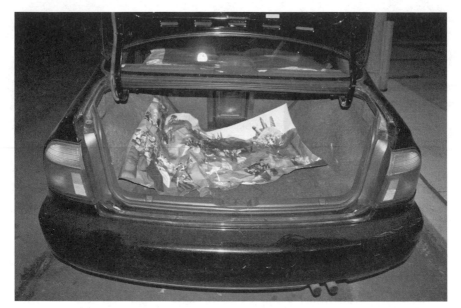

Figure 3.5

collage after Jan van Eyck's *Adoration of the Mystic Lamb*, from the famed Ghent Altarpiece.

■ ▦

IF CONTEMPORARY ART in America finally does decentralize and move toward something like localism, the reason may not be ideological, conceptual, or critical. It may simply be a result of fatigue. The populations of working artists in the big market centers are stretched historically thin; they can hardly be said to exist in the center at all. With the exception of a statistical handful blessed either with commercial success or independent wealth, they work freelance but full-time. They commute for hours and hours every week to teach in faraway cities, and sleep on the floors of their offices there. They pay high rents on studios that may as well be in other time zones than the galleries and museums they want to visit. They have just about enough time left over from making a living to make art, but not quite enough time to see anybody else's art. Don't pity them, necessarily, but understand their situation.

Meanwhile, art-making on the national scale is a picture of uncontainable growth: microworlds of contemporary art bubbling up everywhere, with near-infinite variations and repetitions, responding to conditions on the ground in places as different as Dallas and New Orleans, Portland and Phoenix. Even the market centers of Los Angeles and New York contain smaller art communities so distinct, autonomous, and developed as to constitute localities in their own right. Some of these are miniature reproductions of the high-end art world, replicating its priorities, hierarchies, and exclusions. Others are significant, imaginative deviations from the model.

The only problem is that the bulk of this activity fails to register in the organs of mainstream art media, or in the art market. A huge portion of it is ephemeral, waxing and waning according to changes in the general economy, cycles of the academic calendar, or phases in the evolution of a city, and leaving little in the way of documentation once it passes on.

For many people invested in the art industry—either professionally, as a career, or literally, in the sense of buying the stuff—the idea of treating art as a local product is a profoundly foreign concept. In order to acquire value, a piece of contemporary art is extracted from its initial context—the creative community whose collective work makes any individual's work possible in the first place—and circulated through the giant legitimatization system known in shorthand as the international art world.[10] Thus no matter where it's made, exhibited, sold, and bought, contemporary art is conceived as an import good. Proposing that we approach it like a case of microbrewed beer or a loaf of bread may have significant consequences on its pricing, for starters—but it may also offer a new perspective on the value of art.

Paradoxically, localism in art would first mean a reckoning with the true scale of contemporary art production in the country: that there's more of it by an order of magnitude than can be shown in galleries or art centers, interpreted in magazines or on websites, curated into regional, national, or international survey exhibitions, bought by collectors or acquired by museums, or recorded in art histories. Taking this condition

seriously, as an essential quality of contemporary art (rather than a distraction that history will eventually eliminate), would require new methods of analysis; new journalistic, critical, and historical strategies; and most of all, new modes of appreciation. What kind of art would be as indispensable to everyday life as beer or bread?

Art localism would also mean ditching the fantasies of stasis and flight that have animated discussions about space in American art since the 1930s. What's needed is a more accurate model of the contingent allegiances to place, and erratic forms of motion, particular to most artists these days: everyone has to be somewhere, even if there's no good reason for it, and even if their work happens elsewhere—and no one stays anywhere for long.

On the night I left Milwaukee, Alec, Brittany, and Oliver were sitting around the kitchen table of the loft planning an American Fantasy Classics event at the Institute of Visual Arts next Thursday. On specified evenings, *The Streets of New Milwaukee* housed Nightlife, a mini-festival with a variety of entertainments: seminars in a tiny classroom given by a local artist named Rudy Medina, concerts by a local retro-1950s rock band called Chubby Pecker, and, in homage to the Reeder's legendary Club Nutz, stand-up comedy in the closet-size nightclub called DUNK.

The centerpiece of Nightlife was supposed to be a ramen shop manned by none other than local arts impresario John Riepenhoff—but two weeks earlier, on the afternoon of the opening, the director told them they weren't legally allowed to serve food to anyone in the gallery. This time, they had decided to serve tea instead.

They still needed to fill one spot in the lineup, though. Alec had just learned that Medina, their seminar instructor, wouldn't be able to participate. "I talked to him two weeks ago and asked if he had anything planned for this next event," said Alec. "I said it would be cool if he did something more participatory—last time he just played these cell phone videos. And he was like, 'Yeah, that'd be good, for sure.' And then I found out three days ago that he moved to Mexico City."

4

SIX DANA SCHUTZES

Presentation, 2005

A crowd of curiosity-seekers packs the top of the picture to get a look at two cartoonish corpses, one very small and one absurdly large, that have been exhumed from an open grave. The two bodies are laid out on a wooden plank, and the larger one, which takes up almost the entire fourteen-foot width of the painting, is rendered in thick, confectionary brush strokes of red, green, and yellow. Some of the spectators are interfering with it. A bald man in a white shirt pokes a stick into the corpse's upper thigh. Below him, a yokel hoists a rope that extends diagonally up and out of the picture and then down again, where it supports one of the corpse's arms in a makeshift sling. A young woman with a scalpel makes an incision into its big, floppy hand.

Of the landscape there is little: a band of blue sky at the top of the canvas and a few feet of grass and dirt at the bottom. It's a nice day but the crowd is glum. The large corpse itself, looking chagrined, practically makes eye contact with the viewer. In fact, it seems quite lively; maybe it isn't dead at all. On closer inspection, it's on the verge of delivering a lame wisecrack: *Gosh, isn't this just my luck*, or, *You and me both, huh?*

That's my sense of it, at least. Descriptions of the painting's contents differ. No one says that Dana Schutz's *Presentation* is a painting of a blue

Figure 4.1

horse in a red field, but critics are split as to whether it depicts a burial, an exhumation, a medical procedure, or the making of a piece of sculpture. The scene of the painting has been called "a human dissection,"[1] "some sort of surgery or autopsy,"[2] and "a human figure being assembled or corrected on a table."[3] "Its central figure, the big maybe-dead guy, is "a mutant body, bones broken and limbs ripped asunder,"[4] "a naked giant,"[5] "the dismembered body of an 'Other.'"[6] The looky-loos at the top are "a curious but blank-faced crowd,"[7] "anxious whites,"[8] "ruddy-faced congregants,"[9] "spectators at a surgery."[10] The one thing most commentators agree on is that *Presentation* recalls an 1889 painting by the Belgian artist James Ensor, *Christ's Entry into Brussels*, a crowd scene with a similarly florid palette and pronounced elements of the grotesque—though Rembrandt's *The Anatomy Lesson of Doctor Nicolaes Tulp* (1632) is a close second in the art-historical reference category.

Any written description of a picture has a minute degree of imprecision, which is inevitable because words are different from images.

But the variation here exceeds that, and you can't chalk it up to the so-called subjective nature of art interpretation either. On the formal level, *Presentation* is clear as a bell; each hand and face and the giant mutant corpse are limned in clean, bright colors like a Renaissance fresco.

And that's another thing. Abstracting for a moment the bodies, the grave, the dejected crowd, and dealing with the work merely as an assortment of shapes and colors arrayed on a flat surface, *Presentation* looks downright festive, a real wingding of a painting. This is entirely at odds with the somber linguistic palette of the work's textual interpretation — the ripping asunder and dismemberment, the blank-facedness. Something else is going on here.

Presentation was included in the "Greater New York" survey exhibition at MoMA PS1 in Long Island City, New York, in the fall of the year it was painted, 2005. The entertainment executive Michael Ovitz bought it as a promised gift to the Museum of Modern Art. Perhaps this means we should defer to the museum's official gallery text for the painting, which puts its institutional weight behind the idea that *Presentation*'s narrative is ultimately undecidable:

> A mutilated and partially dismembered figure lies on a board suspended above an opening in the ground. Whether the figure is about to be lowered into this grave or has been recently exhumed, we do not know.

What *do* we know? When she painted *Presentation*, Schutz was twenty-eight. She had been out of graduate school for three years. She'd had four solo exhibitions and participated in twenty-odd group shows in galleries, five in museums, and two biennales, Venice and Prague. Her exhibitions had been reviewed extensively and favorably in most major arts publications. ("I believe she may have an extra wrinkle on her frontal lobe," then–*Village Voice* critic Jerry Saltz wrote on the occasion of her first solo show.)[11] The artist herself had appeared in W and *Italian Vogue*, a young woman in an iconic Brooklynite uniform of plain black T-shirt, jeans, and New Balance sneakers, with a head of

wildly corkscrewing brown curls. Art schools were already full of Schutz imitators.

Now, at thirty-six, Schutz has been the subject of two traveling museum retrospectives and three monographs. Her work sits in eighteen public collections including at the Whitney, MoMA, the San Francisco Museum of Modern Art, the Guggenheim, and the Corcoran. The market for her paintings has grown steadily since her first New York exhibition, held while the artist was still an MFA student at Columbia. In a 2011 show in New York, retail prices for her paintings ranged from $45,000 for a small canvas to $200,000 for a large one. Drawings in the thirty-by-forty-inch range cost about $20,000, and those in the six-by-eight-foot range will run you $60,000.

In the secondary market, these numbers spike. Recently, an eighteen-by-nineteen-inch Schutz from 2002 (*Sneeze*, a woman expelling a stream of mucousy paint out of an upturned, slightly piggy nose) fetched $245,000 on an estimate of $30,000 to $40,000. Schutz's aren't the most expensive paintings on the market, by any stretch of the imagination (though they may be the most expensive paintings on the market made by a woman under forty), but her stats certainly put her in a very small circle of career achievement, one well above the staggeringly huge percentage of artists whose work will never appreciate one red cent beyond its initial purchase price, if it sells at all. To essay a brief, personal comparison here: you could probably buy most of the art I've exhibited over the past ten years with the 20 percent auction-house commission paid on *Death Comes to Us All*, a ten-foot-tall Schutz from 2003 showing a figure in red shorts being attacked by, or transforming into, something between an exploding totem pole and a duck, which sold in 2012 for $482,500 on an estimate of $300,000 to $400,000.

"She's the poster child for everything," said her ex-dealer Zach Feuer: for the dramatic return of expressive, large-scale, representational painting to contemporary art in the early 2000s; for the art market bubble in which collectors consumed it by the square mile; even for the system of graduate education that produced her and her peers. Notable, also, is the

fact that Schutz managed to weather the experience of early, runaway success and come out the other side with sanity and career intact—a hard trick for a poster child for everything.

For all that, it's not clear if we really know much about her work. "Dana Schutz does not prescribe any answers to the numerous questions her paintings raise," a press release from her Berlin gallery sternly reminds us.[12] But what do the paintings themselves have to say?

I'D FIRST MET Schutz in 2000, when we passed each other going through the MFA program at Columbia. Dana visited the studios as a prospective student in the spring before her first semester. I remember that she seemed uncomfortable in a conservative ensemble clearly chosen for her interview, but that she managed to chat normally: instant points in the personality column.

A typical MFA program cycles through a completely different student body every two years, and, as fewer and fewer professors are getting tenured in the United States, may contain a nearly completely different faculty in little more time than that. MFA programs are swiftly flowing rivers into which it's impossible to step twice.

When I left, painting had been a divisive topic within the school: some hard-liners in the faculty championed it, but an equally vocal contingent wrote it off as a waste of everybody's time. As students, we got the sense that it probably wasn't the quickest way to be taken seriously in the contemporary art world and made our choices accordingly.

But in the brief interval between our times at the school, something happened. Painting bloomed in Schutz's class and the one after it, and the program produced several bumper crops of painters who left the program and headed straight to the galleries, into a market ready and willing to embrace them. This rapid, auspicious sea change was a curiosity across the world of art school and the recently graduated. What had happened there? Was it merely a function of geography and pinpoint timing (by virtue of its location, Columbia offered us unparalleled access to the New York art world), or could the phenomenon be repeated elsewhere? I

followed Schutz's career closely, and many years later, I tracked her and some of her classmates down to hear the whole story.

Schutz paints in a floor-through converted garage in a half-residential, half-commercial block in Gowanus, Brooklyn, surrounded by auto-body shops and two-story houses with plastic siding. Entering the studio, you pass through a small, dark front room, with nothing much in it, into a long, high-ceilinged space—about the size and shape of a basketball court—lit with halogen cans on a track. Two long wooden tables toward the back are piled up with brushes and tubes of oil paint, spilling over onto the floor along with rubber squeegees, short-handled brooms, and paint-covered sheets of disposable palette paper lying in sticky drifts. A wheeled cart with a mirror mounted upright on a wooden frame kicks around the middle of the room, usually stacked with artists' monographs borrowed from the personal library housed in a long bookshelf/bench nearby, also on wheels. High on the wall opposite the front entrance is an exhaust fan and the window of a lofted office space. Through the back of the studio are a storage area and a bathroom. Everything is smeared with paint, in Dana's supercharged palette of warm golds and leafy greens, clear bright primaries and weaponized hot pinks. The copy of the Arthur Danto book in the bathroom is smeared with paint.

The first time I visited, a couple of years ago in early summer, there was hardly any art in the studio: no paintings and just a few half-finished drawings tacked to the walls. Schutz had just shipped off practically everything she'd been working on to the Museum of Contemporary Art in Denver, where an exhibition of works on paper would accompany a show of her paintings at the Denver Art Museum.

She was late in delivering the work and felt sheepish about it. Halfway through the project, she'd decided to redo most of the large-scale charcoal drawings for the show in ink. "I think I drove everyone crazy," she said. "With ink, if you mess up, you have to start all over again. You're going along, and then you make a move, and the whole thing is destroyed."

"I really held them up," she added. "I'll get to Denver, and they'll be, like, 'There's that *asshole.*'"

For a high-profile New York painter, Schutz is gracious almost to a fault, the kind of artist who might get buttonholed at an opening by an overzealous fan and feel obliged to keep the conversation going. She's candid about her anxieties as an artist but verbally guarded against anything that sounds remotely art-star-ish. This doesn't seem like a PR strategy; it's more like a tic. Jason Murison, a mutual friend and a director at her New York gallery, Friedrich Petzel, worried that she would run down her own work in print and negatively affect her market. "Did she say she hated any *specific* paintings?" he asked me nervously after the studio visit.

Dana grew up in the Detroit suburb of Livonia. Her parents, a guidance counselor and a junior-high art teacher, are now retired. She decided to be an artist at fourteen, and her school let her paint in a storage closet. Her employment history (apart from her job as a professional artist and the occasional visiting artist lecture or teaching stint) is still limited to having waitressed at Boston Chicken, Kerby's Koney Island, and other fast-food restaurants in Michigan when she was in high school, and at a Middle Eastern restaurant when she was in college at the Cleveland Institute of Art. She was halfway through narrating undergraduate art school when she suddenly clasped a hand to her mouth. "I just remembered I didn't mean to say the thing about the storage closet. It sounds so annoying." I said I'd forget it.

As far as I could tell, Schutz's lifestyle is far-removed from any of the clichéd excesses of young, successful artists. No cocaine-fueled hotel weekends or celebrity trysts. She kicked smoking but has served no time in rehab. She's happily married to the sculptor Ryan Johnson, whom she met at Columbia. ("When he came in for an interview, I got the wrong impression of him," she said. "He does this thing where he'll sigh. Now I know it's just him trying to breathe when he's nervous and afraid of passing out, but it sounds exasperated. So I asked him a question and he went, 'Pffffffffffff . . .' and I thought, 'Oh my god — he's really depressed!'") They live in a modest house near the studio, where Dana clocks in nearly all her waking hours.

She works early in the morning until late in the evening. As she gets further into a given body of work, a phase shift occurs and she begins around noon but works all the way through the night. "People don't call at night. And if you've worked all night, then you feel like you've done something, so it's fine. You wake up at noon, and then you've missed that weird part of the day where people call you and you have to do stuff. It's really hermit-ey."

Her assistant, Anthony Iacono, primarily deals with e-mail and logistics (shipping, crating, gallery and museum interfacing, deadline management) but also cuts paper and cleans brushes. She prefers to mix her own paint, but if she's working on a large painting, or on an especially tight deadline, she'll have other assistants come in to help out with this and other chores.

Prior to the drawing show, she'd done an exhibition of paintings in the spring, and prior to that, a cycle of Wagner-inspired prints for the Metropolitan Opera that opened in January. This meant she had only four months to prepare the painting show—about half as much time as she likes to have. On top of that, it was to be her first exhibition at Petzel—Schutz had parted ways with Feuer, her longtime dealer, in 2011—and there were nerves on both sides.

"I had this idea for this large painting, and sometimes that can be like the Bermuda Triangle," Dana said. "You don't know how that's going to be. I wanted to make a large painting that felt like a coloring book or something . . . And I wanted it to almost feel like synchronized swimming. Or just things happening in a youth center."

The painting, *Building the Boat While Sailing*, is an ebullient thirteen-footer crammed with colorful, geometricized people lounging on a makeshift wooden raft that seems to flip up in space, flattening everyone in a jumble against the picture plane; blue-green waves churn in the corners of the canvas. True to its title, two people are improvising a mast and a sail, a girl fastens some nails into the deck, someone else is hoisting a length of wood, and there's a saw sticking halfway through a plank. Most people on the boat are idling; a few fountain water out of their mouths

in vertical streams. The painting manages to seem becalmed, practically effortless. In fact, it's almost *about* that: overcoming the anxiety of the creative process through determined joyfulness. It's a work free from the undercurrent of dread that has marked most of her large canvases, a sunny *Raft of the Medusa* with no dead bodies.

SCHUTZ MOVED TO her current studio in 2011. Before that, she and her husband worked side by side in a building in Gowanus near the Smith–9th Street subway station, along with six other Columbia MFA graduates. An unusually close-knit group, they'd moved to Brooklyn together in 2005 from a space in Harlem, chipping in to rent an unfinished floor of a warehouse and dividing it up into handsomely proportioned studios. The building is accessible through the parking lot of a Lowe's hardware store, beyond a self-storage facility and a fenced-in area inexplicably crammed with rusting bathtubs, sinks, and department store mannequins. It sits directly under the elevated train tracks, and over the fence of the parking lot you can watch the tops of excavators sifting through mountains of glittering scrap metal in a yard on the bank of the Gowanus Canal—a notoriously polluted Superfund site and one of the last truly unpleasant stretches of the otherwise refurbished Brooklyn waterfront.

Tom McGrath, one of Dana's former classmates and studio neighbors, was also picked up by Feuer; the two were also gallery-mates until 2009. For his thesis exhibition at Columbia, Tom made romantic, panoramic streetscape paintings, blurred and fractured as if seen through a rain-streaked windshield from the passenger side of a car. In his new work Tom has been spraying layers of aerosolized oil paint onto huge canvases, using leaves, tree branches, and lengths of chain-link fence as stencils to make life-size urban nocturnes—broody images reminiscent of the walk to and from the studio.

McGrath speaks very fast, pinballing from one topic to the next. He's handsome in an actorly way, and maybe because of the industrial wasteland feel of his paintings, I thought of Crispin Glover's paranoid punk in *River's Edge*, all non sequiturs and angular momentum. He told me that

the last person who came to interview him threw down his notebook in frustration. "He never wrote—he made—he just—and then we started talking about the work and it got so far so fast he never caught up."

The Columbia program had good chemistry in the fall of 2000, Tom said: promising students and a faculty ideologically divided enough to insure that the students never got the same feedback twice. Visiting artists accepted invitations to lecture in a heartbeat; the commute time from downtown Manhattan was unbeatable. McGrath came in with his friend Kris Benedict from Cooper Union; he and Kris were the youngest people in the class. Tom described a slideshow during the second week of school, in which each member of the two-year program gave a short presentation of his or her work. "I was *really* intimidated by this," he said. "There were a *significant* number of artists doing really interesting things."

The group convened in a temporary building on the Columbia quad that served for a few years as an auxiliary studio space. Jon Kessler, the program's newly appointed chair, put the group at ease by executing an elaborate fake-vomit gag during his opening remarks. A sculptor named Samuel Yates talked about a project in which he'd run a 1974 MG Midget sports car through an auto shredder, then steamrolled the remains, then put the pieces into plastic bags and sorted them by weight ("Get it? MG, milligrams?"), and then placed the bags in folders in a seven-story-tall stack of filing cabinets. Kevin Zucker, with whom I'd later critique art in the Painting program at RISD, showed a series of cool, architectural interiors made with a 3-D modeling program.

"And then Dana showed her slides, and I've never seen people laugh that hard at an artwork," said Tom. In one painting she'd made during undergraduate art school, a pear-shaped woman posed in front of a gray photo-studio backdrop. This woman had a thin, very straight nose, a suggestion of buckteeth, and mouse-brown bangs teased into a gravity-defying whorl above her head. And if that wasn't enough, said Tom, she was wearing an oversize white sweatshirt tucked into a pair of unflattering blue jeans. And if *that* wasn't enough, in the center of the sweatshirt, where you might expect to see a picture of a painting by Monet or Van

Gogh, Schutz had painted a stroke-for-stroke reproduction of Gustave Courbet's *Origin of the World*: a woman's belly, vagina, and upper thighs, modern art's canonical beaver shot. Below it, the word "Daughter" was written out in pink wedding script.

The painting (which someone bought from Dana in art school and later resold through Zach Feuer) teeters on the edge of actual cruelty. "But it was brilliant and it was felt and it was warm, and she had this Midwestern way of making fun of herself and being really sweet," Tom said. "I mean, how can you argue with painting like that?"

If MFA programs are rivers, then the discipline of painting is an ocean. It's continually beset by waves of all lengths and amplitudes: from long, slow historical swells that run their course over centuries to quick fashion ripples lasting a season. It can be hard to see, while bobbing along on its surface, that the changes form a coherent rhythm—to see the structures beneath the water that created the waves in the first place.

When I asked what that ocean had looked like in the fall of 2000, Tom fired off a high-speed barrage of disconnected impressions. There had been funky, ultramodern abstraction and faux-academic figuration. There were the post-pictures artists, and Martin Kippenberger and his former assistants. The prevalence of the sideways drip, and lonely tree paintings. Masking-tape abstractions. David Salle. Cecily Brown's stylish, Ab-Ex-ish orgy paintings ("She's kind of brilliant, you know? I completely misunderstood her!")

Subculture: The Meaning of Style, the Dick Hebdige book that everyone carried around in art school, Tom continued. Mary Heilmann. Rosalind Krauss's lecture course at Columbia ("It seemed to be pointing toward the idea that it was no longer possible to paint"), the New Sincerity ("well there was no sincerity in it, was the thing"), the Museum of Natural History, where he and Benedict went to take drugs and look at the dioramas.

Painting had been sleepy for most of the nineties, taking a backseat to video, installation, sculpture, performance. But perhaps that's

understating it. In critical circles, painting had been high up on the no-no list: theoretically passé, politically suspect, yesterday's news.

So, inevitably, according to the inexorable logic of the fashion cycle, the tail end of the nineties saw a group of practitioners rise to prominence. Acknowledging painting's belatedness, they sifted through the ruins of different painterly traditions: John Currin and Lisa Yuskavage sent up Old Master painting, Luc Tuymans worked from photographs non-photorealistically, Elizabeth Peyton looked at celebrity culture through a filter of teen angst and Sunday painting.

Abstract paintings were few and far between, at least in the under-forty crowd, and most were self-consciously impure: Ellen Gallagher's doodled-over monochromes, Fabian Marcaccio's explosions of photo collage and acrylic modeling paste, Laura Owens's enormous color fields dotted with bees and flowers.

The common thread of the painting of the nineties was quotation. Painters didn't create new forms; they ventriloquized old ones to produce new effects. Painting still operated, in other words, within the domain of pastiche, the combinatory stylistic imitation that anchored the most persuasive theories of the postmodern in the visual arts a decade before. This approach seemed like the best bet painting had for maintaining relevance to the culture at large.

The notion of a painterly style, as something invented, unique, personal, meaningful, had long been written off as an artifact of the modern or derided as an ideological illusion. But if you wore style as an affectation, acknowledged it as the threadbare period costume it was—and painting as the antiquated, somewhat perverse enterprise it was—you could eke some life out of the medium yet.

The field of possibility was thus both wide open and oddly limited. The painting discourse of the 1990s formatted innovation as the shuffling of signs, and required that painters demonstrate a high, nearly incapacitating degree of self-consciousness about their craft. So, the problem facing young painters in the year 2000 was how to loosen up a little and to approach the medium without performing a lot of theoretical calisthenics

beforehand. Or, as Tom put it, the trick was "to make culture without being so programmatic that you're strictly within quotation marks."

In his studio down the hall from Tom's, Ryan Johnson remembered a similar sense of art-historical weight, and a feeling of incipient lightening. "When I met Dana, we talked about the fact that it seemed more radical for someone to just totally invent their own thing," he said. "To go further with it, where you're not so explicitly tied to history. Obviously you can't make a painting that's devoid of reference to its history, but you can treat it in a more intuitive, open way."

Sweetly, husbandly, he added, "Coming out of undergrad, I had the feeling that there was a thing that just had to happen. Weirdly, once I met Dana, I knew she was going to be the person to walk through that door."

Then, on a Tuesday in the first month of his first year in the program (and Dana and Tom's second), a group of jihadis crashed two airplanes into the World Trade Towers, and one into the Pentagon, and one into a field in Pennsylvania, and art history was just the least of anybody's worries for a while. "You felt like you should just be doing exactly what you felt like doing," said Ryan with a *pffffffffffff*.

Frank on a Rock, 2002

He's reclining on a rock jutting out of the water; let's take the cue from the painting's title and call him Frank. The bottom edge of the canvas cuts him off at the knees, and the horizon line has been pushed all the way to the top. The rock is white, the water is blue, the sky is a flinty gray, and Frank is very, very orange.

Frank's is the orange of deep, thermonuclear sunburn, the orange of the lifelong tanner in extremis. It exceeds the level of orange you can produce with an opaque application of oil paint—even the most expensive, high-pigment-count, straight-out-of-the-tube orange. To achieve this color, Schutz laid down a thick coat of red within the contour of Frank's body and then scraped it off with the edge of a palette knife or a rubber squeegee, revealing a layer of transparent yellow underneath that vibrates

Figure 4.2

with the residual red deposited in the weave of the canvas. Quick pink and red daubs suggest the volume of Frank's arms, legs, chest, dick. He is bracing himself on two palms, resplendent in the sun, inviting the viewer to drink him in.

Sadly, Frank is no looker. He has prehensile lips, a sparse beard, and stringy blond hair pasted over the dome of his head. His small, wide-set eyes poke out turtlishly from beneath a prominent brow. *Not if he were the last man on Earth*, you might think, which is exactly who he is.

Frank is the title character in "Frank from Observation," Schutz's first solo exhibition in New York. In an artist statement, she explains:

> The paintings are premised on the imaginary situation that the man and I are the last people on earth. The man is the last subject and the last audience and, because the man isn't making any paintings, I am the last painter.

Frank is an accommodating subject. Other canvases capture him in a field, on a beach, in a leafy jungle. He is always nude; sometimes he is semi-erect. In *Frank at Night*, he holds up a tree branch under a starry sky, and the starlight is reflected in the foamy surf lapping on the beach and in Frank's wide, freaked-out eyes. He doesn't seem to be doing any work, though; and because he isn't making any paintings, as Schutz tells us, the entire project of culture is left up to her.

In 2002, the post-apocalyptic was already a pop-culture staple, but the next few years saw the genre take off in film, television, and literature — the known world destroyed by wave after wave of asteroids, plagues, environmental disasters, zombies, with haggard survivors combing through the wreckage. On that note, lower Manhattan was a ghost town. We'd invaded Afghanistan and we had our eye on Iraq. A depopulated tropical idyll with nothing to do but paint Frank may have sounded heavenly: not post-apocalyptic but prelapsarian.

Schutz already had two New York exhibitions under her belt by this time. During her second year of graduate school, Jerry Saltz, who taught a seminar at Columbia, recommended her to the curators of MoMA PS1. She showed a series of portraits there: awkward, imaginary people conceived as ideal blind dates for her friends and colleagues. Dana carted the paintings to the museum in a U-Haul and unpacked them in front of founder and director Alanna Heiss. Dana recalls that Heiss, historically no fan of painting in general, told her, "You must be the worst painter I've ever met." She remembers being very nervous at the opening and thinking that the paintings were too embarrassing to be out in public.

At the time, a newish gallery in Chelsea was operating out of a small fourth-floor space on 26th Street. LFL Gallery — named for its

two financial backers, Nick Lawrence and Russell LaMontagne, and its precocious twenty-four-year-old director, Zach Feuer—had been giving shows to young postgraduate artists on the East Coast circuit, with modest success. Schutz and Feuer met at a party in spring 2001. Later that year, when an artist canceled an exhibition at the last minute, Feuer arranged a two-person show in January 2002 with Schutz and the painter Holly Coulis. Schutz presented more imaginary people, sneezing or coughing. It got a good review in the *New York Times*. The paintings sold. That success and other windfalls led LFL to a bigger, nicer ground-floor space on 24th Street. Schutz presented "Frank from Observation" there nine months later.

Other canvases in the "Frank" show represented "hallucinatory arrangements of objects, mirages and visions of transitory events" such as the writhing ball of *Slugs*, the exuberantly colorful *Flowers*, and *Skull*, with a cranium laying on the ground under a pink sunset. Everything is rendered in wide, athletic brushstrokes, and the entire world of the paintings is in motion: waves crash, clouds skid across the sky, even pebbles on the beach appear to vibrate. But in a cryptic image called *The Gathering*, it looks like Frank has been dismembered and his choice parts strung up on a crude wooden lean-to.

This last image leads us to contemplate the long-term prospects of Schutz's post-apocalyptic scenario. Did the painter eat her model? If she did, would Earth soon be devoid of human life? Another work in the show, *Suicide*, a picture of a record player stuck in the sand before an onrushing tide, suggests one grim possibility.

SCHUTZ'S EARLIEST PAINTINGS at Columbia had been preoccupied with sculpture. She made thick—absurdly thick—paintings, with pounds of oil paint piled onto the canvas and molded into crude representations of objects: a purse, a bowling ball, a lump of blonde hair. She also made paintings about people making sculptures of a landscape. In our studio visit, I couldn't get this idea straight in my head.

"I was thinking about people who would go outside and then sculpt the landscape," she said.

"OK, so—"

"—so instead of painting it, like a picture, they would sculpt it."

"So this would be a painting?"

"*Of* a sculpture, *of* the landscape, *in* the landscape. But it didn't work out. They just looked like blobs."

She found that most of her classmates, even the painters, had taken at least a stab at making sculpture during undergraduate art school. So she asked them to describe their first, most awkward attempts, and she painted what she thought the results would look like. Her classmate Kris Benedict told her about an assemblage he'd made, about Kafka and the death of rock and roll; Dana painted *Chris's Rubber Soul*, a turntable in a field with an oversize beetle impaled on a stick, and stuck into the beetle, a fish.

I wondered whether Dana's sculpture obsession had been her attempt to skirt the quicksand of post-postmodernist painting theory and get back onto solid ground, so to speak. By metaphorically borrowing the massiveness of sculpture, the artist could anchor her paintings in the world of real, workaday things.

This was wrong. Schutz was asking another question, one that I think may have been too embarrassing to speak aloud within the context of a sophisticated MFA program like Columbia's at the tail end of a theory-driven decade in contemporary art. You could phrase it this way: What's the place of imagination within painting? Or: How can you invent something in art without descending into frivolous fantasy?

"I wanted to find some space where you weren't just making stuff up, but where you could actually paint something you wanted to paint," Dana told me. "I was looking for a way to paint something I was close to, that wasn't apologizing for being a painting or accounting for itself."

Sculpture was a way to tackle these painting problems indirectly. The crucial thing about the sculptures Dana tried to paint (the ones her classmates described to her) was that she'd never set eyes on them. She was painting real things in the world, but she wasn't competing with any other images of them, mental or photographic. So her own necessarily flawed, necessarily subjective images became, by virtue of being the only

ones available to her, perfectly serviceable representations. Plus, there was no *right* way to paint a turntable in a field with an oversize beetle and fish impaled on a stick; she had to invent that too.[13]

It was a short leap from painting real objects that she hadn't seen (like other people's sculptures), to painting *un*real, plausible but unpictured, things: imaginary boyfriends and girlfriends, imagined people caught in the act of sneezing or coughing. From there, she could expand outward and think about how imaginary *situations* could generate paintings—for example, the imaginary situation of being the last painter on Earth and having only one subject to paint and one viewer to paint for. In other words, "Frank from Observation" posed the question of subjectivity in painting within a thought experiment.

THE ROBINSON CRUSOE myth has long served as a vehicle for speculation. The classical economists of the eighteenth century loved it, and the model of a self-contained "Robinson Crusoe economy" eventually became a staple of introductory-level microeconomics. It posited one agent performing as both producer and consumer, optimizing his work and leisure with mathematical precision—the presence of Friday was optional, and served only to model trade.

In comparison, Schutz's Frank economy of painting requires a minimum of two actors. A last painter alone would run aground against boredom and futility, and a last viewer would of course have nothing to view; they require each other to complete the intersubjective circuit that makes the activities of observing and representing make sense. As a thought experiment, it would seem to explore philosopher Gilles Deleuze's concept of the Other as "the tribunal of all reality," who alone has the capacity "to debate, verify, or falsify that which I think I see."[14] So, far from merely loafing on the beach, Frank is actually hard at work maintaining the imaginary reality principle in Dana's imaginary world.

But the whole situation is on pretty shaky ground, philosophically speaking, and in fact it goes seriously awry. Exhibit A, *The Gathering*, where Frank is hacked to pieces and hung up to dry in what Deleuze

(who framed his theories here around a retelling of the Crusoe story) would surely call an extreme instance of "desubjectivation": the subject's failure to recognize his Other that marks the essential "perversion" of the desert island scenario.[15]

Why do thought experiments always seem to end so badly? Why do so many of them involve grotesque forms of violence? From Schrödinger's poor cat, placed in a box with a flask of poison and a radioactive isotope to illustrate something about uncertainty, to the proliferation of brains in vats that help us visualize the mind-body problem, the mental laboratory of Western thought is stacked high with corpses. Freed of real-world limitations, the collective imagination runs straight to mutilation and murder.

Schutz's painting-generation system had a similar grisly bent, and over the next few years she went on to pursue even more elaborate fictional scenarios—many of them similarly tinged with the gruesome—to see what, if anything, they could tell us about the real world. This was no accident. After all, as she later remarked, "The distinction between reality and fiction in America seems like it is becoming really blurry."[16]

Face-Eater, 2004

That girl is eating her own face! is a disturbing sentence regardless of context. Even if you specify that the face-eating in question is happening in art and not in real life, the imagination jumps frantically between a horrified *why* and an appalling series of *how*s: methodology, anatomical possibility, considerations of shock, blood loss, and unconsciousness—are surgical instruments involved? What part of the face does one eat first?

Schutz's *Face-Eater* makes such considerations almost irrelevant. A simplified, blocky figure in a green collared shirt, seen in a standard nineteenth-century head-and-shoulders portrait format, she (I'm guessing on the gender) seems to be having a great time of it. Eyes, ears, and nose are disappearing down a comically enlarged upturned mouth like vegetable scraps down a garbage disposal, tumbled by rocklike teeth and

a protruding red tongue. The only thing missing is the soundtrack: grunts of gustatory approval and wet smacks of the lips.

Face-Eater was first shown in "Panic," Schutz's fall 2004 exhibition at Zach Feuer (who had by now shed his two bracketing backers at LFL

Figure 4.3

and renamed the gallery). "Panic" also included two kindred works, *Eye-Eater* and *Devourer*; *Self-Eaters* 2 and 3 had appeared earlier that year in a show in Paris.

Each canvas depicts a gastro-anatomical exercise carried out with a contortionist's aplomb: in *Self-Eater 2*, a nocturne, a reclining figure stretches out in the shadows and enjoys a midnight snack of her own toes; in *Devourer*, the fingers of both hands are sucked down at once. There's a little blood here and there, but the self-eating seems to be mostly painless, in the way that Wile E. Coyote could be flattened by a boulder and then shake off the experience a few cartoon frames later.

But a cartoon isn't quite the right analogy here. The mere idea of a man eating his own chest (for example, in *Man Eating His Chest*, 2005) is grisly enough to elicit a sympathetic, corporeal twinge from the viewer, no matter how casually it's presented. Schutz had to field questions from critics and peers about her mental well-being—to assure people that she was fine, really. The artist Peter Halley interviewed her about the Self-Eaters series for *Index* magazine. "They're not self-portraits, are they?" he asked. "God, I hope not," said Dana.[17]

Besides (as she had to remind everyone), the Self-Eaters were eating only *themselves*—they weren't cannibals or anything. Autophagy, a perfectly normal process through which living cells recycle unnecessary components to combat starvation or disease, had to be distinguished here from anthropophagy, or eating *other* people. In Schutz's paintings, the process just happened to be occurring on the macroscopic level, not the microscopic.

But the complete story of the Self-Eaters appears only with the addition of related paintings from the same time period. In *New Legs*, a legless woman in a field sculpts herself a replacement pair from an oozing, green-brown substance that may well be the digested and excreted remains of her old ones. In *Twin Parts*, another woman fashions an arm from similarly fecal lumps on a rickety set of shelves. For Schutz, the Self-Eaters were icons of autonomy, engaged in the first steps of a self-sufficient, regenerative process. Self-eating was the prelude to

self-remaking. Describing the chain of associations that led to the paint-
ings, Schutz told an audience:

> I started thinking of the different ways people could eat them-
> selves. Then I thought: Well, that's not enough. Then what
> happens? What if they can remake themselves in any form
> they want to be? Would what they make be considered art?[18]

Let's say that the Self-Eaters are artists. What kind of artists are they?
Body artists is the first thing that comes to mind, and we could choose
from any number of affinities, none of them *exactly* right, around the
theme of ingesting and/or mutilating the self: Janine Antoni, who made
classical self-portrait busts out of chocolate and then licked them into
abstract lumps; Kafka's Hunger Artist, who fasted to death ("because I
couldn't find the food I liked"); or Rudolf Schwarzkogler, the Viennese
Actionist of the 1960s who was rumored to have auto-castrated in a per-
formance (but actually didn't).

But here we're fixating on the destructive moment in the consump-
tion-regeneration cycle. The Self-Eaters could instead be seen as heroic
avant-gardists—like the French playwright Antonin Artaud, who wrote:

> I hate and renounce as a coward every being who does not
> recognize that life is given him only to recreate and reconsti-
> tute his entire body and organism.[19]

Or the German painter Max Pechstein, who began his circa 1920
"Creative Credo" with the self–exhortation

> Work!
> Ecstasy! Smash your brains! Chew, stuff your self, gulp it
> down, mix it around![20]

So perhaps the Self-Eaters are Expressionists of some sort. This
interpretation is borne out by the look of the paintings themselves,
which contain all the hallmarks of the style: strident, clashing colors,

figural distortions, energetic if not violent brushwork, nature imagery. Anatomically, *Face-Eater* recalls some of Picasso's most expressive (and misogynistic) images—the late-1920s pictures of Olga Khokhlova in which the head of his soon-to-be-ex-wife is rendered as a gaping, vaginal mouth lined with razor teeth. It also bears a passing resemblance to Francis Bacon's eyeless, screaming popes of the 1940s and early '50s— though Schutz's variation is remarkably free of angst.

But if the Self-Eaters themselves are Expressionists, where does this leave Schutz's *paintings* of them? What do *they* express? Discussing them in 2010, the poet and critic Barry Schwabsky read the Self-Eaters as emblems for the situation of painting at the beginning of the twenty-first century: perpetually renewing itself by digesting and redigesting its own history, but self-referential to the point of extremism. He wrote, "These self-consuming, self-creating figures are, needless to say, allegories of painting."[21]

The critic Micah J. Malone saw them, instead, as allegories of capitalism—in which many philosophers have noticed a similar interplay between destruction and re-creation.[22] In this reading, Schutz's paintings are expressive in the way that a physical trait is the expression of a certain gene: they look the way they do because of the economic system that generated them.

But both interpretations seem to dodge the question of what Schutz's Self Eaters are saying to us. Because, in what work of art *can't* you find an allegory for the conditions of its own production?

FACE-EATER APPEARED AGAIN the following year in "The Triumph of Painting," a mammoth three-part survey exhibition at the Saatchi Gallery in London. In the first installment, the work of big-name artists like Martin Kippenberger, Marlene Dumas, Luc Tuymans, and Jörg Immendorff staked out a painterly territory explored by the mid-career artists in the second installment, and then the less-established ones in the third; the torch was thus passed from one generation to the next. Most of the paintings in the exhibition were big and representational rather than

small and abstract. A majority of them were owned by Charles Saatchi himself, the advertising executive and mega-collector for whose collection the gallery had been founded to display to the public.

The exhibition's title was a soft pitch down the middle of home plate, and the critics clobbered it: "It isn't exactly a triumph. Resignation is in the air."[23] "On balance, I think 'survival' rather than 'triumph' is the appropriate word."[24] "Titling an exhibition 'The Triumph of Painting' is like putting out a CD called 'The Greatest Hits of 2005' in June: safe, if a little myopic."[25]

The question of the medium's aesthetic supremacy aside, no one could deny that painting was a juggernaut in the market in 2005. That year saw huge art industry gains across the boards. Auction prices for Old Masters, Modern Masters, and established living artists topped previous high-water marks set at the end of the booming, mad 1980s.[26] The steadily increasing heat of the art market, the possibility of investment returns with no ceiling, and the lack of market regulation made contemporary art attractive to an influx of "speculator-collectors" arriving from Wall Street.[27]

The new face of art collecting was the young financial professional: the hedge fund manager who combined cultural philanthropy with portfolio diversification through arts patronage. High prices and stiff competition for works sent buyers in search of more affordable fare in previously untapped strata of the art world. They found it in the work of "emerging artists," an industry category that came to designate artists in the process of achieving visibility in the professional art world. Usually but not necessarily young, talked about but not overexposed, the emerging artist captured the seductive pairing of creative and economic growth-potential that enamored contemporary art to the financial sector in the early 2000s—in the phrase "emerging artist," for "artist" read "market." Art school, which had been tacitly regarded as no-fly zone for dealers and collectors, was open for business. Students made big sales out of their studios, and what they mainly sold were paintings.

If painting had been an iffy proposition in 2000, it was practically a sure-fire winner in 2005. Critical opposition to the practice was largely drowned out by the deafening roar of its commercial success. Chelsea was like a United Nations of painting styles: cartoony paintings and academic paintings, ironic paintings and sincere ones, gargantuan Photorealism and wacked-out Surrealism—a multiplicity of images produced, for the most part, by recent MFAs from a short list of top-ranked schools. The apparent visual free-for-all concealed a handful of commonalities: like the sampling of the medium collected in "The Triumph of Painting," the new painting was representational, handmade (perhaps even traditional in its use of brushes and canvas), unabashed in its painterliness, and often studiously unstudied; references to folk art, outsider art, and Bad Painting abounded in reviews, on blogs, and in the conversational ether of the New York painting scene.

Schutz and her young peers—McGrath, Marc Handelman, Kehinde Wiley, Barnaby Furnas, Mickalene Thomas, and Jules de Balincourt, to name just a few—began to look like elder statespeople compared with the even younger practitioners gracing the scene. And in fact, Schutz was bumped from the third, emerging-artists installment of "The Triumph of Painting" to the more illustrious second, where her work was exhibited alongside that of more well-established figures like Albert Oehlen and Cecily Brown. Along with *Face-Eater*, the show included few of her *Franks*, an early portrait called *Albino*, and new painting called *Twister Mat*: a lump of bones and sticks, a felled tree, and a detached penis playing a forlorn game of Twister in a desert. Saatchi had acquired these paintings on the secondary market and grouped them without any input from the artist.

"THE TRIUMPH OF PAINTING" closely echoed an earlier London painting jubilee: "A New Spirit in Painting," mounted in 1981 at the Royal Academy of Arts. That exhibition also adopted a generational structure, from Picasso to Bacon to Julian Schnabel, then age thirty (whose work Saatchi himself had collected voraciously in the early 1980s). It, too,

emphasized figuration over abstraction: a significant move at the tail end of thirty years of the hegemony of abstract art. Of the thirty-eight artists in that exhibition, none were women.

The newest thing in the show was Neo-Expressionism, an international supermovement cobbled together out of various related tendencies in then-recent art. "A New Spirit" brought together the representative Germans (Anselm Kiefer, Georg Baselitz, Markus Lüpertz, Rainer Fetting), some of their Italian counterparts (Sandro Chia, Mimmo Paladino), and a handful of Americans and Brits working in a similar vein: figurative painting that self-consciously harkened back to early modernist art—particularly, but not exclusively, the Expressionism that flourished in Germany from the beginning of the twentieth century through the end of the Weimar Republic.

Neo-Expressionism was steeped in allusions to art history, myth, and folklore and dedicated to the exploration of the creative self; it was a far cry from the text and geometry, Xeroxes and aluminum cubes of advanced art in the 1960s and '70s. It touched off a frenzy in the art market, where collectors showed a voracious appetite for this colorful, sensuous, and recognizably *art*like (yet still purportedly avant-garde) art. Works by the Neo-Expressionists got expensive, fast—more expensive, and faster, by an order of magnitude than the market had ever seen; the movement dominated the art world of the early 1980s. Art stars hobnobbed with stars from other sectors of the culture industry, and museums rushed to acquire significant Neo-expressionist works. The contemporary art market that exists today, its interplay of speculative buying, celebrity culture, and institutional validation, was built on Neo-Expressionism.

Its critical reception was vociferously mixed. In the *New York Times*, conservative critic Hilton Kramer applauded the Neo-Expressionist challenge to the "consensus of 'advanced' opinion" that preferred an art of reductive, dispassionate analysis to one of ardent subjectivity.[28] For art historian Donald Kuspit, the Neo-Expressionists reunited art with image making: a conceptual pairing that had been systematically severed in the modernist project. For Kuspit, steeped in psychoanalytic theory, this

represented nothing less than a therapeutic breakthrough, "ending art's bad faith with reality."[29]

In the opposite corner, critics and art historians committed to the historical legacy of modernist abstraction (a legacy that Neo-Expressionism casually upset, like a champagne flute in a crowded restaurant) saw in the style an evasion of the social and political responsibility of the artist. Hal Foster and Craig Owens argued that by aping the look of the Expressionists' impassioned response to early-twentieth-century societal turmoil, the Neo-Expressionists simply reduced it to a set of conventions.[30]

Foster and Owens were relatively soft on the movement, compared with the art historian Benjamin Buchloh. "The specter of derivativeness hovers over every contemporary attempt to resurrect figuration, representation, and traditional modes of production," he fumed. "That is the price of instant acclaim achieved by affirming the status quo under the guise of innovation."[31]

Like the art it contended with, this critical battle over Neo-Expressionism was also, in a sense, a historical repetition: both sides drew heavily on a debate about Expressionism itself, a postmortem on the movement waged in the late 1930s among German Marxist intellectuals. Ernst Bloch considered it a powerful lens for viewing the deformations of subjectivity under capitalism; Georg Lukács saw Expressionism as politically incoherent: its embrace of the irrational was ideological preparation for fascism. (In a textbook case of bad timing, the polemical attack against Expressionism reached a peak in 1937, just as the Nazis were rounding up many significant examples of the movement for their traveling "Degenerate Art" exhibition.)

As IS THE case with most movements in art, the term Neo-Expressionism struggled to encapsulate different, often opposing ideas and attitudes. But as the Foster-Owens-Buchloh interpretation gradually won out, being a Neo-Expressionist became a liability rather than an asset. Near the end of the 1980s, the pendulum of taste swung toward a cooler art, historically

indebted to Conceptualism. When the art market underwent one of its periodic crashes in 1990, so did the prices of many of the movement's brightest stars. Neo-Expressionism (if not the entire idea of self-expression in art, period) became the object of a strongly enforced critical prohibition. Naturally, this also made it an attractive option for young painters, and by the turn of the century, the statute of limitations against it was just about to expire.

The dominant painting style of the early 2000s had most, if not all the markers of the figurative painting that stormed the art world in the late seventies and early eighties: brash, unself-conscious figuration, exuberant and colorful canvases, polyglot art-historical references, a penchant for folklore and outsider art, deep subjectivist commitments. It came on the heels of a prolonged period of theory-driven, non-painting art, and it spurred a period of growth in the art market. It was unfolding during the sharpest political turn to the right in the United States since Reaganism. It was even accompanied by two decidedly imperial wars; you didn't have to be an art-historical genius to see that Schutz and her peers were playing with fire.

"That's our job as artists," Ryan Johnson said. "When people say something is dead, that's when it starts to have traction. For Dana, it was probably fresh in her mind as just the *worst* thing you could do."

Tom McGrath rejected the entire discussion as reductive and anachronistic. "Painting isn't 'the language of oppression,' know what I mean? The *language of oppression* is the language of oppression." Painting was the way it was in early-twenty-first-century America because *America* was the way it was. In a moment when the irrational was taking center stage, he said, the only thing artists *could* do was to follow suit—to prod the collective psyche of a country in the throes of warfare, political upheaval, and moral injury. If you wanted to play with the culture, it was the only game in town.

So the question—what do Dana Schutz's paintings of Self-Eaters express?—is hardly a neutral one. Schutz herself was characteristically

demure on the topic of expression, neo- or otherwise. "You read theory from 1982, and then you think it's not good to do certain things. But then, it doesn't quite line up with what you feel at the time," she said.

On the subject of Francis Bacon's screaming popes, art historian Arthur Danto noted that to say "I am screaming" is to fall into a performative contradiction. If you're screaming, you can't *say* you're screaming; and if you say that you're screaming, you're not *really* screaming. The means of the expression makes the content of the expression nonsensical.

Danto made this point to remind us, against popular ideas about self-expression in art, that the screams in Bacon's paintings were not the artist's own: in painting a scream, the artist couldn't himself be in the throes of any overpowering emotion. (In fact, Bacon himself professed utter calm and disinterest, and, for Danto, this was a real problem; the artist was damnably offhanded about other people's agony.)

You could make a similar case about Schutz and self-eating, which is like screaming in reverse. Schutz is necessarily removed from whatever complex experience the painting's subject is undergoing and representing to the viewer. The artist might find it funny, interesting, appalling—but those are *her* emotions, not the ones depicted in the painting or registered by the viewer. The Self-Eaters are science fictions about a physical and emotional state and how a painting might, still (after all the historical arguments for and against it have been made), express it.

Singed Picnic, 2008

What the title identifies as *singed* (the left sides of the people and objects in the painting) look instead like they have been torn off, as if the whole scene were made of paper. There are jagged black edges running down the lengths of heads, arms, torsos, bottles of wine and baguettes, and through the equators of a watermelon, an apple, an orange. The setting of the painting is intact, though: a walled-in park with leafy trees. You can see it in the spaces where the parts of the things that aren't there anymore should have been, for example behind the missing face and chest of a

seated man in a striped shirt, whose hand grabs a bisected apple from the center of the picnic blanket.

Other paintings from 2008 show similarly lessened figures. Two men playing chess at a park bench, the face of one and the back of the other's head both absent, along with the left halves of all the chess pieces between them; a man at a dinner table eating chicken (only the bones remain visible); husks of men in old-fashioned jackets and powdered wigs leaning in to sign a document with a quill pen in an opulent-looking room. Despite the fact that her themes up to this point had included dismemberment, self-mutilation, and exhumation, these paintings seem the saddest of any in Schutz's oeuvre. They recall stories about the neutron

Figure 4.4

bomb (Brezhnev: "the capitalist bomb") that would eradicate people but leave everything else standing.

Of all Schutz's paintings, these also seem the most like corny visual jokes. Here, the artist has applied the same operation — painting things as if they've been burned away — to generic, seemingly indiscriminate subjects from the annals of art history: jolly picnickers, game players, bits of kitsch Americana like the Founding Fathers in the powdered wigs. The paintings suggest themes of illusion and flatness, plays on the phantom solidity of objects in a picture. Rather than the oily tangles of guts that viewers saw spilling out of the punctured bodies of Schutz's earlier paintings, these people reveal only an undifferentiated black non-substance when they're opened up. The paintings look like they've been hit by an unreality bomb.

Speaking of the period of artistic self-doubt she went through between 2006 and 2007, Dana was as candid as usual.

"I didn't mean to focus on the negative. I overdo it a bit. It wasn't that big of a deal," she said.

"You weren't chain-smoking, is what you mean."

"No. But I was chewing nicotine gum."

Any artist who shows her work in public, no matter how good her work is or how nice a person she may be, comes in for a certain amount of public abuse; rapid success simply adds fuel to the fire. Schutz's rise to prominence coincided with the rise of art blog, where the phenomenon of her nearly instantaneous success was placed under the microscope by many anonymous critics:

> People like Dana, who get handed too much, too fast for too
> little, will never know how little of the phenomenon that is
> her current status is actually attributable to her "work" but
> to the star-making, self-serving machinery that has been the
> disgracefully degenerate art market for quite some time,
> now. But she will figure it out when, as happened to so many
> "stars" of the 80's whose names are long-forgotten, their
> rabid patrons, each out a few hundred thousand dollars,

embarrassed and chagrinned by their own stupidity, that she better have invested her fortune well.[32]

I haved personally known dana for years and like her work, but she is also WAY overhyped and her work often falls very short in person which is the worst way to fall short in painting. She has painting subject matter like this since she was an undergrad so it isn't that impressive. All your comments reflect exactly what the problem is with her work and the artworld and painting in general. The whole canniblism of the artworld bullshit???????? That isn't dana, that is some critic reading that shit into her work trying to make it more valid than it is.[33]

personally, i feel burned out on it all. i am tired of hearing about prices and collectors and fashion magazines and wild young artists. the times has covered shutz more than the war in iraq. it doesn't make the work any better.[34]

On top of this inevitable backlash, the ocean of painting was buffeted by new waves and squalls. Following the representation-heavy offerings of the first half of the decade, its remainder would see the dominance of abstraction. Tastes ran toward the monochromatic, the digital, the minimal, the austere, and the de-skilled—just about everything that Dana's paintings weren't. "I understood the urgency toward abstraction," she said, "but it seemed like everything was pegboard with sprayed holes and flopped-over burlap. Saturated color seemed flashy, 'out of it,' and somehow connected to the market. And the market had become this problem—the only thing that people seemed to be on the same page about. It felt as though if you weren't making work to critique it, you were a part of the problem. I thought, 'If I'm using color, what does that mean? Am I just extroverted?'"

She spent a while making small abstract paintings, which she never showed to anyone, and paintings with no color in them; "they ended up just being brown," she said. "I said no to a lot of things, because I think I knew it was a bad situation. You have studio visits and it looks so

depressing in there . . . Like there's nothing in there except for creepy, bad stuff."

The paintings that did make it out of Schutz's studio from that period betray small signs of artistic fatigue ("I think I was just really tired and burnt-out, you know?"), but they hold up well. A series of large works shown at Feuer in 2007 departed the fantastical terrain she'd explored earlier in the decade and focused on the here and now. They represented plausible, almost banal scenes given a slight, speculative torque by the conditional-tense constructions of their titles: *How We Would Dance, How We Would Drive, How We Would Talk, How We Would Give Birth.*

They're subtle, emotionally subdued — at least compared with the gonzo quasi-expressionism of the Self-Eater pictures. In *How We Would Dance*, five angular hipsters contort in a darkened living room under a disco ball. Schutz had stuck lengths of masking tape onto the canvas here and there, painted the image around them, and then ripped the tape off to leave sharp white lines that interrupt and flatten the picture: a precursor of the thinning effect that would occur in her paintings for the next couple of years.

AT THE ZACH FEUER GALLERY, a giant X formed by crossed lengths of steel railroad tracks, a floor sculpture by Marianne Vitale, spanned the main exhibition room. Feuer and I stepped over it four times to get to the office in the back. We sat at the end of a wall-length desk, opposite a set of bookshelves stocked with catalogs and binders for each of the gallery's artists. A fax machine spit papers onto the floor.

Feuer is now in his mid-thirties and looks pretty much the same as he did when he began dealing art in New York in his early twenties: a stocky guy with a groomed beard and receding, close-cropped hair. He'd been an art student in Boston before becoming a gallerist, and he maintains an artistlike wardrobe of cuffed jeans, sneakers, and open-collared shirts. Perhaps the look keeps him in touch with the early days of the gallery, the exhilarating moment before the onrush of success when "we didn't really know what we were doing — we just did a show and that was it." He

told me that during their first studio visit, when she'd still been a student at Columbia, Dana had been hung over and threw up.

We talked about the current state of the gallery world. Feuer worried about the "disposable culture of the emerging artist . . . everyone chases them for two years and then literally, people can't give the work away." I thought about the gauntlet that Schutz—or any artist who succeeds right off the bat—had to run in order to sustain a career beyond the initial flush of fame. Beyond the usual pitfalls of creative burnout and poor decision-making, the mathematics of the art market are statistically set against the longevity of the emerging artist.

The price of an artist's work is only ever supposed to rise. It can do this quickly or slowly, so long as it continues to climb up the bar graph. As it does, the artist requires larger and larger financial commitments from collectors and institutions to keep the whole apparatus moving in the right direction. A young artists whose prices rise too high, too fast risks an equally precipitous drop: all it takes is an iffy review, or a bad day sale at Sotheby's, and the speculators who initially inflated the artist's market may scamper for cover. Feuer struggled to keep Schutz's prices at a reasonable level: commensurate with her works' importance and merit, but beneath the reach of the speculative whirlwind that captured, elevated, and then spat out many of her peers.

We talked about the economic conversation around Schutz's work, which Zach said was the only conversation anyone wanted to have for most of the time they worked together. "I would do everything I could not to talk about Dana and the market."

Then, inevitably, we had a conversation about Schutz's market. "They would attack her youth and her gender and try to push her prices down by talking about how inflated and huge they were," Zach said. "I think her work is *still* tremendously undervalued."

Feuer pointed to the example of Mark Grotjahn, a Los Angeles artist who'd just set an auction record of $6.5 million for a large painting that spring. "I mean, I love Grotjahn's work, but Dana is a really important artist and the fact that her auction record is under a half million dollars is

illogical if people use her as an example of the market craziness. It wasn't crazy compared to everything else—it was just that we were kids and she was a woman."

Schutz exhibited *Singed Picnic* at the gallery in March of 2009, in what would be her last show there. A month earlier, Bloomberg News had reported that Feuer, in an effort to downsize in the post-bubble art market, had dropped eight artists from the gallery's roster over the winter. The move was abrupt and its publicity jarring, most of all to the artists who'd been asked to leave. All but three painters (Schutz, Jules de Balincourt, and Dasha Shishkin) were encouraged to find other representation—which suggested that in addition to weathering a financial downturn, Feuer was also revamping his program: steering it away from the no-longer-so-stylish style of brash figurative painting with which the gallery had become closely associated. For the next few years, the gallery exhibited almost exclusively video and sculpture.

The relationship between an artist and a dealer attempts to combine friendship, creative rapport, and business into one functional arrangement; it's practically inevitable that at least one of these components suffers in the long run. With so many psychological dynamics to contend with, the end of the relationship can be accompanied by feelings of betrayal and competing public relations campaigns: who left whom first, who was the instigator and whom the injured party. Feuer's and Schutz's was no exception, and Zach was visibly wary when talking about Dana's decision to leave the gallery in 2011.

"It seems like it was very hard," I said.

"It was. It was awful," he said. "The biggest fear I had as a business owner for many years was her leaving. And maybe that anxiety actually caused the breakdown that happened."

"Without going into the details of the petty fights we had," he added.

Schutz didn't want to go into the details of the petty fights either. She said she'd felt increasingly isolated in the gallery. (Possibly, the 2009 roster cuts had had a lot to do with this; she was friends with many of those

artists—Tom McGrath being one—and deciding to stay on after their departure put her in an awkward position). "Zach was going through a lot of changes, and so was I," she told me. "I think we just wanted different things. Leaving was awful. I mean, we'd been friends and worked together for a long time. There was no easy way to go about it."

A FEW WEEKS after I saw Feuer, I went uptown to visit Schutz collectors Andrew Cohen and Suzi Kwon Cohen at their apartment on the Upper East Side. Andrew, a prominent hedge fund manager, was careful to distance himself from the style of broad, speculative buying and aggressive auction flipping associated, fairly or not, with the members of his profession who got into the art game en masse in the middle of the last decade. "It isn't like buying groceries," he told me.

We toured the Cohens' collection, devoted almost exclusively to the work of American artists of the couple's generation. A gray monochrome canvas made with an Epson printer by Schutz's gallery-mate Wade Guyton hung in the hallway, opposite a digital print under Plexiglas by the mid-career Conceptualist Kelley Walker (an enlarged *Artforum* cover smeared with toothpaste). In the library, Suzi sat at a desk under an eleven-part Walker (images of turntables) and a sculpture by Dana's husband, Ryan, a clock with painted-on hands pointing crazily in all directions. A hallway was hung with small Mark Grotjahn drawings, and in a playroom with kids playing on the floor (Cohen: "We're just going to look at the art, guys") was a Schutz painting on paper of the face of a coin. We went back through the hall to the dining room, which had a melon-headed woman looking down at her hands (Schutz, *Stare*, 2003) and another painting by Walker. We ended up in the living room: another Guyton (three black circles on a white ground), a Grotjahn over the fireplace (a radial purple abstraction), and a Schutz painting of a disembodied ochre brain on a golden platter that seems to pulsate with mental activity.

Cohen told me that he'd followed Dana's work since the beginning of her career but didn't buy anything until 2006, when he was offered

a painting from her retrospective at the Rose Museum at Brandeis University. Since then, he's acquired pieces from most exhibitions. "When there's so much interest in someone's work, you don't always get to choose," he said, but in Schutz's 2011 show at Petzel, he got the pick of the litter: *Flasher*, a big picture of a man pulling open his raincoat to reveal not genitalia but a field of abstract shapes, squiggles, and smears.

The work at the Rose Museum was called *Google*, an uncharacteristically naturalistic self-portrait painted in 2006 and showing Schutz in her studio, hunched over a cluttered desk staring at an already-outdated iMac—the bulbous model that debuted in 1998. The screen shows the results of an image search, but you could just as easily imagine that the artist is refreshing a blog page over and over as the anonymous, poison-keyboard commentary piles up.

The picture made me think of two prominent self-portraits in the canon. The first was a Chardin pastel from the Salon of 1771, in which the artist, whose eyesight was failing at age seventy-two, shockingly wears a pair of round pince-nez. They look incongruous, even anachronistic. Eyeglasses date back to the thirteenth century at least, but people generally took them off to sit for painted portraits until the nineteenth century.

Google produces a corollary effect. Even an artist like Schutz, whose work is so much concerned with the life of the imagination, spends a lot of time on the computer. But seeing one show up in a painting of hers looks unaccountably awkward: a stage-dressing goof, like the Roman soldiers with wristwatches in *Spartacus*, that punctures the fictional space we enter in order to look at her work. Cohen said he'd been attracted to the painting because it dated itself immediately: it was a perfect piece of contemporary art.

The other was Courbet's panoramic *Artist's Studio* of 1855. It shows the artist perched on a stool in his spacious Parisian atelier, applying the finishing touches to a landscape while a host of symbolic people mill about the dark, high-ceilinged room. To one side are arrayed a cross-section of social types (mendicant, merchant, priest). To the other, an

urbane group of individual onlookers, including a pensive Proudhon and a brooding Baudelaire, represent the artist's intellectual milieu—"all the shareholders," Courbet called them. "It's the whole world coming to me to be painted," he said of the picture, to which he appended a paradoxical designation in the work's subtitle: *a real allegory summing up seven years of my artistic and moral life.* The figures in the painting were at once symbolic and concrete, subjective and objective, *real*-ly allegorical, and together they attested to the breadth of Courbet's world. The artist was naturally at its center.

Schutz had painted herself painting before. In 2003, she placed herself in a surreal studio-landscape (a forest lit incongruously with two tungsten clip-lamps) daubing the outline of a pink homunculus onto an even pinker canvas. But *Google* is the only self-portrait in which we see her properly in *her* world.

It's a mess: overturned potted plants and gum wrappers on the floor, deli coffee cups, plastic bottles of water, and crumpled receipts on the desk. Two calendars and a day planner, an open box of checks, broken CD cases, and an overspilling ashtray attest that the boring, everyday frustrations of the artist are as boringly frustrating as anyone else's.

Compared with the imagistic splendor of Courbet's self-portrait, which shows us that even while alone in the studio the artist is surrounded by the sprites of his creative universe, *Google* is painfully prosaic. But the two paintings are about the same thing; the representatives of Schutz's artistic and moral life appear here, too, as the tiny glyphs on the computer screen. The world doesn't come to the studio to be painted; it's channeled to the artist through the glowing box on the desk, in a layer of colored light that's thinner even than paint on canvas.

Party, 2004

On first inspection it seems to belong with other Schutz paintings from that year, in which groups carry out unspecified tasks in simple land-scapes. Here, simplified men and women form a human sculpture on

a beach. They're wrapped up in microphone cords, and little wedges of bright color suggest falling confetti. Five figures are carrying a larger one, a stick-limbed guy in a navy suit with a round pink head and a snowman's jutting, carroty nose. He isn't dead or dying, like the giant in *Presentation*, but he's slack, three sheets to the wind—all except for his red tie, which points priapically up toward one o'clock. The landscape is three stacked horizontal bands of color.

Like most (maybe all) of Schutz's pictures, *Party* is an art-historical gala. You can trace its landscape of horizontal bands backward in time, from Picasso's surrealistic beachgoing couples of the early 1930s or Max Beckmann's nearly contemporaneous seascape friezes, to Cézanne's bathers a quarter century before that, then back even further to Nicholas Poussin and eventually the Greeks.

I looked at *Party* a dozen times before I noticed that the people in it are George W. Bush's cabinet, circa 2004. Schutz had simplified them

Figure 4.5

to the point of near-anonymity: Donald Rumsfeld is a pale rectangle with a pair of rectangular glasses, John Ashcroft is a puce square with a lank forelock. Dick Cheney is a dull pink circle and Condoleezza Rice is a leg in a blue pump and a flip of brown hair atop an orangey-brown oval. Powell (a sliver of purple) is almost entirely hidden behind the president, the limp fellow with the erect tie.

Schutz told me that *Party* began, like many of her canvases, with an abstract idea: a group of people trying to become one person. Anxieties about the upcoming election, and the photographs from Abu Ghraib that had begun circulating in April of that year, crept into the work—through the artist's computer, no doubt. The figures in the painting took on identities (what better representation of amalgamated personhood than that of a head of state?), and their frolic began to seem like the sinister kind of human sculpture practiced at the notorious Iraq prison, its dogpiles of hooded prisoners. Microphone cords became leashes or electrodes.

"I kind of wanted it to be in between," Dana said. "Not because I *liked* the idea of it being ambiguous—my feelings toward the subject were not ambiguous; I thought the country was in a shitty situation—but I thought it was interesting if the characters were caught in a moment where they could either be celebrating or falling apart."

The idea of ambiguity crops up incessantly in recent art criticism. As a quality of art, it's almost universally desired: it's associated with semiotic richness, interpretive openness, and the active role of the viewer in constructing the meaning of the work. If something is ambiguous, it isn't facile, easy, didactic, affirmative, propagandistic. *Ambiguous* is to painting today what *existential* was to Abstract Expressionism; it's hard to imagine contemporary art without it.

Being desirable themselves, Schutz's paintings are full of the stuff. You could say that ambiguity is Schutz's métier, and many people have: "Dana Schutz [is] known for her large paintings, which combine riotous color with distorted figurative forms, producing scenes as emotional as

they are ambiguous."[35] "These place her paintings in an ambiguous space between fiction and reality, past and future, realism and fantasy."[36] "It's a tour de force, dazzling in its mosaic-like application of color and maddening in its ambiguous approach to mob psychology."[37]

An art-blog review of Schutz's 2006 exhibition at the Rose Museum, in which *Party* was featured, put the case like this:

> Some of her more recent paintings move into gimmicks that would be best avoided. Social and political commentary are not her strong suit. *Party*, a painting of members of the Bush administration melded together and wrapped in microphone cords, is one that could have been a disaster but is saved by ambiguity.[38]

The notion is bracing. For an artist, what does it mean to be ambiguous in a painting about a subject as charged as torture? For a viewer or critic, what does it mean to prefer an ambiguous painting of it to one that is unambiguous? The desire suggests an idea about the division of representational labor: that the painted image is now historically superfluous to the task of bearing witness (even, possibly, to the task of conveying a political message). Other media do this more efficiently and accurately. And in one sense this is true: what painted image of torture could possibly add to the terrible completeness we see in its photographic representation, or feel in the firsthand account of its victims or perpetrators? But if this is the case, what does painting do?

Schutz set *Party* on a beach as a nod to Philip Guston's 1975 painting *San Clemente*. Using the same sky-sea-sand tricolor as Beckmann and Picasso had, Guston painted the recently resigned Nixon skulking around at his family's California retreat. The landscape in the two paintings is nearly the same, and the two presidents' neckties are pointing in precisely the same direction.

Guston had risen to prominence as an Abstract Expressionist before returning to representational art in the late 1960s. This transformation in

his work had everything to do with being an artist in the United States at that time, he told an interviewer after the fact:

> I was feeling split, schizophrenic; the war, what was happening to America, the brutality of the world. What kind of a man am I, sitting at home, reading magazines, going into a frustrated fury about everything—and then going home to adjust a red to a blue?[39]

Abstract art, for Guston, lacked the capacity to address the pressing problems of being alive just then and there. Making pictures could at least make you feel like you were doing something; ask any political cartoonist. And his Nixon takes many cues from that genre of image making. *San Clemente* is an explicit picture, in both senses of the word. It's an obvious caricature of Nixon, and a grotesque one: Guston has transformed the president's nose and cheeks into a huge, dangling cock and balls.

In a few paintings from 2005, Schutz tried her hand at a similar explicitness. In *Men's Retreat*, titans of industry engage in a touchy-feely revel in a Bohemian Grove–esque flowered glen. Unlike the nearly unrecognizable figures in *Party*, the men here are rendered in merciless, caricaturistic detail: Rupert Murdoch crouches in the bushes wearing a headband, Dennis Kozlowski mopes, Bill Gates, in a wife beater and blue briefs, applies war paint to the face of a naked Ted Turner. (Michael Ovitz bought this painting too.) It puts Schutz in the camp of the great satirists of postwar American art: Guston, Robert Colescott, Peter Saul. It also feels slightly out of character.

Party, however, is an altogether more oblique image. It's constitutionally vague. Trying to sort out the tangle of interlocking limbs in the picture, you come up against unexpected lacks and excesses: there are too few legs and arms, and in some cases you can't tell what belongs to whom. Other elements of the picture—the patches and the little falling daubs of color, two cryptic triangles protruding from above the group's shoulders—can't be accounted for within its pictorial logic.

Party is a picture of epistemological doubt. Interpreting it means (to paraphrase one of the painting's subjects) taking stock of the unknowns, both known and unknown. But I don't think it's a more successful picture than *Men's Retreat* because it's interpretively uncertain. It's successful because *Party* is a clearest possible representation of a contradiction: *Party* is the body politic celebrating its own collapse.

Max Beckmann made drawings and etchings of the corpses he saw in Belgium as an orderly during the First World War; "four years of staring straight into the stupid face of horror," he wrote of it.[40] If Schutz's work testifies to anything, it's to the anxiety of seeing at a distance, and only partially—and having to make up what one can't see. (Consider the living-or-dead giant in *Presentation*, a chimerical stand-in for the scores of civilian casualties and dead soldiers whose images weren't, and still aren't, available to us; or the acts of mutilation presented by the Self-Eaters, in which physical violence is experienced at several removes from immediate, bodily reality.) Primarly, her images bear witness to the mood of boom-time, war-time America: festive and horrible, monstrously cheerful, like a party about to get thoroughly out of control.

God 1, *2013*

One is a chubby, iridescent lizard-thing, with suggestions of scales and claws. Its powerful legs are painted in thin washes of orange-red and purple, most of which seems to have been wiped off with a thinner-soaked rag. One of its eyes has a vivid, golden iris, and the other is bisected by the tip of the brushy black V forming the creature's stubby, upturned nose. "There might be a cigarette between her toes," said Dana.

Another has a lower jaw lined with serrated teeth, like an upturned saw, and an eyeball that seems to be exploding. Abstract tattoos run down the length of one arm, and it wears a denim mini-skirt with a beaded fringe. "This one is based on a woman in the neighborhood. I think she's a meth addict. I thought of people who wander around and pick up anything shiny, or trash. Something between that, and those fish that glow from inside."

Figure 4.6

The third, she said, began with an idea of a place rather than a person: a town out in the hills, perhaps outside Los Angeles. Maybe it's abandoned, or inhabited only by actors. The figure has a white short-sleeved shirt and khakis. "I think there could be a lot of black-and-white TVs in it," she said. "Or maybe that's how he sees things. I have to figure out how to paint the sky. I don't know how it would be." She seemed relatively sure about what to do with the figure: "The shirt is going to be more Hawaiian. And he's going to have a ponytail."

I'd gone to visit Schutz's studio again on a hot day in July. I ran into her on the corner of her block. She was taking a break and getting an iced tea; she was supposed to be working on a group of unfinished paintings

scheduled to go to Berlin at the end of the summer but had ended up just lying down in the middle of the studio floor.

The three unfinished paintings were pictures of gods—"Not different gods," she told me, "like the pantheon of Greek Gods. More like different *proposals* for gods . . . what God could look like if you're not religious." The canvases were each about eight feet tall, and Dana said that a large, narrow, vertical format is much harder to pull off than a large horizontal—something about getting up on a ladder to paint and resisting the tendency to divide the canvas into a top and a bottom.

The paint on Schutz's recent canvases is thick and viscous, but unlike on her earlier ones, there isn't a whole lot of it; it doesn't accrete into crusty layers anymore. She tries to complete a section of a painting in one session and to wipe it down with solvent at the end of the day if she isn't satisfied with the results. Life often gets in the way of this approach. "I stopped this one because I started to panic about it, and the paint got all sticky. And then my cousin came to town, and we went upstate . . ."

Schutz told me about a promo she'd just seen for Google Glass. The advertisement is shot from the perspective of the user. He or she is doing a number of interesting things and recording them: piloting a hot air balloon, riding a horse, playing Ping-Pong, walking down a runway at a fashion show. In the segment that caught her eye, the user is about to embark on an ice sculpture of a tiger. He's staring down at the block of ice, and he says to the device, "Pull up photos of tiger heads," and, like magic, images of tiger heads appear in the upper left corner of the viewscreen. A minute later, we see him using one of these as a guide for the sculpture.

"So it seems interesting and also completely ominous," Dana said. I thought again about the painting *Google*, and the uneasy reciprocity in Schutz's work between the screen and the canvas. "I don't know, I *guess* people will still be able to imagine things, and come up with different images, but . . ." She looked uncomfortable.

"I'm not against it or anything. But I like the idea of headspace. I mean, *personal* headspace. That's why I think artists are so great. Because it takes that headspace to make a painting."

When Courbet painted *The Artist's Studio*, painting was just about to cede its position to photography as the medium best suited to transmitting visual information; perhaps that accounts for his insistent desire to picture himself, and painterly realism, at the center of culture and as the apex of art history. But painting and drawing were still the tools by which his culture imagined itself most vividly.

Painting is now a profoundly eccentric way to try to represent the world: as materially and methodologically divorced from our everyday mode of image production as the illuminated manuscript is from the text message. But rather than lessening that gap, Schutz seems to want to keep it open: to bring the culturally complicated act of painting into some functional relationship with the more basic, perhaps fundamental activities of imagining and picturing.

It doesn't always work. Hence the affinity of her work with the paradoxical and the self-contradictory, its dalliance with ambiguity, and the absurd and protracted lengths she goes to in order to invent situations in which the act of painting makes sense. Hence, too, the occasional failures of nerve she experiences, and the immense satisfaction we feel when her images hit their marks and attach themselves to the world.

5

THE ESTRANGER

Mary Walling Blackburn is giving a visiting artist talk at the Pratt Institute in Brooklyn on an afternoon in April 2013. The lecture hall is on the third floor of the Engineering Building, and the audience, a sparse mix of art students and the artist's friends, is distributed evenly across the hall's long rows of wooden chairs and built-in desks. The lights are off and the room is loud. A pull-down screen behind a podium displays a video of a Middle Eastern crowd dancing to fast electronic music. The camera follows a singer in aviator sunglasses, a long leather coat, and a red and white keffiyeh; a man in an elegant gray suit smokes a cigarette and periodically leans in to shout something in the singer's ear.

Walling Blackburn, a small woman in her late thirties, in a dark green shirt tucked into black jeans, sits primly on a stool to one side of the podium. A man in a blazer comes to the microphone and introduces her, but she stays where she is. Two other men now approach the mic. Like the men in the video, one smokes a cigarette and whispers in the ear of the other, who haltingly repeats whatever he is hearing to the audience.

"Do you mind if I smoke?" he begins. "It's part of the reenactment."

A pause, more whispering.

"You'll have to inhabit yourself in order to answer that question . . . Yes you mind . . . Yes I mind . . ."

After a few moments, the two men fall into an easier rhythm. "Mary Walling Blackburn . . . seeks to make people . . . uncomfortable . . . She seeks to do this . . . in a politically or aesthetically . . . productive manner . . . However sometimes this fails . . . and she accepts this as well."

There's some laughter from the audience as the two stumble over a complicated phrase and the telephone game starts to break down.

"To say then teaching is part of her artistic practice . . . to say that teaching is part of her artistic practice . . . Let us begin again . . . It is *misleading* to say . . . that teaching is part of her artistic practice . . . because that would fail to recognize . . . that she is always trying to teach people . . . something." More laughter.

"We are trying to reenact the story . . . right now . . . of a Syrian home . . . of a Syrian *poet* . . . who smokes a cigarette . . . and whispers words . . . to a musician . . . so the musician . . . can sing the words . . ."

FOR EVERY TEN artists who enter the art world through the now-traditional route of the art education system, there's at least one who finds her way to it from without, drifting in through other channels. Art can be a haven for wayward culture-producers: poets who stop writing, computer programmers sick of Silicon Valley corporatism, musicians tired of playing songs, anthropologists who stray from the rigors of academic protocol. It sometimes welcomes visitors from even further afield: farmers, doctors, research physicists, and, even now, the occasional bona fide eccentric — someone for whom the label of art is an acceptable term for otherwise unnamable pursuits.

As a discipline, contemporary art is methodologically open; it thrives on imported ideas. As an *industry*, however, contemporary art is inherently restrictive, tending to delimit access to participants through complicated language games and bizarre social codes. Because of this tension, there's a constant traffic at art's borders: things go in and out of its purview, slipping beneath the eyes of its customs officers. Whether an idea or an action is considered *art* will make a huge difference in terms of its cultural value and the effects it has in the world. But very often,

the question is of surprisingly little relevance to the person thinking or doing it.

Walling Blackburn falls into this second, rarer category of participant (though she's acutely allergic to any categorization of anything, as far as I can tell). She followed an atypical route to end up as an artist—but art, it seems, is merely the least offensive and most pliable name for what she wants to do, one that causes as many problems as it solves.

Her projects run the gamut. Over the past six years, she has become, in the service of her art, a singer, a tutor, a choreographer, a documentary filmmaker, a tourist, a critic, and a translator. Her actions rarely take place in the gallery or the museum but instead crop up in the auxiliary spaces of contemporary art: the classroom, a panel discussion, the after-party for an art newspaper. Others are performed in private, with little or no documentation at all, and recounted later, like personal folk tales. And rather than manifesting as one discrete thing, they creep outward through different forms and contents, drifting across disciplines ("with as many tentacles as possible," as the artist Dave McKenzie put it). Because of this, it's difficult to experience her art without getting implicated in it somehow—as a collaborator, assistant, test subject, or foil.

Figure 5.1

The above description might suggest another list, of softball adjectives like "quirky," "poetic," or "ephemeral"—except that Walling Blackburn's work is deeply and passionately concerned with conflict and misunderstanding, conditions she cultivates with the patience and care of a gardener. She recently wrote a pro-choice children's book. She was once thrown out of a feminist art residency in the Northwest; organizers cited her politics and the contents of her work as grounds for dismissal.

Considered broadly, Walling Blackburn's work occupies a cross-hatched zone between two overlapping genres: performance art and a more recent interdisciplinary mode of art-making known as social practice. The latter emphasizes the virtues of audience participation and community building in highly structured, often collaboratively authored projects: workshops and think tanks, walking tours and community theatrical performances, mobile radio stations and career clinics.

But while many artists working in these two genres are thinking bigger, moving toward spectacle or more ambitious forms of social engagement, Walling Blackburn tends to shrink art down to its most intimate terms. She specializes in providing difficult, uncomfortable, and hopefully significant experiences for small groups of people, often one person at a time.

THE INTERACTIVE TELECOMMUNICATIONS Program at New York University is a cross-disciplinary department that mainly deals with one type of interaction: the one between a human and a computer. It produces a lot of hacked consumer electronics, art-making software, and installations featuring motion-sensitive lights and video feeds. But you can certainly take the field in other directions, as Walling Blackburn did for her master's thesis project in 2003. She looked at commercial satellite imagery and traced the outlines of U.S. bomb craters in Afghanistan onto the surface of New York City in white chalk.

I thought about the notion of interactive telecommunications when, after I e-mailed the artist a few years ago and suggested that she invite me over to her studio, I received a cryptic list in reply:

Hotel Lobby Bullet Hole
Statue of Man Trampling Vice and Corruption Mermaids
Memorial to a Peacock Mistaken for a Vampire
Louis Armstrong Museum
Kurdish Library and Museum

Walling Blackburn asked me to choose one and included directions to each. Each site had a relationship to her art, she said, but didn't elaborate. The Memorial to a Peacock Mistaken for a Vampire lives at a Burger King just off Highway 440 in Staten Island. The Statue of Man Trampling Vice and Corruption Mermaids (I never found out if this was one work or two separate ones) can be found at the Queens Borough Hall in Kew Gardens. Neither landmark appears in any guide to New York City public art. The Kurdish Library and Museum is housed in a private residence in Prospect Heights.

It was a cold weekend in October, so I chose the closest site on the list, the mysterious Hotel Lobby Bullet Hole. A week later I was sitting on a bench in the lobby of the Casablanca, a boutique hotel in Times Square. Walling Blackburn walked in, we introduced ourselves, and she began scouring the walls for any possible traces of gunfire. A maroon-vested concierge with a strained smile followed us nervously around the room.

Walling Blackburn was thinking back to an incident in 1996. A fight between two patrons of a nearby restaurant spilled out onto the street in front of the hotel; a stray bullet killed a fifty-year-old bellhop. The *New York Times* reported it as a cautionary tale about gentrification. The new Times Square, though gleamingly refurbished, was just a ricochet away from its seedy past.

"What about this?" Walling Blackburn asked, pointing to a mismatched square of wood the size of a drink coaster that had been patched into a mahogany wall at shoulder height. Perhaps the bullet hole *had*

been here, but then they'd fixed the wall? The concierge said he was sure it hadn't.

We then sat down on a bench and talked about embarrassment. Walling Blackburn considered it a medium: not to embarrass others but to be embarrassed oneself, to make oneself vulnerable in the course of completing a project. Embarrassment was different from shame—which was to be avoided, she said—and was related to another key word in her lexicon, *excess*.

The artist is fond of making pronouncements on the fly, and it often seems like she's composing them in real time; they twist in unexpected ways toward the end. "The work that I like is not the work that I make," she told me. "There are people that make very direct work with an elegance and emotional economy that I admire. But I'm really excessive. And the danger is that it could collapse under its excess. Another is that it collapses because of self-righteousness, because of the politics that somehow permeates it. I have to be nimble around them . . . shame and self-righteousness come close whenever you have the political."

In the spring of 2011, she installed *Library for (the land of fuck)* at the Bard Center for Curatorial Studies in upstate New York: a crude A-frame shed built out of scrap lumber from a local yard and set out on the lawn behind the school's stylish, white-brick Hessel Museum. Like her thesis project at NYU, *Library* was interactive but only vaguely technological. It had two microphones and two pairs of headphones, rigged through a PA. Mary, who sat inside the windowless shed during exhibition hours, had one set, and the visitor, who could perch on a low stool outside it, had the opportunity to make use of the other.

If you chose to put the headphones on, you would hear (but not see) Walling Blackburn reading from Kafka, the New Zealand novelist Janet Frame, a book on flora and fauna or the Bible, lists of people executed via electric chair in the United States—a selection of texts both utopian and dystopian. Sometimes she would sing. If you sounded like you were a man, Walling Blackburn would offer you a drink from a cooler placed on the ground next to the stool; she would tell you that the drink wouldn't

Figure 5.2

hurt you but that it *would* do something to your body, and that if you
wanted to know what was in it, you'd have to inquire after the encoun-
ter was over. ("The Land of Fuck" is a line from Henry Miller's *Tropic
of Capricorn*: "The world of men and women are making merry in the
cemetery grounds. They are having sexual intercourse, God bless them,
and I am alone in the Land of Fuck.")

 Library was one half of a show called "Double Session" curated by
a graduate student in the Bard program named Natasha Marie Llorens.
Walling Blackburn's work was paired with *In This Hello America*, a
boisterous collaboration by a group of New York–based artists including
Douglas Paulson, Christopher Robbins, and Kerry Downey.

 "Double Session" was billed as an exhibition about social practice
art, and *In This Hello America* served as a textbook example of the genre.

It comprised a series of free, public activities held around a large abstract sculpture on the campus that had been rain-proofed with plastic sheeting and converted into an impromptu meeting place. Scheduled events, publicized on a Tumblr page dedicated to the project, ranged from morning coffee and discussion sessions to workshops on how to build an efficient woodstove, Skype conversations with friends of the artists' in Egypt, and a "Sunset Club" that met every evening to have "an adventure to see the sunset in a new place every night."[1] It channeled two historical precursors to the genre of social practice: Allan Kaprow's Happenings of the late 1950s and the "living art" festivalism of the Fluxus group that followed shortly after.

In 2006, the art historian Claire Bishop noted that recent developments in participatory art such as social practice solicited a different kind of criticism: these works demanded to be considered in ethical, rather than aesthetic, terms.[2] Rather than be evaluated via the categories of originality or aesthetic merit, works of social practice could be judged good or bad based on the types of interactions they proposed: egalitarian, nonhierarchical, consensual, or, conversely, exploitative, repressive, dictatorial. In fact, many artists and critics contested the value of designating these projects as works of art at all, claiming they might more reasonably be considered social or political interventions that only happened to originate within the context of contemporary art.

So while Walling Blackburn's *Library* upheld many tenets of social practice, it diverged significantly from the template in terms of mood. Where *In This Hello America* was positive and community-spirited, cheerfully determined to instill a sense of camaraderie in its participants, *Library* was introverted, melancholic—social practice as a one-on-one mind game. The relationship it enacted between artist and audience, considered in an ethical register, was purposefully murky: is the viewer being educated, seduced, hoodwinked?

So what was the drink? I asked Mary in the lobby of the Casablanca. Lemon, pineapple, cinnamon, celery, and parsley, she said. "If they were to drink it on a regular basis, it would change the taste of their

sperm to what, by Western standards, is better. I thought that some people would think, 'Oh that's great—thanks for helping me out!' And others would think, 'Fuck you for getting into my body!'" Participants who wanted this information could e-mail the artist, who directed them to a webpage with an audio file of a man singing the drink's ingredients and its effects.

The beverage service at the *Library* was also a little jab at an artistic cliché. "There's so much social practice work right now where people are making soup for everyone," she said. "And I think, well, things move in multiple ways. Food isn't without complexity or problem, and generosity can be awkward. Is everyone operating on a level playing field when someone offers another person something?"

■ ■

AT PRATT, THE two men complete their reenactment of the Syrian poet whispering lyrics into the ear of the singer, and Walling Blackburn finally takes the podium herself. "Hello and thank you for coming today," she says. "The title of this lecture is 'Merch Table.'"

She starts it by talking about our expectations for a visiting artist's lecture: that the artist will be introduced by way of her CV, which contextualizes and legitimates her work through a narrative of professional achievements; that the artist will show images of her work—at one time photographic slides, now JPEGs, URLs, or MP4s; that the artist will explain, more or less, what she's trying to do and what it's supposed to mean. By this point we're getting the idea: Walling Blackburn isn't going to do any of these things.

She addresses the students in the audience and tells them earnestly that they don't need to adhere to this format, or to any other format determining professional conduct for artists. "You sometimes have the power to pervert it," she says. "If you don't, then you've also made a choice."

She pauses. "I feel that my voice sounds very serious, but know that inside of my voice is still play," she says—hardly a playful sentence. "You

can be very serious and still fail. Since you might fail either way, then why not play?"

THE GERMAN ARTIST Joseph Beuys, whose idea of "social sculpture" is another forerunner of today's participatory art, told a story about the time his Luftwaffe plane got shot down over the Crimean front in World War II. Beuys said he was rescued by Tatar tribesmen, nomads, who kept him alive in the snowy wilds by wrapping his body in felt and fat. The tale became the origin myth of Beuys the visionary, the charismatic artist-shaman-teacher for whom creativity alone was "capable of dismantling the repressive effects of a senile social system to build A SOCIAL ORGANISM AS A WORK OF ART," and who helped found the German Green Party in 1980.[3]

Walling Blackburn tells similarly vivid anecdotes about her past: not invented, as Beuys's story of life with the Tatars undoubtedly was, but framed in mythic terms nonetheless. And just as Beuys used pieces of felt and lumps of fat in his sculptures for his entire career, much of Walling Blackburn's iconography is rooted in childhood experience and family legend.

A few months after our talk at the Casablanca, Walling Blackburn conceded to a proper studio visit in her space in Greenpoint, Brooklyn — a ground floor live/work a few blocks from Newtown Creek. There was no art to be seen; instead, she produced a postcard of Mount Shasta in Northern California. "That's where I was *almost* born," she said. Her father took her mother on a hiking trip when she was six months pregnant; they got lost, and she went into false labor while on the mountain. "But then she calmed herself down . . . which is a pretty good feat for a seventeen-year-old."[4] Mary was actually born in Orange, six hundred miles to the south, where her mother's family lived. She describes them as ex–Arkie sharecroppers who'd never ascended into the middle class: waitresses, truckers, miners. On her adopted father's side, she told me, you could find both plantation owners and a founder of the NAACP.

The family went to Wyoming, where Mary's biological father worked as a ranch hand in the beet fields. Her parents split, and Mary's already complex childhood itinerary was bifurcated: her mother left for the East Coast, then Africa; Mary went back to California with her father, then to Canada with her mother upon her return to the continent, then to the Mojave Desert with her father and New York City with her mother. She eventually settled into a seasonal oscillation, the Mojave Desert in the summer and the Sierra Nevada in the winter. The migrations continued into adulthood, through Utah, schooling in New Hampshire and New York, teaching English and researching in Istanbul and Saigon, then teaching art in Chicago, back to New York, West Texas, and New York again. She was leaving in a few months to travel in the Middle East; she'd gotten a grant to make a video project retracing the route taken by American hashish smugglers from Syria to Nova Scotia in the 1970s.

That semester, however, Walling Blackburn was teaching a class at Cooper Union about public access television. She had instructed the students to search for archived footage from stations across the United States. They talked about why the archive was missing so many crucial documents from underprivileged communities: stations with scant resources had to reuse videotapes over and over, so that older broadcasts were now just faint, magnetic ghosts beneath the more recent ones. They examined other relationships between artist, context, and audience: Marcel Duchamp's *Étant donnés* at the Philadelphia Museum of Art, in which the viewer looks through the peephole of a wooden door to see a headless, naked mannequin installed in a diorama-like landscape; the "joker" performances in working-class Bangkok nightclubs in the 1980s, where cross-dressing comedians embellished traditional Thai folktales with pop references and political satire; a song by the UK post-punk band Joy Division covered by the South African musician Spoek Mathambo.

For their final project, students would be filming performances to be aired on a New York public access station. But the project didn't end there, Walling Blackburn told me: all the students in the class had to

arrange a screening for their performance, choosing a venue and inviting a specific audience to watch the broadcast. In final critiques, these decisions would be evaluated as part of the student's work.

The project was meant to get them thinking about the art world: how galleries and museums provide artists with a public platform, but also determine what *kind* of public will see their art. "I ask them to think about what capital has taught them about audience," she said. "Has it taught you that spectacle and mass are what's worthwhile, and do you really believe it? And what would it mean for you to make a performance for one person?"

"I didn't come through traditional arts systems," Walling Blackburn continued. "With those who did, one of the things I see is they're incredibly vulnerable to determining their self worth by whether they have been recognized—via a review, or gallery representation. And they'll babble about it as if they've been seized by the Greek hysterical womb walking through their bodies. And I'll say, 'I want to save you guys from that. I want you to not feel so vulnerable. I want you to feel that you have strategies to work outside that system.'

"That's important to me too," she added. "In terms of galleries, if someone asks me, 'Are you against the gallery?' I would say, I don't know. I don't understand the gallery. It's a site of confusion. I don't understand what objects are supposed to mean in that space."

■ ■

SHE ANNOUNCES THAT the Pratt audience will be participating in a performance, and because this is an educational situation, we are going to talk about it afterward. "When I come to a school, I make a little bit of a vow to explain things to you."

She takes a breath and starts speaking again, a little more slowly.

"I will need you to be supportive of the arts. I will not pay you. We are going to distribute some materials to you so you can keep your commitment to be supportive of the arts."

A man and a woman walk up the aisles and hand sheets of newsprint down the rows of chairs.

"You're my workers," says Walling Blackburn. "But you're not only my workers—you're my *sex* workers. I need you to draw as many cocks and balls as you can on this sheet of paper."

I glance around the room. No one seems particularly fazed; this is art school, after all. We start to draw. The newsprint pages fill up with genitalia, some sketched with academic aplomb and others scrawled like bathroom graffiti. Meanwhile, Walling Blackburn doles out instructions in the flat tones of a prerecorded customer service script.

"Your time is my time," she says. "You have no health insurance . . . Take a lunch break—okay, it's over."

Next we are told to flip over our pieces of paper and to draw as many "pussies and clitorises" as we can. We draw again. After a few minutes, we pass our drawings down the aisles. Walling Blackburn's assistants collect them and return them to a table near the door.

"This is my factory," she concludes. "This is all my work now, and I can do whatever I want with it."

A pause, a slight softening of tone, and she tells us that she'd initially performed this piece—called *Five Minute Factory*—in Texas. She'd been asked to speak on a panel as part of an event called "Art Work: A National Conversation About Art, Labor, and Economics." The gig was unpaid, and the performance was her response. "When I did this in Austin, afterwards I said that I felt very tenderly . . . but how am I supposed to pay for the dentist?"

PERFORMANCE ART, as a genre within the visual arts distinguishable from theater, emerged from the same bubbling neo-avant-garde cauldron of the 1960s that produced Fluxus, Conceptual art, earth art, and a spate of inter-related challenges to the dominance of painting and sculpture within the art world. It has as many historical predecessors as it has variations in practice: Russian Constructivist and Dadaist theater, Antonin Artaud's Theater of Cruelty, the experimental, multimedia events of the Gutai group in Japan.

As with social practice, the notion of performance art as a unified genre attempts to gather a lot of different kinds of art under one flimsy taxonomical umbrella: consider Yoko Ono's *Cut Piece* (1964), in which the artist sat on the floor of an art center while audience members scissored off pieces of her clothing; Joan Jonas's *Upside Down and Backwards* (1980), a lush, theatrical retelling of two fairytales from the Brothers Grimm (one told forward while the other is told backward) with masks, painted sets, and prerecorded sound and video; Lorraine O'Grady's *Mlle Bourgeoise Noire* actions of the 1980s, agitprop in which the costumed artist crashed art openings to protest racial apartheid in the New York art world; and Tehching Hsieh's *Outdoor Piece*, 1981–1982, in which he spent a year without entering "a building, a subway, train, car, airplane, ship, cave, tent."[5]

From its role in the development of feminist art practice in the 1960s and '70s, through its urgent politicization in the AIDS crisis of the 1980s, to its fusion with installation and film in ambitious, media-centric artworks of the '90s, the past half century has seen the gradual movement of performance art from the margins of contemporary art to someplace much nearer its center. In the past ten years, much of it has taken place not in the hole-in-the-wall alternative spaces of the medium's mythic past but in major institutions, before large and enthralled audiences. Performance, inherently embodied and usually interactive, now captures the attention of an expanding audience for contemporary art that's eager less for interesting objects than for live experiences.

In the spring of 2010, MoMA hosted a retrospective of works by pioneering performance artist Marina Abramović. The centerpiece of the show was Abramović herself, who sat every day at a wooden desk in the museum's spacious atrium, in silence. Spectators could sit in another chair opposite the artist for as long as they wished — "becoming participants in the artwork," according to the exhibition's literature; many viewers were moved to tears.

Earlier that year, visitors to the Guggenheim encountered a rotunda entirely emptied of art objects. Performers waited in the lobby to escort visitors individually or in small groups up the spiral walkway, engaging

them in semi-scripted philosophical dialogues before handing them off to other actors, in a kind of conversational relay race. The situation was a work of art orchestrated by the British-German artist Tino Sehgal.

Both shows were hugely popular, and at present Abramović is the closest thing the art world has to a genuine superstar, counting Jay-Z and Lady Gaga among her admirers. The mainstream acceptance of this once-liminal art form, historically associated with confrontation and critique, calls into question a received idea about performance art: that in refusing the traditional production of art objects it necessarily works *against* the commodification of art, or the smooth integration of art into entertainment culture. Younger artists desiring to maintain some degree of criticality within the medium find themselves wrestling with the problems of success and approval.

To that end, Walling Blackburn's performances solicit audience participation of a more antagonistic sort than the benign interactions fostered by Abramović and Sehgal. Just as she turned the audience at Pratt into temporary "sex workers" during *Five Minute Factory*, Walling Blackburn often makes her participant-spectators unwitting accomplices to some perceived transgression, drawing them in through reassuring structures like a tutorial or a sing-along.

For a piece at the Parsons Design Center in 2010, she divided the crowd into four sections and led them in a call and response. First, they answered a series of questions:

> Walling Blackburn: Do you like Americans?
> The audience: Yes yes yes yes yes yes yes!
> Walling Blackburn: Do you like to kill Americans?
> The audience: Yes yes yes yes yes yes yes!

Next, she gave each section a few syllables to sing, and conducted them like a choir. The syllables formed phrases:

> We miss pussy.
> I'm an idiot.
> Fuck this country.

While this was happening, she handed out a flyer explaining that she'd found the libretto for the performance on YouTube, in videos posted by U.S. servicemen in Iraq; the soldiers were instructing Iraqi children to repeat these words and phrases in English.

For another project, Walling Blackburn asked passersby outside the Alliance Française in New York to translate a word or a phrase from French into English. Later, she assembled them into an awkward, crowd-sourced translation of a text by the philosopher and queer theorist Guy Hocquenghem, whose works have seldom appeared in English and are hard to find even in French.

Next, Walling Blackburn and the musician Che Chen sang the text together in a peculiar slow chant, alternating breaths and stitching individual words into a sustained, nearly incomprehensible drone, at a performance at Cooper Union. Hocquenghem's text was a critique of "the couple" as an ideological unit:

> A
> tracing
> or
> interlacing
> of
> couples
> official
> or
> not
> the
> modern
> society
> is
> made
> of
> changes
> of
> partners

within
fixed
figures
even
if
they
change
partners
the
couple
is
always
looking
for
the
same
thing

And then Mary shouted, as if it were a political slogan:

The fornicating structure remains, triumphs, extends!

And Che, more casually, read:

We invest even more in the totalitarian symphony of the
couple with only one child. But maybe, in the future, no kids
at all. Why not?

As it is for many artists working in performance, the video camera is
both an indispensable documentary tool and a source of complication
for Walling Blackburn. At the Skowhegan art residency in the summer of
2011, she re-created the 2005 Werner Herzog film *Grizzly Man*, a docu-
mentary about an amateur naturalist who goes to Alaska to live among
the bears. She worked on-site at a small natural history museum on the
grounds of an alternative high school and former orphanage, and asked
the school to help her find actors.

"It was supposed to be a musical starring a full cast of children," she told me. "They offered one twelve-year old girl. "They said, 'Please do this. She has nothing else to do. She's very nice.'"

Walling Blackburn's version, *Grizzly Man Again*, stars local youth Hannah Bouchard in a dual role. As Timothy Treadwell, the doomed nature enthusiast whose video journal forms the basis of Herzog's film, Bouchard films herself with a handheld camera on the grounds of the museum, reciting lines from the film as two bears (Walling Blackburn's fellow Skowhegan residents dressed in bearskin rugs borrowed from the museum's collection) mill about in a grassy field.

Later, in a performance inside the museum, Bouchard performs the role of Herzog. In front of a diorama with two stuffed white owls as footage of herself plays on a nearby screen, she reads the director's voice-overs in a wispy Bavarian accent: "Ve vere given access to Treadvell's last video tape . . ." A bear-costumed artist appears from the back of the room and looms up in front of her, growling. They collapse in a heap of screams and roars, to nervous giggles from the audience.

The artist Dave McKenzie, who taught Walling Blackburn at Skowhegan that summer, remembers that *Grizzly Man Again* was never actually *finished*, in any traditional sense, and remains so to this day. Walling Blackburn

Figure 5.3

is continually re-editing the videotape of the performance. "It just seems like it's always bubbling. It's done, but it's not done," he told me. But then again, the whole business of re-creating the Herzog film might just have been a device that allowed Walling Blackburn to get at another subject matter altogether: the emotional dynamics between collaborators in a work of art.

"For Mary, the relationship is always, from the beginning, one that could fail—and fail in the most antagonistic way," McKenzie said. "You get the sense that when she worked with this young girl, the young girl might get *scarred* a little bit. Maybe she's not ready for Mary."

Antagonism comes to the fore in a long middle segment of *Grizzly Man Again*, in which the narrative is interrupted while Walling Blackburn interviews her twelve-year-old star. She wants Bouchard to talk about the different kinds of danger posed by wild animals, children, and adults. Hannah doesn't want to play ball, and Mary gets audibly frustrated. "It's all so vague. It doesn't tell me a story, so I don't know what it means," she says off-camera.

Mary is leading Hannah to a discussion of their safety monitor, a man named Steve who has been assigned by the museum to observe the two as they work.

"Why do I always have to have a monitor?" she asks Hannah.

Hannah smiles nervously and looks away. "So they know where you are," she replies.

Hannah clearly knows the answer, but doesn't want to give it: Steve is there to make sure that Mary, a grown-up of unknown provenance, doesn't do anything unseemly with a twelve-year-old girl during the production of an art film. When the *Grizzly Man* re-creation resumes, we're uncomfortably aware of the power relationships involved in the making of the work: between adults and children, and institutions and artists—and the awkwardness of seeing a grown man in a bearskin rug tackle a twelve-year-old girl in front of an audience of adults.

IN LINE WITH the reductive tendency of the art of the 1960s, many early works of performance art were concerned with stripping away the mediations separating an artist from her audience. The art object, and the

formality of the theatrical context, were removed in the name of a direct and affecting *immediacy*. This notion persists in the received image of the performance artist as someone whose experience, emotional or physical, is made accessible to the viewer. Audience participation is framed as a kind of communion; Abramović's recent MoMA retrospective was pointedly titled "The Artist Is Present."

In Walling Blackburn's performance work, experience is conceived as an absence. It has happened elsewhere and often in the past and must be conjured up in the present through scraps of language and borrowed context: soldiers' jokes, translated texts, reconstructed footage. Participation is on the order of reenactment.

In Brooklyn, Mary had asked me if I knew any psychoanalysts who'd be willing to act in a piece. It would maybe happen on public access television, but more likely she'd do it for a show that Natasha Marie Llorens from Bard was putting together at Ramapo College in New Jersey, later in the fall of 2012. Mary had been kicking the idea around for a while, letting it periodically drop off the to-do list, but now she seemed more enthused about it. "I still want this to happen, because last week I was reading about the polar bears eating the polar bears," she said.

"Wait—what?" I asked.

"Because they're at such an ecological end."

Reports of male polar bears attacking, killing, and eating cubs had been circulating on the Internet. One particularly gruesome photo from Manitoba, Canada, showed a traumatized mother bear dragging the bloodied head and spinal column of one of her offspring.

"I did see that," I admitted.

"And you probably tried to forget it," she said. "You're trying to emotionally survive."

In the performance, an analyst would counsel a patient whose only psychological problem was the inability to cope with the prospect of impending environmental collapse. Mary needed to find someone to play the patient too. "I don't qualify—I have too much else going on." She was

Figure 5.4

frustrated that she hadn't been able to stage the piece yet. "It will be realized in the fall . . . But I want it realized now! I looked at the polar bear picture and thought, I need this artwork right now!"

■ ■

AFTER THE DRAWING exercise, Mary asks us to leave our seats and check out her wares. The lecture's eponymous merch table is next to the door and holds a small collection of unlikely objects, all for sale. Her partner, the artist Rafael Kelman, is standing by to receive our money. We file past the table.

A dingy white T-shirt reads YOU ARE A WHITE TERRORIST in messy white acrylic letters. Next to this are two gray sweatshirts silk-screened with a painting of a male nude with long blond hair. Beside these, pieces of cardboard propped against the wall have stained, crumpled-up polo shirts stapled to them. Beneath each shirt, a scrawled text reads: *If I had known black and Asian people were going to buy my shirts, I wouldn't have made them. —Tommy Hilfiger.*

As we look, Mary explains that the cardboard–polo shirt piece was her proposed contribution to a social practice project in a survey exhibition: a

bulletin board listing goods and services available for exchange by artists and audience members. The Hilfiger quote was a hoax from an e-mail that had circulated the Internet in 1996. The piece, which she called "the worst object," was meant as "a critique of barter within an urban art elite."

Mary talks about the informal school she once ran, in which tuition could be paid through the barter system. She found herself dissatisfied with the possibilities of that economy: there she was, trying to support herself as a working artist, and in exchange for teaching, she'd be offered lasagna, mittens, and gift certificates for manicures. The aggressively undesirable, racist Hilfiger assemblage was a way to say—she tells us-"You don't want to give me what I really need, so I'll give you something you don't really want."

The school in question was the Anhoek School, which Walling Blackburn ran from 2009 to 2011. "Anhoek" is a Dutch-English-Siwanoy permutation of the name of Anne Hutchinson, a midwife expelled from the Massachusetts Bay Colony in 1637. Walling Blackburn named the school in honor of a woman whose banishing offense was to have espoused a controversial theological doctrine in evening discussion groups for the wives of Puritan colonists: a social practice artist 350 years avant la lettre.

Anhoek School was a series of seminars, with enrollments limited to seven students, on topics corresponding to what Walling Blackburn was thinking about at the time. The groups read French philosophers Jean-Luc Nancy and Michel Foucault, American feminist writer Chris Kraus, historical accounts of escaped slave colonies, *Our Bodies, Ourselves*. They watched Herzog's *The Enigma of Kaspar Hauser* (1974) and a horror movie called *Cannibal Girls* (1973), which had traumatized Walling Blackburn as a child. She did the first few Anhoek seminars at her home in Brooklyn. Later, she temporarily relocated to Austin, Texas, at which point the school was announcing itself more formally as "Experimental Graduate-Level Education for Women."

Its syllabi, however, read more like poems. From "Accidental Pornographies: The Visual Effects of the American Women's Health Movement Since 1970," January 2010:[6]

> Each class will be thematically organized around the vagina conceptualized as one of the following: Subject, Object, Site/ Specimen, Stranger, Animal, Flower and Volcano, Cannibal and Meal, Ghost/Zombie/Shape-shifter.

From class notes for a session called "The Human Bite":

> How the bite tasted:
> soft clean girl taste
> delicate, breaking
> tasted of opportunity
> slightly salty
> air

The artist Caroline Woolard, then a recent Cooper Union graduate, attended the first Anhoek School seminar, in 2009—"The Mutinous Classroom," dedicated to the possibility of nonhierarchical education. (Another participant, an activist and ex-student of Mary's from NYU named Sofía Gallisá Muriente, remembers that the seminar was actually called "Teachers Fuck Students.") Of the barter tuition system that led to Walling Blackburn's disenchantment with the model, Woolard said, "In order to participate, you needed to give her something. You could help in the garden, you could do all these different things. I think my job was to write a reflection or a report, which I delayed a month or more—I can't remember, but enough that she said that it was not acceptable, and that it failed.

"She is kind of a slippery person, and it was hard to tell whether she was actually upset or whether she enjoys being antagonistic and it's just a learning process for her," Woolard added. "So, I never know exactly how she felt, but she says it was a failure, and that barter doesn't work. And that's very meaningful, because it was a moment when she gave up on barter and I became enchanted with it." Woolard went on to start

OurGoods, the barter network to which Mary later submitted her mildly infamous Tommy Hilfiger piece.

Like performance art, the social-practice subgenre of the artist- or activist-run school had gone from an eccentricity at the margins of culture to a relatively popular phenomenon in less than a decade. As tuition in MFA programs spiraled upward, similar projects were cropping up all over the world. In 2014 in New York, you could take classes on economics, freeganism, or debt resistance (for free); Sichuan cuisine, tree identification, or soldering (for under forty dollars); how to write a nonfiction book proposal (in exchange for a mix CD or a bottle of water)—all from first-rate teachers, all without enrolling in a college or university.

So, by the time Walling Blackburn was wrapping up Anhoek in 2011, the organizers of other pedagogical projects were deciding whether to take, or not, the next step: to expand their audiences, put down roots, and try to become sustainable in the long term, even to contemplate the question of accreditation. Also like performance art, experimental education was now facing the prospect of its own institutionalization.

In an essay she published that year in the online journal *e-flux*, Walling Blackburn takes broad aim at this. Describing what she saw as the fetishization of institutions endemic to artists working in social practice, she poses a question of its miniature schools and ad hoc libraries, soup kitchens and summer camps: what were they really achieving, and why were artists so drawn to them? "Especially for Americans, the institution has become as natural as sky, land, and empire," she writes. "Nothing else exists. Or rather, we fail to imagine how we will fruitfully exist without imperial institutions."[7]

Roaming through the story of the first mental asylum in the state of Arkansas, an experimental hospital in postwar France, Nat Turner's slave rebellion of 1831, and an early-twentieth-century educator's work with autistic children, the essay finally comes to rest at a family story about Walling Blackburn's maternal great-grandmother Fanella, "who is thirteen years old and newly married" to a sharecropper named Jewel in 1930s Arkansas. In a dubious joke, Jewel blackens his arm with shoe polish and hides under the bed to scare his wife. Fanny, who is biracial and

attempting to pass as white, is not only scared but also terrified. The rest of the family "all laugh hysterically—and it is hysteria," she writes.

For Walling Blackburn, the chain of associations suggests the violence—physical or interpretive—involved in the formation of institutional categories of race, class, and gender. By extension, it proclaims the incommensurability of the problems posed by American society with the solutions offered by artists. She proposes a series of impossible or antagonistic artworks—"The Institute of Racial Passing," "The Bureau of Escape"—before landing on a self-implicating critique of social practice art: that its benevolence is usually limited to the sphere of the already privileged, and its potential for good works has been severely overstated. She writes:

> The artists who make pretend institutions (temporary schools, fake agencies, and so forth) rarely set out to invent little prisons or workable nuthouses that serve real people—really crazy, really violent. It is possible that artists are not equipped . . . As I do, these artists flirt with soft institutions, playing with the remains of madness—touching it lightly, quickly, and then moving away.

The scope and implacability of the critique runs the risk of seeming counterproductive to fellow artists pursuing similar goals. Woolard, whose relationship with Walling Blackburn seems to involve both mutual frustration and mutual respect, described their ongoing disagreement over the methods and aims of social practice.

"I think on some level you can make a bigness with people, and help each other," she said. "It *is* complicated, but [Mary] dwells on things in a way. My fear is that she's saying, 'It's just impossible, and therefore let's keep to the status quo.'"

Nevertheless, Walling Blackburn is clearly at home in the role of the gadfly. At "Experiments in Extra-Institutional Education," a 2013 summit of artists and activists involved in the DIY school movement held at the City University of New York, she wore one of her gray sweatshirts with the naked Andrew Wyeth portraits on them and read aloud a series of

challenging questions: "Do experiments cease to be experiments when they succeed? Is amateurism as a teacher a form of resistance? Do we care that the same people show up? Is the nature of a community contingent on exclusion?"

She declared, dramatically, that the Anhoek School was no longer in the business of offering classes; it was now committed exclusively to the administration of its own standardized test: the Anhoek Record Examination, or ARE, a "pedagogical perversion" of the GRE taken by most students seeking admission to graduate programs in the United States. Question 11 of the ARE's sentence completion section reads:

> The prisoner's weapons were confiscated by the guards and handed over to _____.
>
> ☐ their children
> ☐ their superiors
> ☐ the museum
> ☐ eBay
> ☐ the waste facility

■ ■

TOWARD THE END of the Pratt lecture, Mary asks, "Is there anything in particular that you came here to see, or you want me to discuss?"

"Are you getting compensated for this talk?" someone shouts.

"I actually *am* getting compensated for this talk, which is wonderful," she says.

"So you think," jokes the guy in the blazer who'd introduced her.

McKenzie asks her about failure: "You seem to revel in it." He describes the way her projects "wobble" from idea to idea with an elaborate gesture. "It's always like *this*," he says, sticking out both elbows, letting his arms hang down, and then rocking his shoulders from side to side. "Can you say more about that?"

"I want to be surprised by my own work," Mary says. "It's about wanting the work to change you, as hokey as it sounds."

"Do you accept barter for the merch table?" inquires the blazer guy.

THE WORK OF French philosopher Jean-Luc Nancy is a touchstone for many artists engaged in participatory art. There is no thinker more passionate about the need to rethink the category of community, especially in view of its near total eclipse in the political imagination over the past quarter century. There is also no thinker more painfully attuned to the miseries—philosophical, political, and even just practical—of getting people together in groups. For Walling Blackburn, who cites Nancy as a formative influence, the accent falls strongly on this second theme of his work: that collectivity, while essential, is nearly as much trouble as it's worth.

In his 2000 essay "The Intruder," Nancy describes getting a heart transplant and the protracted complications that followed the procedure: the debilitating side effects of the drugs needed to ensure that his body accepted the foreign organ, the debilitating cancer resulting from the drugs, and the debilitating complications of treating the cancer. It's not an uplifting story, but Nancy uses it to produce a brilliant, almost giddy meditation on the mixed intimacy and estrangement of the experience. "An intruder is in me, and I am becoming a stranger to myself," he writes of the feeling of walking around with someone else's heart beating in his chest.[8] He concludes that strangeness isn't vanquished by intimacy but is instead its shadowy double. Rather than the antithesis of community, estrangement is its precondition.

At some point on her research trip to the Middle East, Walling Blackburn's project underwent a transformation. She started out with the intention to retrace drug smuggling routes back to the United States, but she ended up on another path altogether. With Nancy's "Intruder" in mind, she decided she wanted to explore the absurd, outer limit of the concept of the stranger—"The Strangest Stranger," she called this. So, traveling with a videographer, Walling Blackburn looked for people who'd go on record about extraterrestrials.

"Everywhere I went, I would say, 'I'm looking for someone who has had an experience with *oofoe*,'" she said, employing the phoneticization for

"UFO" common in Turkey. "The strategy shifted with each person I came across. With some people I'll start off really soft, and I say, 'Can you tell me a story about any strangers you've ever encountered here?' And we'll talk about strangers. Then I'll say, 'An alien is a real stranger. Anyone have any encounters with aliens?' So it's just real slow, real talky. It takes a lot of time."

If by some stroke of luck she found someone who had encountered an alien, she would try to convince this person to reenact that experience: to help her understand the experience by re-creating it, physically, in the site where it had occurred.

This was a big ask, and naturally her success rate was nearly zero. The work was painful, humiliating—and being humiliated was a part of doing it.

Walling Blackburn and her videographer finally found a viable subject in Konya, Turkey: a local leather maker claimed to have had a run-in with space aliens. They visited man's shop, a tiny room with walls covered in newspaper clippings, upstairs in a shabby mall.

"We were there for hours," said Walling Blackburn. "He made me prove I was not with the government. Part of that was a hazing process." She was photographed in a ridiculous alien costume, a conical hat made of silver, quilted cloth; in the picture, she looks utterly miserable. The group then drove out to the site of the leather maker's extraterrestrial experience, in a small village outside Konya, to do the reenactment.

They filmed it a few times, at the end of a dirt lane flanked by brick walls. In the video, the leather maker, playing the part of the alien, walks back and forth, and at one point starts hopping, as he describes his experience to the translator, who repeats it ("They said they came here to talk . . . He thought it was kind of like theater. He didn't know what was happening . . . But he wasn't scared, at all"). At the end of the footage, Walling Blackburn and the leather maker walk off together toward the far end of the street.

But the video misses the crucial dramatic moment of the reenactment, Mary told me.

"He slapped me across the face," she said. "Because he said they, these strangers, had slapped *him* across the face. And I had said to him

that my intention was that, at the site of this exchange that had occurred years ago, he would be helping me understand *bodily* what he had understood. Hence, *pow*. Hence—*the assault*."

■ ■

AFTER THE LECTURE, I bought the T-shirt reading YOU ARE A WHITE TERRORIST from Mary's merch table. I paid ten dollars. Maybe I wanted to make her work into something easier to deal with: an art object, pure and simple, with no messy conceptual strings attached. A week later she e-mailed, "Have you worn the shirt yet?"

The shirt came with an interaction script. I was to wear the shirt in public until someone read its text aloud to me, to which I would reply: "No—you are." We would then exchange views on race and state violence.

For almost a year, YOU ARE A WHITE TERRORIST sat at the bottom of my T-shirt drawer, yellowish and speckled with what looked like rust. I ended up putting it on right at the end of T-shirt season, as I left to teach a painting class in Cambridge—very near, as it happened, to the site where the Caucasian brothers Dzhokhar and Tamerlan Tsarnaev are accused of killing an MIT police officer and hijacking an SUV after detonating a homemade bomb at the Boston Marathon.

Perhaps predictably, no one said anything. No one at my hotel when I checked in, at Chipotle, in the subway, or in my painting class. I had a moment of apprehension when I crossed the street in front of a fire truck loaded with firefighters. Otherwise, my day as a Mary Walling Blackburn project was uneventful; whether this proved or refuted her thesis was unclear.

That evening, I thought again about her work with respect to the field of contemporary art. Though many of her projects skirt the perimeter of that field, her position is nearly impossible to understand *except* as that of an artist. In fact, she's more like an artist than most artists are. The seeker, the revolutionary sloganeer, the critic of the critics—Walling Blackburn has embraced some of the most time-honored traits of the avant-garde in

an era when the avant-garde is the stuff of myth and has chosen to play out the role completely, with self-awareness but no irony.

I asked her once, over e-mail, about her creative influences. She wrote back, somewhat testily:

> I don't think I am one to tend to line myself up within a lineage of artists. I do see other artists do this, perhaps . . . primarily because they were traditionally schooled in an art school (as I was not) and are often asked to look for, embody and then reject influence within art canons . . . Institutionally produced artists, in general, seem more desperate for fame or to grant more empathetic agency, thirsty for public dialogue, and this seems to lead them to comparison and channeling.

Nevertheless, she produced a long list: the Mohawk midwife and environmental justice activist Katsi Cook; Dinah Young, an outsider artist from Newbern, Alabama; Benjamin Smoke, a musician and drag queen from Atlanta; the Swiss prostitute turned sex-worker advocate Griséldis Réal.

It was a romantic list, to be sure, and perhaps a grandiloquent one. It was also wildly ambitious: a reminder that art exists in a much larger cultural space than the narrow, circumscribed field of the professional art industry—and that we should expect more out of it than we're currently accustomed to. Walling Blackburn's most compelling proposition is that art can be a way to ask the biggest questions and to attend to the most immediate of human needs.

That summer, Mary and Rafael were living in a cabin on the grounds of a former commune in eastern Vermont, a few hours from where I live, on the western edge of the state. Rafael's family had moved there in the 1970s and stayed in the area after the commune failed. Mary was finishing some projects and putting together a residency application; Rafael was doing research on the commune and helping his brother build a solar house. They were having a baby; during the Pratt lecture, she told me, she'd had morning sickness.

She gave me a phone number and vague directions to Rafael's aunt's place (the cabin was deemed too hard to find): a house at the intersection of two roads, a barn, a valley with horses if they were out grazing that day. I set out from my house and got lost. My dashboard GPS refused to navigate, and Google Maps informed me that no such intersection existed just before my phone lost service. A woman at a restaurant told me to just keep going straight, and five minutes later I pulled up at a house with a barn and a little valley with horses, and Mary sitting on the back porch, typing at a laptop.

She said, "One thing that's good about being here and it being this beautiful is it reifies to me why I don't make beautiful work. We wake up every morning and there are these mists in the hills and the valley. I don't need to make things that are beautiful. There *are* beautiful things."

She'd been in San Diego earlier in the summer, on a research trip for an upcoming show at UC San Diego's University Art Gallery. She was planning to do an extension of her work in Turkey about strangers and *oofoes*. Sofía Gallisá Muriente flew in from New York to be her videographer, and the two went to Tijuana, where the project began in earnest.

They interviewed men at the Casa del Migrante, a mission for deportees, refugees, and migrants, and asked if anyone there would talk to them about strangers—not necessarily of the space-faring variety. They filmed two men who'd crossed to the United States from Mexico, through the Sonoran Desert, who described the constant mortal fear of the illegal border-crosser. Sofía and Mary had an argument over the filming. Mary didn't want to show the men's faces—she felt that representations of the human face in documentary film now served to dehumanize the subject; Sofía thought it was disrespectful *not* to show them.

They set out to visit some of the sites the men had described. They went to Ajo, Arizona. They met a pharmaceutical company representative staying at their motel who told them about a spate of arsons in the town, possibly drug-related. Mary and Sofía spent an afternoon with a man who drives around the desert in a truck with a trailer shaped like a flying saucer, pranking the border patrol.

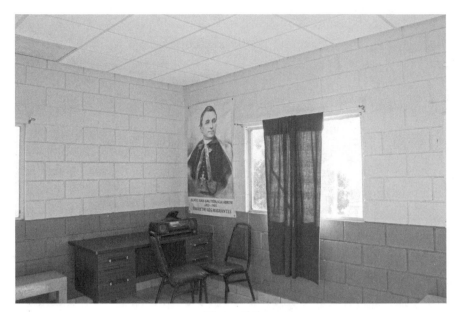

Figure 5.5

Predictably, Walling Blackburn's relationship with the gallery at UCSD was complex. They had insisted that she make a clear itinerary for her research trip, a timetable for production, and a plan for the exhibition; she didn't want to do any of those things. She wanted the work to be flexible, organic, open—an actual creative process, from beginning to end.

I told her something I'd read about Marcel Duchamp: he said that if someone wanted to have an argument with him, he'd just pretend to agree with them so he could get back to doing whatever he'd been doing before the argument. Couldn't she just *lie* to the UCSD people, go through the motions, so she could get on with her work?

"I'm not going to lie," she said. "Because I'm not. There's a certain kind of artist who's very willing to reassure you that it's all going to be fine, whether that person knows it or not. They've been coached to perform confidence. And that performance of confidence is . . . unsavory! I would prefer some humility. I would prefer some vulnerability.

"It *would* be a lot easier," she added. "I make my life very hard all the time. I used to fight everything. Now I fight, like, ninety percent of things."

6

THE END

ONE SUMMER SEVERAL years ago, I went to California to talk to the Conceptual artist Stephen Kaltenbach, who lives in Davis, a university town on the edge of the Central Valley.

I'd first heard about Kaltenbach from Bob Nickas, a curator in New York. Bob delivers a lecture, usually in art schools, on the topic of artists who stop working. There's Cady Noland, a well-regarded New York sculptor in her fifties who has refused to exhibit her work since 1992, and whose main interaction with the professional art world since that time has been to discourage anyone else from exhibiting her work either. And Gary Beydler, an experimental filmmaker from Los Angeles who, in the mid-1970s, painstakingly edited a year of footage into a magnificent sixteen-minute cinematic walk from one end of the Venice Pier to the other. In 1976, Beydler screened the film in a gallery to little interest; nobody wanted to buy it, and nobody wanted to show it anywhere else. Figuring that this was the best film he was capable of making, and if people didn't like it, well, *fuck them*, he quit. He was thirty-two.

There's Lee Lozano, a painter and Conceptual artist active in New York in the late 1960s. In '71 or '72, after conducting a series of increasingly drastic "life-art actions," as she called them, she began to perform

her *Dropout Piece*—her gradual but complete withdrawal from all social and professional interactions with the New York art world. In her notebook, she wrote: "Drop out from world, no calls no work no obligations no guilt no desires, just my mind wandering lazily off its leash. This evidently it [*sic*] the only way to take a rest."[1] She continued to perform the piece, in private, of course, until her death in 1999. There's also Lozano's close friend, Stephen Kaltenbach, who fits halfway into Bob's dropout canon: he quit, but he never stopped.

The funny thing is, *most* artists quit working. In fact, if you take into account all the post–art school artists who give it up after a few fruitless years kicking around Silverlake or Bushwick, and the artists who get married and have kids and get a full-time job to pay for them, and the ones who get sick of being poor and go back to school for retraining, and the ones who simply get sick, and/or drop dead, then you realize that, statistically speaking, quitting making art is practically in a heat with starting to make it in the first place.

So for Bob's audience, art students trying desperately to drop *in* to the art world, to beat these long odds and thrive in a chancy, often-alienating industry in an era when to be alive is to be networked, the phenomenon of people voluntarily cutting themselves off from art's social and professional systems is darkly romantic and puzzling.

KALTENBACH WAS BORN in Michigan and attended the University of California, Davis, where he was a classmate of pioneering sculptor and video artist Bruce Nauman. When he moved to New York in the late sixties, he was almost instantly absorbed into the downtown art scene. He participated in important shows like "Information" at MoMA and "When Attitude Becomes Form" at the Kunsthalle Bern, watershed moments in the development of Conceptual art. He had a solo show at the Whitney in 1968.

He was known, then, for works he called "time capsules": steel or aluminum cylinders, contents (if any) unknown, engraved with specific instructions as to when, under what circumstances, and by whom they

Figure 6.1

could be opened. A set of three, one-foot-long milled-steel capsules from 1967 reads:

MUSEUM OF MODERN ART
TO BE OPENED AT THE REQUEST
OR DEATH OF STEPHEN KALTENBACH

BARBARA ROSE
PLEASE OPEN THIS CAPSULE
WHEN IN YOUR OPINION I HAVE
ATTAINED NATIONAL PROMINENCE
AS AN ARTIST
STEPHEN KALTENBACH

BRUCE NAUMAN
RETAIN POSSESSION OF THIS CAPSULE
DO NOT OPEN UNTIL NOTIFIED

"They possibly contain things and possibly they do not contain things," he told Cindy Nemser in a 1970 *Artforum* interview. "I don't say anything about their content, or that there's any content at all, because I found out the concealment of information is as primary a function of the capsule as preservation."[2] Thus far, all of Kaltenbach's time capsules have remained sealed. One owned by the Allen Memorial Art Museum at Oberlin College was supposed to be opened in 2000. But the capsules don't have rivets or a screw-off lid or any other latch mechanism; they're welded shut. You'd have to take a hacksaw to them, or more probably a torch, to get at their contents. From an archival standpoint, this is a major drawback, and so, institutions have evidently decided to just leave the things intact.

Kaltenbach was *not* known for a series of advertisements he placed anonymously in *Artforum* for one calendar year, 1968–1969. In big, friendly block letters, nestled among the exhibition announcements and art school advertisements, Kaltenbach's ads offered the reader sage bits of advice like *Trip, Smoke, Start a rumor, Tell a lie, Perpetuate a hoax*, and *Become a legend*. Then, in 1970, at a crucial point in what looked like a promising art career, he vanished.

He wasn't alone — 1970 was a banner year for dropping out in America. Artists fled the art world in droves to become activists, academics, or entrepreneurs; rock musicians killed themselves with drugs; hippies left the city to grow vegetables organically in New England. Kaltenbach's personal version of the void was Sacramento, California, where he moved to teach at the state college. In the early seventies, when even Los Angeles felt like a remote outpost of the art world, Sacramento was about as far from the action as you could get.

When he moved back to Northern California, Kaltenbach become an entirely different kind of artist. He switched from gnomic, barely there Conceptualism to lush paintings and decorative public sculptures, of the type scorned by the international avant-garde he'd recently forsaken and beloved by people who hate that hoity-toity shit. And over the four and a half decades he's been there, he's gotten pretty good at it. He has built

a substantial reputation as a "regional artist" (as he puts it), to the point that, up until very recently, his public profile in Sacramento wasn't so much Stephen Kaltenbach, the historically important Conceptual artist, as Steve Kaltenbach, the guy who made the big fountain in the front of the convention center.

But the really interesting thing about Kaltenbach is that all of it (withdrawing from the professional art world, living in obscurity while making the "wrong" kind of art) could be considered, as per those mysterious *Artforum* ads, something between a lie, a hoax, and a legend—or to put it in terms the artist himself suggests, a life's work of Conceptual art planned in 1968 or 1969 and executed over the course of nearly half a century.

So in 2010, when a small gallery in Los Angeles put together an exhibition of Kaltenbach's work that purported to spill the beans on this alleged forty-year meta-masterpiece, people took notice. Around the same time, the artist spoke on camera to an interviewer from a local art magazine about his disappearing act. In the video you see Kaltenbach, who has short gray hair and white stubble and is wearing a blue dress shirt, talking to the off-camera interviewer over the unmistakable golf-crowd murmur of an art opening.

He's in the middle of describing a piece he did in the late sixties in New York, a "life drama" in which he made a bunch of amateurish paintings and tried to get them shown in the Lord and Taylor department store. This led him in a roundabout way to "go for a big project," as he says in the video, which was "to duck out of the contemporary art world and move to the boonies" and reinvent himself.[3]

"This is what I referred to as 'hyperrealism,'" he continues. "Because this life that I've lived for the last forty years is not an artificial life. It's truly me. It's expressing a part of my aesthetic that I wasn't expressing directly in my contemporary art. But I mean, there were things like, I got married and had children—and that wasn't all just a put-on. It's a real thing. I became a Christian. And that wasn't a joke."

"*Really?*" blurts the interviewer, clearly caught off guard.

"Yeah. I'm sorry," he says, laughing. "That actually happened to me."

Bob told me that Kaltenbach has been getting a lot of curatorial attention lately and strong interest from the museum sphere. After a hiatus from the contemporary art world that Kaltenbach predicted would last one decade, tops, but which went on for over four, he's being reinstated as a contemporary artist in good standing.

■ ▪

IN LOS ANGELES I stayed with my friends James and Susan, two young arts professionals. James was working on and off in galleries and dealing some art on the side. Susan had just lost her job at the Museum of Contemporary Art (MOCA); she was caught up in a bloody internecine feud between its senior curator, the beloved local hero Paul Schimmel, and its new director, Jeffrey Deitch, the former New York dealer turned aggressive museum re-brander. During the week I was there, LA was awash with unemployed curatorial assistants. They were applying to Ph.D. programs in the morning and going to the beach in the afternoon.

On the drive to their apartment in Culver City from LAX, James and I caught up by cheerfully trashing some of the artists who live in LA: the narcissistic photographer who doesn't go anywhere without an entourage of graduate students, the sculptor who kicked around for a decade before beginning to show and then getting suddenly, to our eyes unreasonably, famous.

"I heard that guy had a nervous breakdown after grad school, that's why he waited to have a show," I said.

James waved this off. "Practically every LA artist has had a nervous breakdown at some point."

I tried to explain my desire to meet Kaltenbach. Most artists, I said—not just the maladjusted or dyspeptic ones—harbor some desire to drop out of whatever version of the art world they happen to operate in, and they usually have a pretty good idea how they'd do it and what they'd do afterward. These fantasies of career suicide (what else can you call it, really?) allow them to continue working in an occupation that, even in

the best of times, is unstable and filled with anxiety. At one point I myself entertained the idea of trying to make a living as a pet portraitist. But after some Internet research, I decided that pet portraiture was probably a more cutthroat industry than contemporary art; there are a lot of seriously good cat painters out there.

So here was a guy, Kaltenbach, who actually *carried out* this fantasy. He'd ridden into the sunset, gone to the dark side of the moon, entered the black hole — pick your metaphor. But at the same time, he was still in contact, and he seemed willing to talk about his experience. So, he presented a unique opportunity to see *what it's like* in the sunset, on the dark side of the moon, or in the black hole. James, whose own professional exit strategy was to quit shilling contemporary art and open a radio-controlled car shop in Oregon, saw the beauty of this and agreed to drive me around for my pre-Kaltenbach warm-up interviews.

The next day, a Saturday, we went to the Pacific Design Center to meet Kaltenbach's gallerists, David and Cathy Stone. The center ("the ugliest building in LA," as Susan had pronounced it) was closed for the weekend. A man in a security kiosk directed us to a set of escalators beyond a corridor lined with empty furniture showrooms. The Stones' gallery, Another Year in LA, was the only illuminated space along a darkened hallway of glass-fronted shops on the second floor.

The Stones are a well-matched couple in their mid-fifties, both dressed that day in art-dealer black shirts and dark jeans. Cathy's mass of blond hair was tied up in a ponytail; David could be a character-actor playing a gruff but good-natured Los Angeles police detective. Both David and Cathy had studied at Sacramento State in the seventies, where Kaltenbach had been their teacher. They remember him in those days as a nice, somewhat drug-addled guy and a laid-back art instructor.

"He was not a very difficult teacher," David said. "Anyone could have gotten an A from him. He was just doing his thing." Though he kept a low profile, every so often Kaltenbach would let slip a surprising pronouncement about his stature as an artist — surprising for a guy teaching at Sac State, a fine institution with a serious art program but by no

means the epicenter of the international avant-garde. "I remember one night we had gone to somebody's party," David said, "and walking back to his truck, we were just talking about his work, and he says, 'History will remember me.'"

Cathy stayed on to teach in the art department after she graduated, and over the years the three became close. In 2004, the Stones moved to Los Angeles, first to be artists and later to operate a gallery; one of the first shows they did was a small survey of Kaltenbach's work.

David said, "One day I was looking at *Artforum* and somebody had 'rediscovered' somebody, and I thought, my God, somebody's going to do this with Kaltenbach. We might as well be the ones—we *know* him."

The Stones led us into the gallery's storage room, to look at some of the Kaltenbachs—a set of objects so diverse that, if you didn't know otherwise, you'd assume were the work of five or six different artists. We passed a basketball-size hole excised from a wall about a foot below the ceiling and lined with gold-painted ceramic, and a small trash can filled with crumpled-up drawings—*Petit Salon des Refusés* proclaimed an inscription on its lid. They showed us a blueprint rendering for one of the artist's "Room Constructions" and a dollhouse-size wooden model of the same piece: a square room with a smaller cube set inside it, leaving an eighteen-inch-wide space for the viewer to walk around its inner perimeter. The piece had been built at the Whitney Museum in 1968 for Kaltenbach's show there.

David pointed out a framed paper stencil, the words NOTHING IS REVEALED haloed in blue spray paint. Cathy unwrapped an inkjet-on-canvas reproduction of one of Kaltenbach's paintings from the Lord and Taylor department store series. He had given away all but one of the originals; this reproduction had been made from a grainy slide. It showed the head of a woman with dark hair reclining on a table behind a vase of flowers, rendered with the clumsy strokes and chalky colors of a dedicated but inept Sunday painter.

"Where's *Blood Money*?" David was rummaging around in a cardboard box full of tissue paper for one of Kaltenbach's early works. He

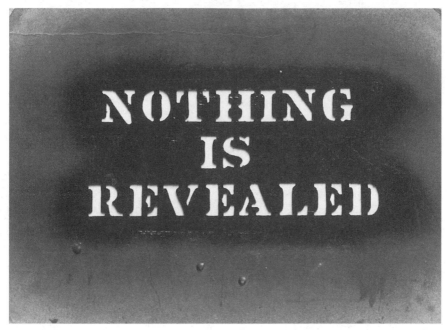

Figure 6.2

pulled out a ziplock bag with an inkpad and a rubber stamp in the shape of a pair of lips—the artist's. "He used this on a Fruit of the Loom ad." Triumphantly, he unwrapped a twist of paper and held up a small, brownish disc in a plastic sleeve. "It's a Kennedy half dollar cast in his own blood and acrylic medium. He had some doctor friend extract the blood."

Cathy spotted a sculpture on a shelf in the back of the room, a piece by one of Kaltenbach's alter egos: Clyde Dillon, an earnest but limited sculptor of abstract bronzes, things you might find in upscale but tragically conservative galleries in shopping malls. Kaltenbach had created the persona in New York and has sporadically made work "as" Dillon throughout the years. The Dillon, which David hoisted with some difficulty, was a lumpy, seventy-pound funnel; it looked like a bronze tornado.

David said, "He did two time capsules regarding Lee Lozano. This is *Lozano's Mind*." He showed us an oblong, highly polished steel box, about the size of a DVD player, with the words *LO, AN OZ* engraved

in block letters into its top face. Next, David produced a smaller, cubic capsule and held it up to us. Its front read "Kleines Kloster," which in German means "small monastery," and it had a tiny, tapered hole bored dead center between the two words, like this:

KLEINES

•

KLOSTER

As we talked, I realized that the Stones are not only Kaltenbach's art dealers but also perhaps the preeminent scholars of his work. David walked us through the artist's anonymous *Artforum* ads, which, he said, laid out Kaltenbach's entire career plan in aphoristic form. "Always go back to the *Artforum* ads," he said knowingly. "Think about that largest ad, 'Become a legend.' You can become famous, but that might not make you legendary. You become a legend when people have to look back and try to remember things. You have to kind of disappear for that to occur."

THE NEXT DAY we stopped in on Jon Pylypchuk and Paul Cherwick, two sculptors from Manitoba, Canada, who share a storefront studio in Los Feliz. It was so hot that we all sat in folding chairs between the metal-grille door and a box fan on full speed. Paul and Jon talked about having a pool party for their respective kids and a plan to get a game of art poker started; the participants, all LA artists, would ante with pieces of their work of comparable market value. Afterward we met Sarah Lehrer-Graiwer at a nearby restaurant called Little Dom's.

Sarah studied criticism and theory at Art Center and was working on a book about Lee Lozano's *Dropout Piece*. She had just returned from a morning's trip to the Orange County Fair and brought us copies of *Pep Talk*, her self-published art gazette. In 2009 she had devoted an issue to Kaltenbach.

Sarah became interested in Kaltenbach through his relationship with Lozano. He's a recurring character in Lozano's voluminous notebooks. In them, he's usually referred to as Kaltenbach—never Stephen or Steve—as

in, "I'll end the *Grass Piece* with a fanfare: a cap of mescaline Kaltenbach gave me."[4] The two were close friends in New York, and though they never saw each other after the mid-seventies, Lozano remains an important figure in Kaltenbach's thoughts. In 2009, Sarah visited Kaltenbach in Davis, and, as they were standing and talking outside his house, the artist paused and bent down to remove some bricks from a walkway. "He started digging with his hands, and the *Lozano's Skull* time capsule was there, buried in his backyard," she said.

During the time Kaltenbach lived in New York, Lozano was painting and performing life-art actions: prescribed behaviors carried out for fixed periods of time, recorded as sets of instructions followed by detailed notes. The notes paint a portrait of the downtown art scene as an endless, druggy hangout, in which everyone was constantly showing up in everyone else's art project. For *Real Money Piece* (1969), Lozano wrote: "Open jar of real money and offer it to guests like candy."[5] She performed it for ninety-seven days and noted that the painter Ron Kleeman took twenty dollars on April 15, the Minimalist sculptor Robert Morris refused to take any money on May 17, and Kaltenbach's upstairs neighbor, the painter John Torreano, didn't take any money on May 22, but he did take the jar.

Lozano mentioned something called a "Dropout Piece" only a few times in a thousand or so of pages of notes—and never in direct relation to any accompanying description. And since dropping out meant, ipso facto, ceasing to make or exhibit artwork, Lozano's *Dropout Piece* exists as a historical conjecture: she certainly dropped out—she stopped talking to people, and former acquaintances were later surprised to learn she'd been living with her parents in Dallas since 1982. So it stands to reason that there is such a thing as Lozano's *Dropout Piece*—though what *is* means, in this context, is still up for grabs.

The Lozano hagiography largely attributes her withdrawal to righteous anger toward the New York art world of the late sixties, with its misogyny and clique politics; Kaltenbach's can't as easily be chalked up to rejection. He had a steady teaching job and a studio in SoHo. He was in the Rolodex of influential private dealer Seth Siegelaub, and his work was being included in all the right shows. "He says it was extremely difficult for

him to leave New York," Sarah said. "He was in the middle of an intensely active and cerebral community that he'd never had before and would never have again, and he loved it."

In 2010, Sarah wrote in *Artforum* about Kaltenbach's "Elephant Project": the sum of his art from 1970 onward, made after his departure from the city. The paradoxical idea of the project is that of a unified body of work impossible to grasp as a totality. Kaltenbach has said that it will continue until he has a retrospective at a museum, at which point the game will be up.

The title comes from an Indian parable, in which a group of blind men grope an elephant and compare notes. One takes hold of the animal's leg and says the animal is like a pillar, one touches its flank and says it's like a wall, one grabs its trunk and says it's like a tree, and so on. Sarah wrote, "The work is so utterly convincing and faithfully carried out—like flawless Method acting or a one-to-one scale model—that it is basically imperceptible as art and suggests that being 'of art' may be beside the point."[6]

The thing about the elephant parable is, you could just as easily imagine that the blind men were standing around in a colonnaded courtyard with a tree in it and, in a kind of shared delusion, talked one another into the idea that it contained an elephant. The elephant must be posited. I asked Sarah if Kaltenbach's project might involve us in a similar epistemological error: *Is* there an "Elephant Project?" Did Kaltenbach really plan all of this out, or is he putting us on?

"People are skeptical about considering it intentional—maybe you guys are—and I'm not. There is plenty of material evidence that confirms such intentionality, and that kind of long-term strategy is fundamental to the way he thinks. You'll see when you meet him; he's an amazing guy. Seeing him in the flesh answers a lot of questions."

We left Little Dom's and headed back to Sarah's apartment so she could show us something that Kaltenbach made for her as a gift; halfway down the block she realized she didn't have her keys, so she described the work for us: a dollar bill, on one side of which the artist had drawn the word LOVE, and on the other, LEE.

■ ■

A WEEK LATER, I drove up to Northern California to talk to the artist. Kaltenbach and his wife, Mary, live in a Craftsman-style house in a narrow, alphanumeric grid of residential homes between the Amtrak station and the UC Davis campus. He greeted me at the door, enveloped in a radiant cone of pink light.

No he didn't—but I'll admit I had high expectations for the meeting, based on the reverential way that his friends in LA had talked about him. In an e-mail, David had told me that "he is a super nice guy and very forthcoming." Sarah said, "He has a grace about him"; and Cathy, in a transport of admiration, said, "He's the real deal. He's the real artist guy. He's like, *it*." So I'd driven from up Salinas, where I'd visited my mother, fantasizing about the idea of a totally elevated, Conceptual art guru living in an agricultural town in the Central Valley—the same exact kind of town I'd left twenty years earlier in snobbish, adolescent horror— amid the foreclosed tract mansions and flooded rice fields, surrounded by separatist ex-hippies, long-commute tech workers, and cattlemen in Range Rovers.

In fact he looked pretty normal. Kaltenbach wore a faded purple T-shirt and a pair of blue jeans. He had short gray hair, which missed the aggressive, older male New York artist's buzz cut by an inch or so—it looked monastic, not paramilitary—and a lot of stubble. He's tall and solid and has big hands and ears.

He took me though the house into the narrow backyard, where a couple of chickens pecked the dirt next to a concrete Buddha head as big as a prize-winning pumpkin. We peeked inside his studio, a tall, freestanding shed tucked into the back of the yard, before the afternoon sun made it unbearably hot. Then we went back into the house and talked in the parlor. The walls were hung with drawings of the Kaltenbachs' two children, Kate and Danny, and a painting of his from the seventies showing an iridescent tree dissolving into a pattern of interlocking circles. Kate's dachshund watched us from an ottoman in the middle of the room.

This was an August day with temperatures in the mid-nineties, so we began with climate and geography. He said he grew up in the foothills and preferred the coast. "They complain about no summer—great by

me," he said. He told me that he'd ridden through this area in as a child in 1947, on a similarly scorching day at the end of summer, and vowed to himself he'd never live in a place like this; now he loves it. "A nice town. Very conscious. Friendly." I told him that my whole family had gone to UC Davis to study agriculture. He said, "That's what it's for."

In conversation, Kaltenbach has a habit of changing topics almost in mid-sentence, calmly but without warning, like a driver turning sharply across lanes of highway traffic to take an exit ramp. Usually, after a minute or two, the purpose of the digression became clear and we returned to the main roadway—though occasionally we didn't and ended up on a completely different route.

For example, after we'd dispensed with the weather, he told me about a sculpture project he'd been working on: simple objects designed to interact with the architecture of a room and animate the space between the walls and the floor. These were inspired by two bodies of work he'd made while in graduate school in Davis, forty-five years ago. Then, he addressed the idea of densification, a city planning philosophy championed in many California towns of the Central Valley. Rather than expanding outward to consume more and more farmland, city planners prefer to build up the centers, filling in gaps between existing structures. Densification, when managed properly, can increase the efficiency of an urban area and reduce the cost of extending infrastructure to outlying zones.

After a beat, in which I must have looked at him blankly, he let me know that this was a metaphor for his current project. The new sculptures represented a densification of his early sculptural work, an effort to fill in the gap between two things he'd done in the sixties. He described this process as "looking at the line of my work, and looking at it sideways."

Many of the motifs running through Kaltenbach's art have their origins in his time in art school. He attended junior college in Santa Clara, California, where he met the Bay Area sculptor Bob Arneson and worked primarily in ceramics. He was drafted and spent a few years in military

service. When he was discharged, he found Arneson teaching at UC Davis and enrolled in the art program there.

He remembers his art training as informal—hardly the professional development curriculum it would become by the time he retired from teaching in 2005. "I was working one day in the studio, and Bob came in and said, 'Are you going to grad school?' And I said, 'Yeah I think so.' And he said, 'Well, where are you thinking of going?' and I said, 'Well, I thought I'd probably go here.' And he said, 'Okay.'"

At Davis, Kaltenbach and his classmate Bruce Nauman synthesized the Minimalist sculpture coming out of New York with the more hands-on approach of their professors, Arneson and the painter William T. Wiley. Kaltenbach remembers the young Nauman as a manic innovator, ripping through material variations on sculptural ideas over the span of months: first constructions out of reflective Plexiglas and aluminum, then oil paint smeared over welded tin forms (all of which the artist destroyed).

"Then he made this—it was probably the ugliest piece of art I ever saw," Kaltenbach said. "It was a post that basically flared out at the floor, and it was about three feet high and was made out of caramel-colored resin, a little bit drippy." The two artists picked up extra money by entering work in juried shows. At the Walnut Creek Annual in 1964, Kaltenbach's piece won second prize, and Nauman's entry was rejected. "But now, those kinds of works are in museums, and my piece is in the basement," he said, concluding what I imagined was a well-rehearsed anecdote.

While Kaltenbach was a student, the New York artist Robert Mallary came to UC Davis to teach a class. He gave his students an assignment: make a list of all the pieces of art you've ever made, starting with the most recent and working backward. Next to that, in two columns, write a physical description of each piece and a description of what you think it means.

For Kaltenbach, this was revelatory: "The main thing that came out of it," he said, "was that I was trying to evict data from my work. So there was less and less to look at. By the time I graduated, I was pretty much set to push Minimalism beyond simple sculpture."

He moved to New York City three months after graduating from Davis and hit the ground running. "When I took a cab into the city, I asked the driver to take me where the artists live," he said. The cabbie dropped him at Spring and Greene, in the middle of what would soon be SoHo—the neighborhood was still nameless in 1967. "There was a guy standing on a loading platform. He looked at me and he said, 'You looking for a loft?'"

The late sixties were a legendarily interesting time to be an artist in New York; downtown Manhattan was full of them. The art market was expanding but rents were cheap. "People would just lock themselves in their studio until they got stir-crazy, and then they could go out, do something, visit, whatever," Kaltenbach said.

John Torreano, Kaltenbach's upstairs neighbor in a building on Greene Street, described the scene as compact and vibrant: big enough to generate different subcommunities but small enough that everyone still hung out together. "If you were working in the avant-garde tradition, that was five hundred people, maybe," he told me. "If somebody had a party at a loft, mostly everyone was there: older, younger, dealers, collectors, artists, all dancing. As a result, it was easy to meet and engage with people whose ideas were completely different from your own."

Kaltenbach met Lozano, who'd been in the city since 1962, and she introduced him around. He met the art critic Barbara Rose and her partner, the prominent Minimalist sculptor Robert Morris. He hung out at Max's Kansas City. His girlfriend found work with a Quaker organization. An acquaintance from Davis got him a teaching job at the School of Visual Arts.

In New York, Kaltenbach started working by completing projects he'd begun in graduate school. These included his time capsules as well as a series of "Room Constructions," simple architectural interventions that could be built in any exhibition space. In one, the floor of a room is raised to half the height of its ceiling, leaving the viewer only a narrow entrance to the room at the top of its doorframe. In another, walls are extended from the perimeter of the door to a section of the wall opposite (its height

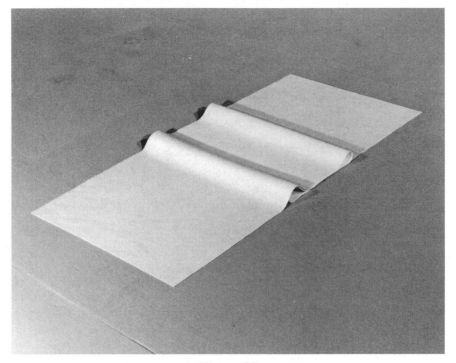

Figure 6.3

equal to the width of the door), creating a wedgelike space for the viewer to occupy. He built a few; many more simply exist as blueprints.

He made fabric sculptures, first in canvas and then in felt. The idea was to exert less and less creative control over their appearance. First he specified the shape of the piece of fabric and the way it was to be folded for display. Then he specified the shape but gave the exhibitor or collector different options for arranging it. Finally, for the traveling exhibition "Soft Sculpture," curated by Lucy Lippard, he bought a piece of fabric and told exhibitors to just do whatever they wanted with it. "Why should I impose my California–New York aesthetic on how this thing should be folded when the piece is going to be shown in Vermillion, South Dakota, or Ithaca, New York?" he asked art historian Patricia Norvell in 1969.[7]

As it happened, Kaltenbach's early artistic goals—to evict data from his work, to push past the limits set by Minimalism—were shared by a lot of

artists working in the mid- to late sixties, in New York and elsewhere. He showed up during a period of rapid general mutation in the art world, manifesting in a plurality of forms but sharing a distinctive orientation. The late fifties and early sixties had seen an explosion of concurrent trends in avant-garde art practice: Pop Art, Minimalism, Color Field painting, the Neo-Dada experimentation of Robert Rauschenberg and Jasper Johns. In magpie fashion, younger artists picked up certain aspects of these forms and discarded others: Minimalism's aversion to the hand-made minus its premium on physicality; the simple geometries of Color Field without its decorative appeal; the Duchampian linguistic games of Rauschenberg and Johns detached from their investment in painting; Pop's advertising sheen with no image to advertise. Within a very short time, a cluster of terms were proposed to identify this loose constellation of related tendencies: Process art, Serial art, Anti-Form, Systems art, Idea art, and—ultimately beating out all other contenders as the definitive name for the genre—Conceptual art.

The most noticeable trait of the new art was how little there was to look at. In 1966, Mel Bochner organized an exhibition at the Visual Arts Gallery in New York consisting of Xeroxed artists' drawings collected in loose-leaf binders set atop pedestals. In 1967, Lawrence Weiner excised thirty-six square inches of plaster from a wall to expose the wooden lathing underneath. In '68, Robert Barry exhibited a roomful of electromagnetic waves generated by a battery-powered transmitter hidden behind a wall of the gallery.[8]

In the mid-sixties, New York art discourse was still dominated by the formalist criticism of pioneering Modern Art champion Clement Greenberg and younger disciples like historian Michael Fried. In their opinion—which counted for a lot—the meaning of the work of art should be found in its visual and material properties, with no recourse to other information—biographical, theoretical, or otherwise. The very best art, which in the mid-sixties meant big, simple abstract paintings and geometric sculpture, provided the viewer with a self-contained, self-explanatory aesthetic experience.

Conceptualists pushed against this tendency; the aggressive non-visuality of their art ensured that no one could interpret it formally. If there was nothing to see, viewers would have to look elsewhere for the meaning of the work: toward the idea. The stray bits of stuff on display—the Xeroxes, binders, pedestals, photostats, words, absent plaster, even the electromagnetic waves—weren't the art. Rather, they were places that art temporarily lived, like shells occupied by a roving, metaphysical hermit crab.

A 1968 article in *Art International* by Lucy Lippard and John Chandler glossed this phenomenon as "the dematerialization of the art object": a process by which the physical attributes of the artwork receded in order to foreground its ideational content. They saw this reductive process as the clear historical trajectory for avant-garde art, one that paradoxically generated new possibilities as it approached total self-dissolution. "Has an ultimate zero point been arrived at by black paintings, white paintings, light beams, transparent film, silent concerts, invisible sculpture . . . ? It hardly seems likely," they concluded.[9]

Because it wasn't seeable, Conceptual art wasn't beautiful. But by that logic, it wasn't particularly ugly either; in fact, it seemed to have very little to do with aesthetics—art's usual bailiwick—at all. "From the Conceptual standpoint, material properties and esthetic qualities are secondary and could be dispensed with," wrote artist Ursula Meyer in her introduction to a paperback anthology of Conceptualist essays and projects.[10] Joseph Kosuth, the movement's most garrulous practitioner-theorist, went so far as to state that art should be completely divorced from aesthetics, full stop. Conceptual art was the inheritor of the legacy of analytical philosophy, he declared in 1969. As such, there was no logical reason why it should concern itself with questions of taste or decoration. Instead, as he put it, "being an artist now means to question the nature of art."[11]

When the thingness of art receded from view, what appeared was information—all different kinds of it—and the varying ways it could be documented and presented. Artists exhibited statements, photographs, charts, graphs, books, and architectural renderings, all of which served

to indicate something—an action, an event, an idea, a fact about the world—not otherwise presentable by means of the traditional art object. Hanne Darboven generated numerical visualizations of time spans from the permutation of calendar systems. Weiner specified simple activities, like throwing a rubber ball into the sea or pouring a quantity of house paint onto the floor, and insisted that, as works of art, they were identical whether performed or simply written down. Adrian Piper mapped her movements through space in complex arrays of graphic and textual notation, turning quotidian activities—meditating, eating breakfast, reading the newspaper—into data for analysis.

These ideas and tendencies had different political or ideological valences depending on whom you talked to. Critic Gregory Battcock saw in the dematerialization of the art object "a rejection of the 'bourgeois' aspects of traditional art" in line with the anti-establishment tenor of contemporary leftist movements (the student rebellions of May 1968, anti-Vietnam activism).[12] Meyer noted Conceptualism's "disdain for the notion of commodities" and suggested an anti-capitalist agenda at work in artists' refusal to make aesthetic goods.[13] John Perreault, a critic for the *Village Voice*, read the work more neutrally, as a reflection of a changing mode of production: "Is it so surprising that in a time when postindustrial ephemeralization is rampant, when information bits are speedier and more important than heavy matter or face-to-face contact . . . that artists everywhere should come up with Conceptual Art?"[14]

Despite the strongly anti-aesthetic stance of much Conceptual art, it had an unmistakable look and feel. Its vibe was generic, ascetic, clinical, neutral. Its artists wore black and looked pensive and rigorous in press photographs—not like they were crazy or drunk or suffering. Personal expression was out; polemics and propositions were in. Existentialism and phenomenology were out; linguistic philosophy and the history of the sciences were in. Graph paper and tape recorders were in. Marshall McLuhan's media theory was *kind of* in.

Writing was also in—way in. An art of neutral documentation and abstract content required a lot of explanation; the first thing advocates

needed to get across to a general public was why nothing looked like art anymore. The artists themselves produced most of it, to the joy of some and the consternation of others. "The dematerialization of the object might eventually lead to the disintegration of criticism as it is known today," Lippard and Chandler wrote somewhat ambivalently.[15] The British group Art & Language worked almost exclusively in text, publishing a journal devoted to an articulation of its complex position. Kosuth took on a pseudonym—Arthur Rose—and published interviews with leading Conceptual artists, including himself. ("Being an artist now means to question the nature of art" first appeared in one of these auto-journalistic exercises; he later quoted himself interviewing himself in his seminal essay "Art After Philosophy I.") Conceptualism produced far fewer things than art movements usually did, but it generated more text in six years than the entire Académie des Beaux-Arts did in the nineteenth century.

LIPPARD WAS AS quick as anyone to point out the fact that "dematerial-ization," or any such term trumpeting the ephemeralizing qualities of Conceptual art, could be misleading. (Kaltenbach's time capsules, for example, are certainly material objects: they're heavy, they have color and texture, and one of them currently displaces a certain volume of air somewhere deep within the storage facilities of the Museum of Modern Art.) Dematerialization was also an expansion of artistic media. Rather than limiting themselves to paint, clay, or wood, artists could work in *anything*: radio waves, mathematical equations, conversations, dinners, political actions, clouds of smoke, trees, telegrams, sociological surveys, nature walks, secrets, hoaxes. In 1968, Agnes Denes planted rice and buried a tablet engraved with haiku in a field in Sullivan County, New York. In 1969, Robert Barry submitted an idea to an exhibition through the medium of telepathy.

For Kaltenbach and others, these new forms of art required new ways to get it to an audience; the question of art's place in the world became inseparable from the question of what it meant or could do. "I had an

epiphany that the gallery-museum atmosphere put a barrier between the viewer and the art," he told me. He participated in a series of exhibitions of "Street Art," which involved a bunch of artists running amok in SoHo on specified evenings, trying to break down the fourth wall between the gallery space and the audience. Kaltenbach's interventions were characteristically droll and minimal. He had a series of bronze plaques fabricated bearing single words—FIRE, WATER, BLOOD, FLESH—and set them into the sidewalk. They were meant to resemble normal street hardware, like hydrant markers or dedication plaques for buildings, or the paperweights holding down stacks of magazines at a newsstand.

One day, Kaltenbach walked to work at the School of Visual Arts and saw a little glyph drawn on the side of a building, in black ink or paint— "like hobo graffiti," he said—and decided to get his art completely out of the gallery situation. He started spray-painting walls with cryptic phrases (like NOTHING IS REVEALED, the stencil for which I'd see forty-four years later in Los Angeles), or rubber-stamping his lips onto the legs of a model in a Fruit of the Loom ad on the subway. He made circular badges with rainbows on them, thinking of them as insignias for nonexistent movements (the gay pride flag was years in the future), and handed them out to people.

Such dispersals of the aesthetic into the everyday responded to a nagging condition of the art experience: despite having been smeared across a spectrum of material possibilities, from conversations to Xeroxes to shots fired at a wall with a pellet gun, the work of art was still held firmly together by its institutional and discursive matrix. In other words even if art was no longer something you could see, you still knew it was art because you did the not-seeing in a gallery. Whereas, Kaltenbach said, "when you were out on the town, you could see something and it could operate with your consciousness in a more free way."

KALTENBACH'S INSPIRATION FOR the bronze sidewalk plaques was an early Bruce Nauman piece, he told Cindy Nemser in 1970. "I like Bruce's thinking and use a lot of his ideas," he said. "Usually it's pretty much

unconscious."[16] In previous formations of the avant-garde, this kind of admission would have been a form of career suicide: the premium on originality was too high to go around proclaiming yourself a follower. Picasso and Braque weren't important because they were the best Cubist painters, but because they were the *first* Cubist painters. And even in the context of late-sixties art practice, in which the Modernist ethos of the pioneering individual artist was giving way to a hipper, more nuanced attitude toward innovation, Kaltenbach's candor was disarming. But it also signaled what would become a career-long theme in his work: the idea that influence could be a mode of art-making.

In the same interview, he discussed his relationship to Robert Morris. Both he and Morris had been making fabric pieces, and both were interested in the idea that fabric lent itself—unlike steel or ceramic—to potential reconfiguration by a viewer, exhibitor, or collector. The problem was that Morris was an older, more-established artist whose work Kaltenbach, the new kid on the block, was inadvertently repeating:

> Bob Morris has been a large part of my art ego. It started in California. We were duplicating each other's work a lot. I was hearing a lot about him, and seeing his work constantly in *Artforum* made me feel very ineffectual and I was very much concerned with that kind of thing.[17]

As a late-arriving, provincial transplant to the world capital of contemporary art, Kaltenbach may have felt the anxiety of influence more keenly than most. But it's also true that the perennial problem of originality was good grist for his Conceptual art mill—and that many artists at this time were also grinding it up along with other once-sacred aesthetic qualities. Originality, like visuality, was now an optional feature of the work of art.

Conditions were ripe for tweaking the Modernist model: a type of art emphasizing generic forms over unique personal styles is inherently likely to create repetitions. A checklist for "955,000," a Lippard-curated exhibition, notes that the show included, by different artists: two books on a table, eight books on a table, two books on a stand and one book on

the wall, forty feet of rope on the floor, and fifty feet of rope on the floor. This led to the attendant problem of differentiation: how do you tell one artist's length of rope on the floor from another's? Is there a point at which you give up trying?

What's more, ideas were often unwittingly shared between artists; Robert Barry's interest in the telepathic transmission of ideas seemed to have some evidentiary merit. In New York in 1968, Kaltenbach did a series called "Personal Appearance Manipulations"; for one of these, he walked around the city wearing mirrored contact lenses. Later, he learned that an Italian artist, Giuseppe Penone, had done the same thing in Turin in 1970. "A lot of the art thinking that was happening worldwide was sort of growing together," Kaltenbach said. "The same things were happening all over the world."

The utopian angle here was that Conceptual art could reconfigure the relationship between uniqueness, originality, and value—that the economy of ideas would turn out to have different rules than the economy of objects. It also presented a critique to the methodology of art history, that vast ledger of credits and debts by which we assign value to artists and their works. It just didn't make sense to chart the transmission of ideas in the same way one traced the development of perspective in Renaissance painting. "The art historian's problem of who did what first is almost getting to the point of having to date by the hour," wrote MoMA curator Kynaston McShine in 1970.[18]

Lippard and Chandler hoped that Conceptual art would call forth a critical response based on "creative originality" rather than "explanatory historicism."[19] In such a situation, one might move from the rigorous accounting of historical analysis to a more fluid mapping of intellectual affinities based on the principles of reciprocity and free exchange. "Pass on ideas. Never mind who gets the credit for them, you rival rabbits. Give away your ideas," Lozano wrote in 1970.[20] Or as Kaltenbach summed it up for Nemser, "I'm influenced, others are influenced by me, and I in turn am influenced by them—groovy." For the 1969 "Art by Telephone" exhibition at the Chicago Museum of Art, he gave the

Figure 6.4

museum preparators instructions to make a piece identical to one made a year earlier by Walter de Maria.

Kaltenbach found the physics of influence to be an even groovier field of study than its economics. How do ideas propagate in the first place? How is it that their transmission sometimes seems to violate the laws of time, space, and causality? Kaltenbach wondered if this process could actually be a form of art itself.

When he arrived in New York and showed his slides to Barbara Rose, who told him that he and Robert Morris were barking up the same

tree, ideawise ("She kept saying, 'Bob did this. You gotta meet Bob!'"), he arranged to exchange studio visits with the Minimalist sculptor. As a kind of subtext to the encounter, he tried to see if he could get Morris to change his art: to plant an idea in his head and wait for it to germinate in an artwork. Whatever resulted from the experiment would, in a sense, be both a Robert Morris sculpture and a Stephen Kaltenbach piece— something he named a "Causal Work": an artwork consisting *only* of the transmission of an idea between two subjects, with no material substrate whatsoever: a perfect piece of Conceptual art.

If it isn't abundantly clear yet, Kaltenbach and his colleagues were also into drugs. They used drugs both recreationally and as a creative tool, and usually in some combination of the two. This was nothing exceptional—drugs were to the art world as wigs are to the opera—but the procedures of Conceptualism provided a new basis for their incorporation into artistic practice. The taking of drugs could be treated as an action to be documented, analyzed, and presented within the work of art. From 1965 to 1967, Adrian Piper made a suite of paintings about, and sometimes while on, LSD. In 1966, Dan Graham produced *Side Effects/Common Drugs*, an infographic table listing everything from phenobarbital to Dexedrine and what it did to you. In 1969, Lozano performed several dope-centric life-art actions: *SDS Piece* ("Do three identical paintings: stoned, drunk, sober"), *Grass Piece* ("Stay high all day, every day. See what happens"), and *No Grass Piece* (you can guess).[21] The unique contribution of Conceptualism to the practice of drug use was to subject it to a critical self-assessment, a clinical-aesthetic trial. Many Conceptualists got stoned, but they got *rigorously* stoned.

To preemptively counter the idea that Conceptual art, in its very far-outness, was simply an epiphenomenon of the drug culture (and thus easily dismissed), Siegelaub mounted an aggressive image-management campaign. Conceptual art was a movement of future-oriented thinkers who jettisoned the baggage of the past and embraced an ideology of progress. The Conceptual artist was a serious young man: his beard was the

dignified beard of the intellectual or the research scientist, not the ragged scruff of a dope fiend.[22]

This characterization of the movement, in line with the self-image of an emerging technocratic elite, was brilliantly pragmatic: Siegelaub had accurately pegged the emerging technocratic elite as an untapped reservoir of potential art collectors. He cultivated individual and institutional patrons in the corporate world, at one point founding a public relations firm that encouraged companies to collect and display contemporary art in order to capitalize on its associations with youth and vibrancy.[23] In the mid- to late sixties, the art market expanded to an unprecedented size as mainstream media and the business world responded to this and other overtures. "When Attitude Becomes Form," the landmark 1969 Conceptual art survey at the Kunsthalle Bern, was proudly sponsored by Phillip Morris Europe.

This campaign was so successful that by the time I was in school, the *History of Modern Art* textbook version of Conceptualism had for the most part been shorn of its psychedelic fringe. It was all Bertrand Russell and no Timothy Leary. A picture of Joseph Kosuth's *One and Three Chairs* typically represented the entire movement (itself lumped in with kinetic sculpture, photorealism, and other unclassified tail-end-of-Modernism phenomena): a plain wooden chair, a photograph of the same chair, and an enlarged copy of the dictionary entry for *chair*, circling one another in endless, self-reflexive ennui. And looking back over the austere documentary legacy of the movement — its innumerable black-and-white photographs of notebooks on tables, copious sheets of graph paper marked with cryptic notations, and punitively dry artists' statements — it's possible to imagine Conceptual art, as art historian Benjamin Buchloh did in 1990, as a reflection of the protocols of a "totally administered world," a term he borrowed from Adorno: a bean counter's art, an art for the managerial class, void of emancipatory purpose or utopian aspiration, heralding the numbing blandness of the information society to come.[24]

In many ways this reading of Conceptual art hinges on the idea of tedium — a commonality in the experience of both postwar office culture

and many landmark works of Conceptual art. In "Dematerialization," Lippard and Chandler praised the "unbearable" slowness of Michael Snow's landmark structuralist film *Wavelength*.[25] Dan Graham's early performances, such as *Lax/Relax* (he says the word "relax" while a taped female voice says the word "lax," over and over, for thirty minutes), were aggressively tedious. On Kawara's *One Million Years (Past)*, a ten-volume set of hardbound books enumerating the years 998,031 B.C. to A.D. 1969, is lousy with the stuff. Kaltenbach's work escapes tedium only by virtue of the relative brevity of its reception: you didn't spend enough time with it to get bored.

But of all human experiences, tedium is the one most radically reconfigured by the practice of taking drugs; drugs can turn experiential poverty into experiential plenitude, in life or in art. It's possible to be in a state in which you read page after page of typewritten lists of years, or rearrange a piece of fabric on the floor of a gallery, or listen to Dan Graham say "relax" while at the same time a taped voice says "lax" over and over, and *never want it to end*. Similarly, exchanges like the one between critic Michel Claura and Lawrence Weiner from 1971,

> M.C.: In what way do you concern yourself with color?
> L.W.: In terms of color.[26]

can be interpreted differently whether you imagine them emanating from a rigorous framework of analytical philosophy or from the center of a dense cloud of pot smoke.

Kaltenbach, however, had no qualms about presenting himself as a head. In his 1969 interview with Patricia Norvell, he linked his shift to a more rationalized form of art-making with—surprisingly—the decision to start smoking marijuana. "I began to trust the feelings I had on grass because I found that, for the most part, they were more logical than I would normally come up with," he told her.[27] He credited the inspiration for his fabric works to the experience of being stoned in a friend's figure drawing class and watching the models pose with a bolt of patterned cloth.

Forty-one years later, in an essay in the catalog to Sarah Lehrer-Graiwer's exhibition in Los Angeles, he described a formative mescaline trip taken with John Torreano in his loft on Greene Street. "That single time John and I shared an experience of spectacular beauty," he wrote. "For the next decade I attempted to recapture that amazing experience by dropping LSD every few months while I tried to come to an understanding of how to portray that vision in paint."[28]

Torreano, for his part, seems to have been unmoved by the experience. When I interviewed him in New York, he recalled the whole drug thing in a less than glowing light. People hurt themselves, he told me, and relationships were irrevocably harmed. Lee Lozano ended up severely damaged by her commitment to drug use as a component of her art; according to Torreano, it contributed greatly to her eventual withdrawal from the art world. "Steve had a more spiritual connection to it," he said.

I said, "Steve remembers that you and he went on a mescaline trip that was very important—"

"To *him*," he said.

CAUSAL WORK, THE attempt to produce a work of art by influencing another artist, turned out to be kind of a dud. The problem, as Kaltenbach found out, was a matter of both etiquette and verification. "I wasn't comfortable with it. It was pretty invasive, and right away I realized I couldn't talk about specifics." In the case of Robert Morris, he could report on how the older artist had influenced him (he walked away from the studio visit having decided to make his fabric pieces out of felt rather than canvas), but he couldn't say what, if anything, he had imparted to Morris. The same was true for the other artists he attempted to influence in New York—a group whose membership he never divulges for the reasons listed above. "There was really no way of telling what I had given them," he told me. "I don't have a list. I remember it, but when I'm gone, it's gone."

Causal Work also marked an asymptote in Kaltenbach's New York trajectory; it's hard to imagine a more minimal or data-evicted form of art

than this. Other artists arrived at similarly absurd reductions around the same time. For a 1969 exhibition in Seattle organized by Lippard, Robert Barry submitted an untitled work comprising the phrase:

> All the things I know but I am not at the moment
> thinking—1:36 PM; June 15, 1969, New York.

Bernar Venet decreed that, for the duration of "Art of the Mind" at Oberlin College in Ohio, "any extra effort by the students of Oberlin College, in all disciplines" would constitute his artwork. No sooner had artists commenced the programmatic testing of art's ontological minimum than they arrived at the conclusion that it probably didn't have one: either the "ultimate zero point" anticipated in 1968 by Lippard and Chandler had been reached almost immediately, or else it never would be. Facing this paradox, artists were left to decide what to do after art had swallowed its own tail.

What's more, the initial utopian thrust of Conceptual art was rapidly fizzling out. Attempts to lay the groundwork for an open-source economy of ideas had been quickly enclosed by innovative strategies to stabilize, privatize, and monetize even the most ephemeral of artistic gestures. In 1970 came the "Information" show at MoMA, Kynaston McShine's seminal survey of Conceptual art devoted to the expansion of art's audience via technology and the mass media, and the birth of the United Nation's World Intellectual Property Organization, a committee devoted to policing the international transmission of technical knowledge through worldwide copyright accords. In 1973, only five years after "The Dematerialization of Art," Lippard noted with chagrin, "Hopes that 'conceptual art' would be able to avoid the general commercialization, the destructively 'progressive' approach of modernism were for the most part unfounded."[29]

In its first phase, the aggressive anti-object stance of Conceptualism promised to liberate artists from the commodification of their work, whether they wanted it or not. But nothing spoils an avant-garde like success: "Three years later," Lippard continued, "the major conceptualists are selling work for substantial sums here and in Europe."[30]

In the 1969 Open Hearing of the Arts' Workers Coalition, an activist group devoted to the reform of financial and exhibition practices in New York museums, Dan Graham expressed a frustration shared by many artists: that a transformation of the work of art, however thorough, did nothing to change the system in which it existed. In a rambling statement, Graham opined: "It's time to leave all this shit behind; the art world is poisoned; get out to the country or take a radical stance."[31]

■ ■

BEFORE I MET Kaltenbach in Davis, I made three stops in Sacramento, about fifteen miles to the east. The first was to see *Time to Cast Away Stones*, a monumental public sculpture he completed in 1998 for the Sacramento Convention Center.

The piece, the largest of the commissioned outdoor works Kaltenbach has been making since the eighties, is a bisected fountain, sixty-eight feet across, set into a diamond-shaped traffic island where K Street meets 13th Street at the center's entrance. Water spills over the edges of two rectangular platforms into larger, triangular pools. On each platform float rafts of concrete heads, torsos, hands, and feet, representing figures from different world sculptural traditions. There are chunks of Buddhas, bits of Bodhisattvas, dismembered Greek *kouroi* and Qin dynasty Chinese warriors, and, facing southward down the street, the head of Kaltenbach's former teacher and the presiding deity of Northern California art, Bob Arneson.

Visible beneath the falling water are four poetic questions ("What have we thought?" "Where are we going?" "What have we wrought?" "How are we loving?") engraved into the vertical faces of the platforms—though I missed them entirely on my visit and saw them only later, in pictures of the sculpture on a blog about Sacramento cultural life. Completing the work, two sets of concrete benches run north and south from the fountain on the sidewalks of 13th Street, beneath lines of tall,

leafy trees. On one side of the street, engravings along the bottom of the benches read

HEARTHEARTHEARTHEARTHEART

On the other, they read

HEAR THE ART HEAR THE ART HEAR THE ART

The fountain is one of four public Kaltenbach sculptures in the city. The other three occupy, respectively, a lawn on the Sacramento State campus (*Ozymandias*, a pair of seven-foot-tall bronze legs); a pool at the capitol building (*Peace*, two dismembered hands shaking each other); and the plaza of a shopping center (*Matter Contemplates Spirit*, a neoclassical head of a woman). Kaltenbach has placed other sculptures in Napa, California, Los Angeles, and Tucson.

Richard Haley, a young Detroit-based artist who grew up in Sacramento and studied with Kaltenbach at Sacramento State in the mid-2000s, came to Kaltenbach through his public sculptures. "I knew of Steve, but only knew of him as the guy who had made the great big fountain in Sacramento," he told me. Only when he started digging around in the annals of Conceptual art did he notice his professor's name popping up here and there in the literature.

At the School of Visual Arts in New York, Kaltenbach had spent most of his time as a teacher trying to get out of the classroom. He took a group of students on a field trip to the Metropolitan Museum in garish costumes and face-paint. He instructed another group to track down the elusive mail-art artist Ray Johnson, who by the late sixties had left the city for a town on the north shore of Long Island.

But in Sacramento, Kaltenbach's teaching style was more traditional. He taught mold making and figure sculpting classes, preferably in long stretches on Saturdays, from nine in the morning until three in the afternoon. "He was very approachable. His style of teaching was to sit and talk with you about your ideas and try to understand them . . . He didn't really give criticism, he just wanted to help you work through them and see where

you might be able to take them," Richard said. (Kaltenbach said, wistfully: "I was a much better teacher in my first decade than in my last two decades. But I never lost sight of the fact that one of the worst things I could do was to teach someone how to do art.") Sculpture classes at Sacramento State took place in a corrugated metal hut with an enclosed yard in the back. Kaltenbach had filled it up with bits and pieces of his sculptures—molds, test casts of concrete heads, hands, bodies, and pillars—either discarded as failures or left outdoors to age, Richard wasn't sure.

IT'S TEMPTING TO imagine Kaltenbach's move from New York back to California as a gesture made in resentment, disappointment, or anger, in keeping with Lee Lozano's own passive-aggressive withdrawal, or as a response to the general darkening of the mood in the city: Dan Graham's sense that the art world had become "poisoned" and that it was time for some fresh air. Nixon was in office and the United States had just entered Cambodia; the School of Visual Arts was in a turmoil following the Kent State Shootings; the city was heading into a decade-long recession. The revolutions of Conceptual art weren't liberating anyone from anything.[32]

In Davis, I mentioned this to get Kaltenbach onto the topic of why he left. Was he bummed out in 1970? "I never did own up to any angst," he told me, "and I don't believe that it would be honest for me to." For him, the decision to leave New York was dictated entirely by the demands of his work; it followed logically from ideas he'd been pursuing in the years leading up to it. A big part of Kaltenbach's tendency as an artist had been to try to get *outside*: of the object, of the gallery, of the category of art that imposed itself between himself and the viewer. Getting out of New York was the inevitable next step.

In addition to the work he made for public exhibition, Kaltenbach had also been doing projects on the sly—surreptitious art actions that extended his interest in concealment and influence. His first "life drama" began in 1968, on a trip to the Lord and Taylor department store with his girlfriend. "There was a gallery of couch paintings on the furniture

floor that had paintings hanging on the wall and furniture related to it," he told me. The paintings were competent, attractive, and utterly boring: floral still lives, pretty portraits, brushy decorative abstractions. The artists who made them operated within a totally different system of art than Kaltenbach and his peers did; they had as much to do with Conceptual art as Herb Alpert and the Tijuana Brass had to do with La Monte Young. Standing in the Lord and Taylor furniture showroom, Kaltenbach decided he would like to have a show there.

Painting was very much on his mind, and so was something he calls "the protocol of opposites": the idea that to be innovative as an artist, you could usually just observe what everyone else was doing and then do the reverse. "People were talking about 'good painting,' and how this artist was good, and how this artist didn't make 'good paintings,'" he said. "And I thought, how could I guarantee that I would make 'bad' paintings?"

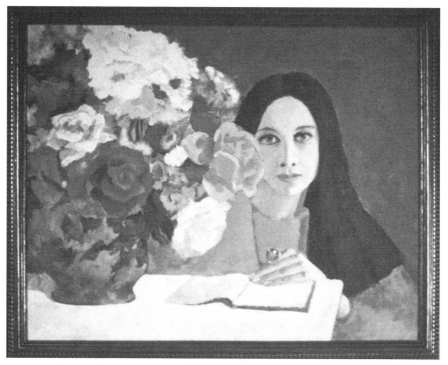

Figure 6.5

Over the next month, he made nine. He painted flowers and women. The work was excruciating; he hadn't painted in years. "They had to be professional. Bad, but professional." At the end of the month he made an appointment and brought his work to Lord and Taylor for review.

"The woman that ran the gallery was very encouraging," he remembered. "She said, 'You've got it—I just think you need to work more. Just come back next year and show me what you've done, and I bet we can give you a show.'" Chagrined, Kaltenbach went home and gave the paintings away, most of them to his landlord.

Next, he turned his attention to sculpture. He imagined a young artist who, instead of aspiring to get his work into one of Seth Siegelaub's or Lucy Lippard's shows, dreamed of exhibiting in the fancy uptown galleries specializing in conservative abstract sculpture à la Henry Moore. He had a little money (the art dealer Gian Enzo Sperone had just purchased a wall drawing and some sidewalk plaques) that he allocated to this project. He gave the artist a name, Clyde Dillon, bought him a wardrobe—a false mustache, a wig, and a sports coat—and started making bronzes. (He had been unfamiliar with Marcel Duchamp's own pseudonymous artistic identity, Rrose Sélavy. "I was sort of disappointed to read about that," he told Sarah.)[33] Unlike the couch paintings, Kaltenbach didn't give away his Dillon works; after a flood, they were thrown out by an ex-girlfriend's father, who had been storing them in a box in his basement in Scarsdale.

Kaltenbach based these two personae on an inversion of his own. "I saw myself as an international avant-garde artist. That sounds like a pretty high opinion, but actually it was only based on the fact that I was, on a monthly basis, getting invited to do this or that, a lot of it in Europe," he said. The protocol of opposites dictated that, as an international avant-garde artist, he should stop making international avant-garde art, and retreat back into convention.

If these life dramas had a genre it would be tragicomedy: their protagonists—the anonymous, sad-sack, couch-painting painter, and the earnest sculptor Clyde Dillon—were fated by their author to stumble through the

business of being artists but fail to grasp the essentials. "I felt the couch painter didn't understand the potential of art," he said.

These pieces led him directly from SoHo to Sacramento. Kaltenbach had kept strong ties to the Northern California art scene, returning to teach in the summers after he moved to New York. In 1970, he got a job offer to teach at Sacramento State.

"I realized I could do this really huge project," he said. "I decided I wanted to create a regional artist. I wanted to make him as good as possible, but have his concerns be *off* enough that it wouldn't really be received by the avant-garde world."

He paused. "And that has worked for a long time. But I think in many ways it's beginning to fail. Because some of the work I've done is now being taken seriously."

MY SECOND STOP in Sacramento was to see Kaltenbach's *Portrait of My Father* at the Crocker Museum, a first-rate art institution in a city with little interest in art. A trim nineteenth-century California-Victorian mansion with an enormous Modernist appendage, the Crocker sits beside the Sacramento River a few miles west of downtown; Kaltenbach's painting hangs in a gallery of photorealist art on the third floor.

David and Cathy Stone had made sure I was planning to visit *Portrait* when I headed north. Kaltenbach had spent most of the seventies making it, and it was some kind of masterpiece; they weren't sure what kind.

"There's nothing like seeing it in person," Cathy said.

"There's this LSD quality to the color," said David.

"He was taking psychedelics when he was painting this stuff—he was a big acid head, pot smoker—"

"He might have started it at that point, and maybe finished it when he wasn't."

"I think he had his religious epiphany in that period. I remember being in school, about how he was doing drugs, and then he was wearing this little leather cross."

The painting is fifteen feet long and ten feet tall, and most of the canvas is taken up by the reclining head of its subject, who stares upward

out of small eyes nearly hidden in the shadows of bushy eyebrows and folds of wrinkled flesh. His white hair and beard form a stringy frame around his face and disappear into an expanse of pillow beyond his nose and forehead. The light source in the painting, and in the photograph on which the image is based, is somewhere behind and above the figure, so that it outlines his profile and catches a few strands of his beard, while leaving most of his face in half-shadow. In the two bottom corners of the canvas, tangles of hair fade nearly into complete darkness.

From all the way across the room, the painting has a faint, iridescent sheen, like the colors floating on the surface of an oil slick. From twenty paces, you realize that all the color in the painting is coming from a pattern, an arabesque that hovers in front of the black-and-white image of the man's head. From five, you can see that the arabesque is composed of translucent, interlocking shapes floating in pictorial space like an impossible glass sculpture. The artist has rendered each one, and each strand of beard or fold of aged skin, with acrylic paint sprayed through an airbrush, inch by painstaking inch.

If Kaltenbach's Conceptual works operate through concealment and eviction, offering the viewer less and less until the work of art achieves

Figure 6.6

total invisibility, *Portrait of My Father* represents the complete inversion of this method; it couldn't be more maximal. Art-historically speaking, it sits uneasily between the visionary paintings of the Russian Surrealist Pavel Tchelitchew, who depicted heads and bodies dissolving into luminous filigrees of radiant color, and something you might see painted on the side of a VW van in the parking lot of a Dead show. Its photomechanical cool—recalling Chuck Close's outsize airbrushed portraits of the late sixties, of which Kaltenbach might have been aware—is completely negated by the obsessive, illusionistic fervor with which the painting is made: each nodule of its latticelike overlay is rendered with a tiny white starburst of reflected light.

In other words, *Portrait of My Father* disregards every precept and injunction laid down by the theorists of advanced art from Greenburg to Kosuth. This is the point, said Kaltenbach. Just as his Lord and Taylor paintings were meant to be seen in one place only—the furniture showroom of Lord and Taylor—*Portrait of My Father* is a work designed with a specific audience in mind: one for whom the names Greenberg and Kosuth don't ring any bells. The painting is so popular with visitors to the Crocker that there's a picture of it on the foldout map of the museum next to its location in the floor plan. Bob Nickas told me that when he saw it in a show at MOCA in Los Angeles, entire busloads of schoolkids on field trips were crowding around it to get a better look.

Kaltenbach started *Portrait* in 1972, after his father passed away, and worked on it through 1979 in a studio forty miles out into the country from Sacramento. "I didn't have an address; I didn't have a phone. All I had was running water and electricity," he said. "It was a great place to work. I put in sixteen-hour days on that painting, week after week after week." According to Cathy Stone, Kaltenbach had a rig that allowed him to raise and lower the painting, so he could work up-close on all areas of the huge canvas, and a cast-acrylic model of the pattern that overlays the image; he looked through it in order to more accurately render the painting's translucent color effects.

He was also at the peak of his involvement with psychedelic drugs. In fact, the inspiration for the piece was to represent, in paint, the "experience of spectacular beauty" that Kaltenbach had shared with John Torreano while tripping in their building on Greene Street in 1968. ("The target audience for the portrait of my dad . . . is people who don't know about art and would never take mescaline.")[34]

Eventually, perhaps inevitably, the mood in Kaltenbach's isolated studio darkened. He had been cycling through different religious practices, Transcendental Meditation, Scientology, Zen Buddhism, without much relief from a worsening depression. "I was in an extremely low period, lower than I could ever have imagined was possible," he said. "I just had a bad opinion of humanity, and the world, to the point where I committed to never having children. I told people it would be so unethical to bring a human being into a world like this." He began to get more and more visitors to the remote studio—friends from Sacramento who were worried about the artist's mental state and, most of all, his drug use. "There was a rumor that he was packing heat," Torreano recalls.

At some point during this long night of the psychedelic soul, a peculiar thing happened to the artist, which is that God started talking to him—and not in the metaphorical sense, either. Kaltenbach held extensive conversations with the Divinity in his studio. He later recounted his religious conversion during a gallery talk at Sarah's 2010 exhibition:

> The last LSD trip I took of about twenty trips, I landed in a worldview that I never really did get completely back from. Where I went, I went to this place where God was not a monster. He was this very authoritative but friendly person. He knew what was going to happen to me, and I had some problems, and I said, "So, this is like what becoming a Jesus freak is?" And He said yeah. And I said, "So that means I'm not going to have a lot of friends when I get back, right?" And He said, "Well, you're always complaining about inadequate studio time."[35]

In Davis, Kaltenbach described the experience to me in more detail: "One day I was listening to public radio, and I heard this Tantric teacher talking about meditation. He was talking about yoga, and he said, 'In yoga, a person will meditate for five thousand lifetimes until they're clear enough to realize there is absolutely nothing they can do to make themselves worthy of God—so they just surrender to God.' He said, 'In Tantra, we do it right now.' It made so much sense to me. It really hit me between my brain and my heart."

The artist began to have visitations. "I was hearing God, he was telling me things that were going to happen, and they would happen. It was just not possible."

Telling the story in 2012, Kaltenbach recalls his experience in utterly calm, matter-of-fact tones; maybe coming to God from psychedelic drugs, or Conceptual art, fosters a sort of equanimity about the whole thing. He is self-deprecating and funny, and I sensed this was his way of acknowledging and mitigating the alarm, even scorn, that such a confession encounters in generally anti-religious milieus like the contemporary art world. Kaltenbach said that he's always been committed to a philosophy of openness in communicating with others—and that his religious conversion tested this practice. "I lost friends, gradually, as the years went on, because I think people couldn't really take it. I became known as a weirdo," he said, chuckling. "And I wouldn't argue."

Though he'd been raised a Lutheran (he left the church in early adolescence) and was open-minded about spirituality, he remembers being utterly astonished by his encounter with God, and reporting on it to his friends; they were even more frightened by this new development than they had been about all the LSD. "I was scaring people," he said. "They really thought I was going to be Géricault or something—finish my painting and kill myself." John Fitzgibbon, a colleague in the Art Department at Sacramento State, drove the forty miles from the city to Kaltenbach's studio almost daily, just to check up on the artist.

After a few months, he said, not just God but Jesus Christ, too, was communicating with him—to his initial consternation. "Why would I

need a figurehead of a religion when I have God in person?" he remembers thinking. "It just didn't make sense to me. I had some concern that I was getting bad information or something." But the experience persisted. "Eventually I caved in, basically."

Over a period of many years, Kaltenbach became a regular churchgoer—though he occasionally identifies as a "Southern Baptist Catholic," a denomination not likely to be found in any registry of religious orders. "It's all one church, in my opinion," Kaltenbach told me. Christianity helped clear up his depression and pessimism about the world and provided a moral compass for navigating the business of daily life. "I felt like I was being guided, and when I'd do things that were grossly selfish, I'd be tapped on the shoulder," he said. "I can't say it's made me a good person, but it's made me a person who's a bit more able to act like a good person. I don't feel like I'm ready for heaven. But I think it will happen . . . I believe that I'm an eternal being and that it's going to be an amazing amount of fun."

It was late in the afternoon and the dachshund was asleep on the ottoman. After we finished talking, we walked back out to the studio so I could take some pictures. Kaltenbach showed me some of the new sculptures he'd been making, the "densifications" of his early work: gray-painted boards with curved details and inexplicable notches, like disassembled components of some impossible piece of Ikea furniture. They were piled on a low table on the patio in the narrow backyard. On a wall of the house, we looked at a maquette for a public sculpture, a ring of interlocking human figures to be made into a large concrete-composite structure and installed, vertically, in a cleft between two hillocks.

The studio has a tall, vaulted ceiling; a half wall of corrugated metal separates a bay devoted to painting from a larger workshop. The storage racks at the rear of the space were lined with sculptures, some of them part of his Conceptual art—variations on the time capsules, mainly—and others corresponding to his figurative, public art. There were even some Clyde Dillons around. ("I think he's gotten better," Kaltenbach said of Dillon. "I mean, I'm allowing him to get what I would call better.")

Taking up most of the front wall of the studio was an enormous paint-
ing in progress, showing Kaltenbach's daughter as an ethereal, glowing
cherub floating against a field of stars. A pattern similar to the ghostly
arabesque in *Portrait of My Father* had been sketched in pencil over the
whole canvas, and the artist was in the process of painting it in with an
airbrush. Once this was finished, he said, he was going to make a nine-
by-nine-foot portrait of Jesus. He showed me two pencil sketches for
the work, tacked up to the wall next to the studio door. In each, a softly
smiling, almost cartoonish head of the Messiah regards the viewer with
unbearably clear, bright eyes. Kaltenbach said he was having trouble find-
ing the right kind of source material to base the image on—surprising,
given that in the history of art, there are probably more images of the face
of Jesus than of any other face in the world. But then again, how *do* you
paint a deity that shows up unannounced during an acid trip in a barn in
the seventies and makes Himself permanently at home in your life?

Entertaining the idea of Kaltenbach's "Elephant Project"—the
cohabitation of austere Conceptual art, monumental public sculpture,
prankish pseudonymous jokesterism, and earnest if unusual religious
painting, all in the same body of work—requires a certain amount of
mental limbering up beforehand. ("You have to take all of it in at once,"
David Stone had soberly advised). Though he was forthcoming about
most everything else, Kaltenbach was unwilling to spend a lot of time on
Elephantology during our interview.

"I've thought about it, some," he said. "I have some understanding
of how things occurred to me and why I did them, but I don't really have
time to go into it to any extent." He also seemed to feel it wasn't really
his job to do so. In the way that the time capsules were designed with
certain receivers in mind, and the *Artforum* ads were meant to target an
anonymous group of magazine readers, so too is the "Elephant Project"
intended for a specific audience: art historians of the future. "My hope is
that somebody will, and hopefully they'll discover interesting structures
of flow and thought," he said. "That'd be nice . . . I just don't want to be
around to see it."

Though he talked about being embarrassed by certain aspects of his work (his narrative was full of references to his sense of unease with a lot of the things he's done), Kaltenbach evinced no actual traces of the feeling. His embarrassment is purely rhetorical. In fact, he seemed to relish the discomfort that the more outré aspects of his work produce for his audience in the contemporary art sphere—including, for example, the twelve-foot-tall painting of his daughter as an angel that he showed me in his studio. "Seeing it from an avant-garde view, there's nothing right about that painting. Don't you agree?" he asked.

■ ■

BEFORE THEY MOVED Another Year in LA to the Design Center, the Stones were running their gallery as a room in their live/work space, itself within a former record-pressing plant across from a Kia dealership on San Fernando Road in Glassell Park: not exactly a stop on LA's art-world map. But in 2005, when they presented a small survey of Kaltenbach's early Conceptual art—one of the first exhibitions of his work outside the Central Valley since 1970—people showed up. Los Angeles County Museum of Art curator Lynn Zelevansky visited, as did artist John Baldessari (whose enthusiastic comment, according to David, was "How come art isn't fun anymore?"). Kaltenbach was invited to do a show at Konrad Fischer, a venerable gallery in Düsseldorf with strong historical ties to the Conceptual art movement. Los Angeles critic Bruce Hainley reviewed the exhibition for *Artforum*.

The Stones did a show of Kaltenbach's room constructions in 2007 and a survey of his time capsules a year later. In 2010, Another Year in LA mounted "Legend: Annotating the Elephant," the first exhibition at the gallery to include the artist's post-1970 work. This one really let the cat, or the elephant, out of the bag; it featured not just Kaltenbach's Conceptual art but also some psychedelic religious works, a wonky Clyde Dillon sculpture, and framed reproductions of his Lord and Taylor paintings. Passersby unfamiliar with the artist generally didn't stop in to look,

Cathy said, because the show looked like something that crawled out of a mall in Laguna Beach.

Sarah Lehrer-Graiwer, who had studied with Hainley at Art Center, wrote her *Artforum* piece at this time. Curator Peter Eeley put a time capsule in a Conceptual art survey at the Walker Art Center in Minneapolis. Sarah organized the Lozano, Kaltenbach, Graham show "Joint Dialogue" at the young LA gallery Overduin and Kite.

All this attention led to a gratifying scene at the exhibition "Land Art" at MOCA in the spring of 2012. "Steve came down for that, and we went to the press preview," David recalled. "[Jeffrey] Deitch came up and introduced himself to Steve and said, 'I just wanted to introduce myself. It's such an honor. When artists are talking about who's really happening, everybody's talking about you.'"

Bob Nickas, who'd turned me on to Kaltenbach in the first place, once told me about his "half-assed theory of the box set." He proposed it around the turn of the twenty-first century, and it's about the recuperative function of the art market.

In the 1990s, the music industry found a lucrative new revenue stream in the collection, digitization, and recontextualization of archival musical materials from the distant and recent past. You could take an artist (anyone from John Coltrane to the Velvet Underground), gather up all of their miscellaneous recordings (demos, studio outtakes, concert tapes, radio performances), add their complete back catalog and remaster the lot, hire a music scholar to write an historical essay and graphic designers to put together a booklet, and then sell the whole package to aging baby boomers for seventy-five dollars a pop. The multiple-CD box set was born. The genius of it, from a record industry standpoint, was that the raw material already existed; you didn't need to nurture new talent, produce new albums, or even cultivate a fan base. In fact, the box-settee didn't even need to be a particularly well-known artist: the box set produced its own effect of historical legitimation.

Bob's theory was that the same logic held true for the visual arts, and that, in the 2000s, the contemporary art industry was about to start box-

setting everything it could get its hands on. And in the past dozen years, galleries and museums have launched many well-coordinated campaigns of historical retrieval, securing markets and audiences for under-known artists from the postwar period. Anybody from the fifties through even the nineties could become a candidate for career revivification. The art world saw a boom in lavish coffee-table books, museum retrospectives, and museum-esque gallery shows devoted to the work of lesser-known Pop artists, Color Field painters, Minimalists, Post-Minimalists, Conceptualists, Energists, Appropriationists, and Lyrical Abstractionists. Lee Lozano herself has been retrospectively accorded a prominent place in the art-historical record that once neglected her; her work has undergone a similar leap in visibility and market value.

The process relies on a convergence of market pressures and capacities. To make it profitable, you need the following: a reservoir of good, undervalued art that's loose on the market and hasn't been looked at very much; accessible historical documentation (in the form of secondary media like magazine reportage and exhibition catalogs); a labor force of accredited scholars to supply the critical imprimatur; and most important, a collector base—individual as well as institutional—broad enough to buy everything.

The expanding, accelerating contemporary art industry provides all these things; in fact, its somewhat alarming speed of growth ultimately *requires* the retrieval of art from the past to sustain its forward motion. "The market needs material, now more than ever," Bob said; a major gallery that does twenty shows per year in two or three locations, plus a dozen art fairs worldwide, will find it economically expedient to work with mature artists rather than emerging ones. "Collectors don't take things seriously if they only cost fifteen thousand dollars. They don't care; it's not important. And the gallery doesn't want to spend all that money to make seventy-five hundred dollars. But if you have artworks with a built-in provenance, and the artist is historically significant, and can be put almost instantly into the institution at the museum level . . . *that* they will work on."

As David Stone had once intuited while thumbing through *Artforum*, Stephen Kaltenbach is an eminently viable candidate for the box-set treatment. He was active during a historically significant period, he has the CV to prove it, and he's produced enough stuff over the years to make his work attractive to collectors interested in buying in bulk. As he anticipated while hiding out in Sacramento, history will remember Stephen Kaltenbach—if only because he was in the right place at the right time. It will do so because history is in the business of remembering things; and lately, business has been good.

But despite the enthusiasm from a new generation of artists and critics, Kaltenbach's return to the art market hasn't been without logistical difficulties. The Stones have had to work hard to get Kaltenbachs into collections and institutions that reflect the artist's stature and historical importance. After his 2005 show, the Los Angeles County Museum of Art expressed an interested in acquiring *Modern Drapery*, one of Kaltenbach's arrange-it-yourself fabric pieces from the late sixties. Despite its impressive pedigree (the piece was first shown in a landmark exhibition at the Leo Castelli Warehouse in 1967), the Stones had a difficult time agreeing with the museum on a price. Even in 2005, it still wasn't easy to convince an acquisitions committee to shell out five figures for a three-by-twelve-foot piece of ordinary beige cloth.

In "The Aesthetics of Administration," Benjamin Buchloh observed that Conceptualism created a situation in which the work of art was "on the one hand a matter of linguistic convention and on the other the function of both a legal contract and an institutional discourse."[36] In other words, when you dematerialize an art object, you'd better be sure its paperwork is in order. Unlike Lozano, who at least kept detailed notes about what she was doing even if she never intended to exhibit it, Kaltenbach seems to reject even tacit compromises with documentation. Artworks have been given away, kept secret, falsely documented, made up, produced anonymously, or buried in the backyard.

"He thinks a lot about fucking with art historians," Sarah Lehrer-Graiwer said. "I don't think he's ever told me something that isn't true, but he *will* withhold information, happily." Cathy remembers visiting the artist's studio in Davis, armed with a notepad and a pen, to make a complete list of its contents. After hours of work, Kaltenbach generously offered to type up the list. Cathy handed it over, and never saw it again. "I swear to God he threw it away."

From a commercial standpoint, the most important form of art documentation — one that Kaltenbach's art utterly lacks — is an auction record. Despite his impressive exhibition history, Kaltenbach's art has few indices of value on which buyers or sellers might base their calculations. When he removed himself from art-world circulation, he interrupted not just the historical narrative but also the economic narrative of his work. "Part of that 'Leave New York and become a regional artist' thing is, in the meantime, you don't have market pricing that's going up with how many years you've been doing art," David grumbled.

If one of the problems of selling Stephen Kaltenbach is that the artist himself likes to muddy the art-historical waters around him, then, it occurred to me, maybe the Stones weren't making things any clearer. Introducing quasi-artworks such as reprinted blueprints, new maquettes of old sculptures, and inkjet prints of lost paintings adds a further level of ambiguity to an already confused archival situation. The smart thing to do, I thought, would be to get very hard-ass and forensic. Pin the artist down about dates and quantities, and get everything on paper. Don't replicate anything. Produce a catalogue raisonné. Convince an art history Ph.D to write a dissertation. Furthermore, hide the religious stuff. Get the artist some cool-looking pants and put him on the plane to New York to lecture at the Whitney.

All of this, of course, is thoroughly against the spirit of Kaltenbach's art, which, despite coming to resemble nothing like Conceptual art, has held fast to one of the most central tenets of the movement: that art ideas

can operate across time and space, nearly in defiance of physical and causal laws; the rest of it is window dressing.

Recently, Kaltenbach decided to honor Lee Lozano by remaking some of her work: pieces that she never documented but that he remembers seeing in her studio in New York. Among these are *Time*, a small assemblage of two lengths of string nailed to a wall, with a metal washer. The washer hangs on the strings and slides back and forth, into the past or toward the future. "I didn't know anybody who knew about that piece," Kaltenbach told me in Davis. "It didn't exist, it was very ephemeral, and so I was basically saving it for society."

But when the artist wanted to include some of these pieces in his 2010 exhibition, he and the Stones disagreed on the issue of attribution: Kaltenbach wanted to credit the works to Lozano, period, with no explanation.

"I was like, 'I cannot sell this to people as a Lee Lozano work,'" David said. "People are going to ask, 'Where's the documentation?'" (Kaltenbach: "They said it's dishonest. To me, it was just interesting.")

Figure 6.7

Eventually, they agreed on a phrasing—*Lee Lozano (as remembered by Stephen Kaltenbach)*—that would satisfy Kaltenbach's insistence on the actuality of the works while heading off any legal-ethical issues about authenticity: a wary linguistic truce between the last, utopian tendencies of Conceptualism and the bureaucratic realities of the art industry.

THE FINAL STOP on my Kaltenbach tour of Northern California was an Office Depot plaza at the corner of 65th Street and Folsom Boulevard in Sacramento. *Matter Contemplates Spirit*, a concrete woman's head in Greco-Roman style, about the size of a golf cart, rests on a stone dais in a patio between the Dos Coyotes Border Café and a Starbucks. Nearby, in an oasis of tall potted plants and metal tables with yellow parasols, a couple in T-shirts and shorts sipped iced coffee and looked at their phones. I ordered some food and sat down facing the sculpture: man awaiting burrito contemplates the meaning of art. The head looked up blankly at the California sky.

On the flight to the West Coast the week before, I'd read *The End*, Kaltenbach's self-published eschatological science fiction novel. It begins with two twentysomethings suddenly experiencing the Rapture while driving to LAX in a Jeep. As the faithful are bodily assumed into heaven, the city convulses: drivers disappear from cars, cyclists vanish from cycles, and airplanes drop pilotless from the sky (needless to say, I don't recommend it as in-flight entertainment).

When I mentioned I'd read the book, Kaltenbach goggled at me. "Oh, I'm so sorry! I'm a terrible writer." The prose in *The End* is certainly clunky, although sometimes this is charming ("Mark and Marci were high in more ways than one and for once it wasn't all drug related" is its incredible opening sentence). But it isn't clear how good it's *supposed* to be. *The End* is undoubtedly a novel. But based on everything else the artist has done, it may very well be a "novel" too: a self-conscious work of

Conceptual art that resembles an amateurish attempt at Christian fiction, in the way that Kaltenbach's furniture-showroom paintings resembled the clumsy daubings of a Sunday painter. Is *The End* terrible, brilliant, or brilliant because it's terrible? Christ, I thought. Once you go down this kind of rabbit hole, it's really hard to pull yourself out.

Kaltenbach's art poses many such challenges. Doubling is everywhere: there's Kaltenbach the Conceptual artist and Kaltenbach the "regional artist," the arch-strategist and the intuitive maker. There's the "Elephant Project," in which a cannily prescient artist engages the art world in a forty-year game of hide-and-seek; and then there's the simpler story, endlessly repeated, of an artist who gets tired of the big city and settles down to teach in a small town. Kaltenbach's unique talent, Sarah Lehrer-Graiwer told me, is "being able to be critical of it and also totally *in* it"—*it* being, I assumed, art, or life, or both. Probably both.

A few things are clear, though. In 1970, Kaltenbach set off for a remote point in non-art space, in order to work in a zone outside its industry and culture. In the intervening years, the industry and its culture have grown to encompass most, if not all, of that zone; Kaltenbach's position now feels eccentric but hardly remote. He rode into the sunset on the dark side of the moon but came out the other side of the black hole; pick your metaphor. So, what do you do when art catches up with you?

Kaltenbach's dealers had clued me in to a subtle feature of his time capsules: the ones he's made since moving to California are officially dated *1970–present*, regardless of whether they were assembled in 1975 or 2015. In one sense, this is yet another of the artist's attempts to tweak of the nose of art history, with its uptight, non-groovy attitude toward provenance and chronology. But it's more than that, too: a gesture toward a different sense of longevity, foreign to that of a world where innovations must be dated by the hour, movements come and go in handfuls of years, and careers rise and fall in decades or less. That dash in *1970–present* is an elastic cord, stretching further and further between then and now; the work of art expands to fill the time in between.

Figure 6.8

The Stones had one of these in their storage room, a time capsule to be uncorked before Kaltenbach's speculative future retrospective at MOCA. "And this one has a secret!" David said. He rocked the object forward on its base, and something inside it rolled and struck the inside wall with a low and resonant *bong*.

IMAGE CAPTIONS AND CREDITS

Figure 1.1. Sign-up sheet for spring 2012 midterm reviews, Rhode Island School of Design, Department of Painting, MFA Program.

Figure 1.2. Zach Seeger, *Saskia*, 2012. Canvas, fabric, foam, shells, 62 x 32 x 38 inches. (Image courtesy of the artist)

Figure 1.3. Claudia Bitran, *My Reflection*, 2011. Acrylic on wooden panel, 5 x 5 feet. (Image courtesy of the artist)

Figure 1.4. Taniya Vaidya's midterm review, spring 2012. (Photograph: Douglas Burns)

Figure 1.5. Joseph Bochynski, *DIY Chair Kit (Shaker Model)*, 2012. Cement, rebar, wood forms, tools, cardboard box, 5 x 7 x 2 feet. (Image courtesy of the artist)

Figure 1.6. Arthur Peña, (left) *Attempt 14*, 2012. Stitched canvas, latex, 36 x 36 inches; (right) *Attempt 15*, 2012, stitched canvas, latex, 36 x 36 inches. (Photograph: Kevin Jacobs; image courtesy of the artist)

Figure 1.7. Douglas Burns, *Untitled: Television Project*, 2012. Mixed media, dimensions variable. (Image courtesy of the artist)

Figure 2.1. Jan van der Straet/Stradanus (Phillip Galle, printmaker), *Color Olivi*, 8 x 10.5 inches. (16th–17th century). Woodcut. (Flemish Prints Collections, Graphic Division, Department of Rare Books and Special Collections, Princeton University Library)

Figure 2.2. Jaime Sabartés. Photograph: *El Comercio*, Guatemala, 1913. (Public domain)

Figure 2.3. Andy Warhol, *Oxidation Painting (in 12 parts)*, 1978. Acrylic and urine on linen, 48 x 49 inches. (The Andy Warhol Museum, Pittsburgh; Founding Collection, Contribution The Andy Warhol Foundation for the Visual Arts, Inc. © 2010 The Andy Warhol Foundation for the Visual Arts/ Artists Rights Society (ARS), New York)

Figure 2.4. Claire Fontaine, *Working Together*, installation view, 2011. (Image courtesy of Metro Pictures, New York)

Figure 3.1. Nicholas Frank, *Nicholas Frank Biography, page 72 (Second Edition)*, 2002. Framed printed book page, 9 x 11 inches. (Image courtesy of the artist)

Figure 3.2. Paul Druecke, *Blue Dress Park Invite*, 2000. Four-color printing on paper, folded size 5.25 x 6 inches, open size 10.5 x 12 inches. (Image courtesy of the artist)

Figure 3.3. Kim Miller, still from *Quincy Jones Experience*, 2008. Digital video, 4:25 minutes. (Image courtesy of the artist)

Figure 3.4. The Mary Nohl Art Environment. (Photograph: Debra Jane Seltzer)

Figure 3.5. Carly Huibregtse, *Adoration of the Mystic Lamb*. Installed at 516-TJK. (Photograph: Imagination Giants)

Figure 4.1. Dana Schutz, *Presentation*, 2005. Oil on canvas, 120 x 168 inches. (Image courtesy of the artist and Petzel, New York.)

Figure 4.2. Dana Schutz, *Frank on a Rock*, 2002. Oil on canvas, 66 x 47 inches. (Image courtesy of the artist and Petzel, New York.)

Figure 4.3. Dana Schutz, *Face-Eater*, 2004. Oil on canvas, 23 x 18 inches. (Image courtesy of the artist and Petzel, New York.)

Figure 4.4. Dana Schutz, *Singed Picnic*, 2008. Oil on canvas, 80.25 x 90.25 inches. (Image courtesy of the artist and Petzel, New York.)

Figure 4.5. Dana Schutz, *Party*, 2004. Oil on canvas, 72 x 90 inches. (Image courtesy of the artist and Petzel, New York.)

Figure 4.6. Dana Schutz, *God 1*, 2013. Oil on canvas, 106 x 72 inches. (Image courtesy of the artist and Petzel, New York.)

Figure 5.1. Mary Walling Blackburn, still from *Oofoe (Exercise One)*, 2012. Digital video, 4:21 minutes. (Image courtesy of the artist)

Figure 5.2. Mary Walling Blackburn, *Library for (the land of fuck)*, installation view, 2011. Bard Center for Curatorial Studies. (Photograph: image courtesy of the artist)

Figure 5.3. Mary Walling Blackburn, still from *Grizzly Man Again*, 2013. Digital video, 34:16 minutes. (Image courtesy of the artist)

Figure 5.4. A large male polar bear with the remains of a cub he caught and killed in the Manitoba Conservation Churchill Wildlife Managment Area, November 20, 2009. (Photograph © 2009 Daniel J. Cox/NaturalExposures.com)

Figure 5.5. Casa del Migrante, Tijuana, Mexico. (Photograph: Mary Walling Blackburn)

Figure 6.1. Stephen Kaltenbach, *Mirrored Contacts (Personal Appearance Manipulation)*, 1968. Photo collage, 18 x 24 inches. (Image courtesy of Nationalgalerie im Hamburger Bahnhof, Staatliche Museen zu Berlin)

Figure 6.2. Stephen Kaltenbach, *Nothing is Revealed (Graffiti Stencil)*, 1968. Stencil card, 9 x 12 inches. (Image courtesy of the artist and Another Year in LA)

Figure 6.3. Stephen Kaltenbach, *Artist's Canvas to be arranged by Collector (Modern Draperies)*, 1967. Canvas, 3 x 12 feet. (Image courtesy of the artist and Another Year in LA)

Figure 6.4. Giuseppe Penone, *Rovesciare i propri occhi*, 1970. (Photograph © Paolo Mussat Sartor)

Figure 6.5. Stephen Kaltenbach, *Couch Painting 3 (Lord and Taylor Series) by Es Que*, 1968–2010. Digital print on canvas, edition of 5. (Image courtesy of the artist and Another Year in LA)

Figure 6.6. Stephen Kaltenbach, *Portrait of My Father*, 1972–1979. Acrylic on canvas, 10 x 15 feet. (Image courtesy of the artist and Another Year in LA)

Figure 6.7. Lee Lozano (as remembered by Stephen Kaltenbach), *Time*, 1969. (Image courtesy of the artist and Another Year in LA)

Figure 6.8. Stephen Kaltenbach, *PRESENT*, 1970–present. Steel and unknown contents. (Image courtesy of the artist and Another Year in LA)

ACKNOWLEDGMENTS

THANKS FIRST OF all to the people I interviewed for this book, for their patience and generosity. I'd also like to thank my agent, Edward Orloff, and my editor, Rachel Mannheimer, for their expert guidance through the process. The following people provided essential help, whether they know it or not: Ryan Edwards, Dushko Petrovich, Prem Krishnamurthy, James Bae, Susan Yi, Sarah Hromack, Christopher Hsu, Naomi Fry, David Kearns, Megan Heuer, Edward Vazquez, Holly Veselka, and Noah Sheldon. Thanks also to Lee Roberts, Thomas Brauer, Steve Wetzel, Peter Barrickman, Michelle Grabner, Cassandra Thornton, Nicholas Cueva, Che Chen, Jamie McCallum, Ricardo Gomes, Marc Handelman, Peter LaBier, Natasha Marie Llorens, Nathan Lee, and The Camel Collective. Finally, enormous gratitude for the support of my family: Jeanne Pryor, Janet White, the Clintons and the Eckharts, and of course Maggie Clinton and Helena, who make all things possible and worthwhile.

NOTES

Introduction

1 See Hal Foster, "Against Pluralism," in *Recodings: Art, Spectacle, Cultural Politics* (Seattle: Bay Press, 1985); and Craig Owens, "The Problem with Puerilism," *Art in America* 72, no. 6 (Summer 1984): 162–63.

2 For a survey of recent attempts to articulate "contemporary art" as a periodizing term, see "Questionnaire on 'The Contemporary,'" *October* 130 (Fall 2009): 3–124; and Richard Meyer, *What Was Contemporary Art?* (Cambridge, MA: MIT Press, 2013), 14–16.

3 In *What Is Contemporary Art?* (Chicago: University of Chicago Press, 2009), art historian Terry Smith plays on multiple interpretive registers of the word "contemporary" to situate contemporary art at a confluence of discordant temporalities, engaging with the experiences of globalization, neoliberalism, and the digital revolution that form its context.

4 In a 2013 article in the *South Atlantic Quarterly*, art historian Yates McKee nominates the Rolling Jubilee, a project of the activist group Strike Debt, as an example of post-contemporary art: a collectively-authored intervention in the public sphere in which aesthetics and politics are productively integrated. See Yates McKee, "Occupy, Postcontemporary Art, and the Aesthetics of Debt Resistance," *South Atlantic Quarterly* 112, no. 4 (Fall 2013). https://yatesmckee.files.wordpress.com/2014/07/mckee_saq1.pdf.

1: The Art School Condition

1 Howard Singerman, *Art Subjects: Making Artists in the American University* (Berkeley: University of California Press, 1999), 13–14.

2 "Breakthrough Ideas for 2004," *Harvard Business Review*, February 2004. See also Daniel H. Pink, *A Whole New Mind: Why Right-Brainers Will Rule the Future* (New York: Riverhead, 2005).

3 Singerman, *Art Subjects*, 211.

4 Coco Fusco, "Alternatives," *Brooklyn Rail*, February 2013. http://brooklynrail.org/t/8348.

5 Ibid.

2: The Assistants

1 See Bruce Cole, *The Renaissance Artist at Work: From Pisano to Titian* (New York: Harper and Row, 1983).

2 Christopher Beam, "6. Outsource to China," *New York*, April 22, 2012. www.nymag.com/arts/art/rules/kehinde-wiley-2012-4.

3 Roberta Smith, "Standing and Staring, Yet Aiming for Empowerment," *New York Times*, May 6, 1998. www.nytimes.com/1998/05/06/arts/critic-s-notebook-standing-and-staring-yet-aiming-for-empowerment.html.

4 Bruce Hainley, "Vanessa Beecroft" (review), *Artforum*, Summer 2001. www.thefreelibrary.com/Gagosian+gallery%3A+Vanessa+Beecroft.+(Reviews).-a080485061.

5 David Shapiro, "Vanessa Beecroft" (interview), *Museo*, 2008. www.museomagazine.com/VANESSA-BEECROFT.

6 Helena Kontova and Massimiliano Gioni, "Vanessa Beecroft: Skin Trade" (interview), *Flash Art* 228 (July–September 2008): 211.

7 Gary Comenas, "Andy Warhol Chronology, 1969," Warholstars.org. www.warholstars.org/chron/1969.html.

8 Felicia R. Lee, "An American Life in Mixed Media," *New York Times*, September 11, 2003. www.nytimes.com/2003/09/11/arts/american-life-mixed-media-bearden-honored-with-national-gallery-retrospective .html.

9 Robert Storr, "At Last Light," in Gary Garrels and Robert Storr, *Willem de Kooning: The Late Paintings, the 1980s* (San Francisco: San Francisco Museum of Modern Art; Minneapolis: Walker Art Center, 1995), 39.

10 Harry F. Gaugh, introduction to *Willem de Kooning* (New York: Abbeville Press, 1983).

11 Storr, *Willem de Kooning*, 47

12 Susan Sollins and Susan Dowling, "Fantasy," *Art21*, Season 5 (2009).

13 Ibid.

14 Gary Comenas, "Andy Warhol's Piss Paintings," Warholstars.org. www.warholstars.org/warhol_piss_oxidation.html.

15 Rirkrit Tiravanija, *JG Reads*, Gavin Brown's Enterprise, New York, November 22–December 20, 2008.

16 "Claire Fontaine interviewed by John Kelsey," *Claire Fontaine*. www .clairefontaine.ws/pdf/jk_interview_Eng.pdf.

17 Chris Kasper, "An Open Letter to Labor Servicing the Culture Industry," *Dis*, "Labor Issue," 2011. www.dismagazine.com/discussion/16545/open-letter-to-labor-servicing-the-culture-industry.

3: *Milwaukee as Model*

1 Thomas Craven, *Men of Art* (New York: Simon and Schuster, 1932), 512.

2 Thomas Craven, *The Story of Painting* (New York: Simon and Schuster, 1943), 239.

3 Grant Wood, "Revolt Against the City," in James M. Dennis, *Grant Wood: A Study in American Art* (New York: Viking, 1975), 230.

4 Ibid., 231.

5 Ibid.

6 Mary Louise Schumacher, "Bright Ideas at Blue Dress Park," *Tap Milwaukee*, May 24, 2011. http://www.jsonline.com/blogs/entertainment/122512138.html.

7 See Frances Stonor Saunders, "Modern Art Was CIA 'Weapon,'" *Independent*, October 22, 1995. http://www.independent.co.uk/news/world/modern-art-was-cia-weapon-1578808.html.

8 Alexander Alberro and Patricia Norvell, eds., *Recording Conceptual Art* (Berkeley: University of California Press, 2001), 52.

9 Nicolas Bourriaud, "Altermodern Explained: Manifesto," *Tate*. http://www.tate.org.uk/whats-on/tate-britain/exhibition/altermodern/explain-altermodern/altermodern-explained-manifesto.

10 For an analysis (and archive) of the unrepresented forms of collective, creative labor undergirding the art industry in the age of neoliberalism, see Gregory Sholette, *Dark Matter: Art and Politics in the Age of Enterprise Culture* (London: Pluto Press, 2011).

4: Six Dana Schutzes

1 Miles Hall, "Dana Schutz at the Neuberger." http://www.miles-hall.org/#!dana-schut-review/c1clm.

2 Karen Rosenberg, "The Fantastic and Grisly, Envisioned," *New York Times*, October 6, 2011. www.nytimes.com/2011/10/07/arts/design/dana-schutz-at-neuberger-museum-review.html.

3 Barry Schwabsky, "Autopoeisis in Action," *Dana Schutz* (New York: Rizzoli, 2010), 13.

4 Brian Sholis, "Under Close Observation," *Parkett* 75 (2005): 54. www.briansholis.com/essay-dana-schutz.

5 Daniel Belasco, "Transformer: Dana Schutz," *Art in America*, November 2011, 137.

6 Terry Smith, *What Is Contemporary Art?* (Chicago: University of Chicago Press, 2009), 33.

7 Mia Fineman, "Portrait of the Artist as a Paint-Splattered Googler," *New York Times*, January 15, 2006. www.nytimes.com/2006/01/15/arts/design/15fine.html?pagewanted=all&_r=0.

8 Smith, *What Is Contemporary Art?* 33.

9 Sholis, "Under Close Observation," 54.

10 www.artsy.net/artist/dana-schutz.

11 Jerry Saltz, "Wild Card," *Village Voice*, December 17, 2002. www.villagevoice.com/2002–12–17/art/wild-card/full.

12 www.cfa-berlin.com/exhibitions/if_it_appears_in_the_desert/ press_releases.

13 This isn't to say that Schutz's paintings were now free from the pastiche effect that marked painting in the 1990s. In fact, she stole with impunity, haphazardly, from early European Modernism, the Bay Area Figuration of the 1960s, the Bad Painting of the '70s, the Neo-Expressionism of the early '80s, folk art, underground comics, cartoons, and slightly older artists like Laura Owens, Cecily Brown, Carroll Dunham. The scope and eclecticism of the theft, however, meant that these references operated differently within her paintings: there were simply so many of them in every canvas, and they multiplied so promiscuously, that pointing each one out began to seem pedantic. Why bother?

14 Gilles Deleuze, "Michel Tournier and the World Without Others," in the *Logic of Sense*, trans. Mark Lester (New York: Columbia University Press, 1990), 311.

15 Ibid., 320.

16 Maurizio Cattelan, "Dana Schutz: Me, Frank and My Studio," *Flash Art* 244, October 2005, 82.

17 Peter Halley, "Dana Schutz, 2004," *Index*. www.indexmagazine.com/ interviews/dana_schutz.shtml.

18 Mei Chin, "Dana Schutz," *Bomb* 95 (2006). www.bombsite.com/ issues/95/articles/2799.

19 Antonin Artaud, "I Hate and Renounce as a Coward . . . ," in *Artaud Anthology*, ed. Jack Hirschman, trans. David Rattray (San Francisco: City Lights, 1965), 222.

20 Max Pechstein, "Creative Credo," in *Art in Theory, 1900–1990*, ed. Charles Harrison and Paul Woods (Oxford: Blackwell, 1992), 269.

21 Schwabsky, "Autopoeisis in Action," 11.

22 Micah J. Malone, "Dana Schutz @ The Rose," *Big Red and Shiny*, March 19, 2006. www.bigredandshiny.com/cgi-bin/BRS.cgi?section= review&issue=39&article=DANA_SCHUTZ_19173310.

23 Peter Campbell, "At the Saatchi Gallery," *London Review of Books* 27 (February 2005): 4. www.lrb.co.uk/v27/n04/peter-campbell/at-the-saatchi-gallery.

24 Svetlana Alpers, "Wheel of Fortune," *Artforum*, September 2005. www.saatchigallery.com/current/reviews13.htm.

25 Craig Garrett, "The Triumph of Painting: Part One" (review), *Flash Art* 240 (January–February 2005). www.papercoffin.com/writing/articles/ triumph.html.

26 Kelly Crow, "Hot Art Market Stokes Prices for Artists Barely Out of Teens," *Pittsburgh Post Gazette*, April 17, 2006. www.post-gazette.com/ frontpage/2006/04/17/Hot-art-market-stokes-prices-for-artists-barely-out-of-teens/stories/200604170103#ixzz2akTSMU2i.

27 Michael Plummer and Jeff Rabin, "Could the Art Market Be Undergoing a Fundamental Restructuring?" *Art Newspaper* 209 (January 2010).

28 Hilton Kramer, "Expressionism Returns to Painting," *New York Times*, July 12, 1981. www.nytimes.com/1981/07/12/arts/art-view-expressionism-returns-to-painting.html.

29 Donald Kuspit, "In Search of the Visionary Image," *Art Journal* 45 (1985): 319.

30 See Hal Foster, "Against Pluralism" in *Recodings: Art, Spectacle, Cultural Politics* (Seattle: Bay Press, 1985); and Craig Owens, "The Problem with Puerilism," *Art in America* 72, no. 6 (Summer 1984): 162–63.

31 Benjamin H. D. Buchloh, "Figures of Authority, Ciphers of Regression: Notes on the Return of Representation in European Painting," *October* 16 (1981): 60.

32 Anonymous, November 19, 2006 (3:05 a.m.), comment on Edward Winkelman, "Artist of the Week 07/19/05," Edward Winkelman, July 19, 2005. www.edwardwinkleman.com/2005/07/artist-of-week-071905.html.

33 Anonymous, December 6, 2005 (11:00 p.m.), comment on Winkelman, "Artist of the Week 07/19/05."

34 Anonymous, March 18, 2006 (7:05 p.m.), comment on "Judith Linhares," Painternyc, March 18, 2006. www.painternyc.blogspot.com/2006/03/judith-linhares.html.

35 Jarrett Earnest, "In Conversation: Dana Schutz with Jarrett Earnest," *Brooklyn Rail*, June 4, 2012. www.brooklynrail.org/2012/06/art/dana-schutz-with-jarrett-earnest#.

36 Elwyn Palmerton, "Dana Schutz: Stand by Earth Man" (review), *Art Review*, July–August 2007. www.bluetoad.com/display_article.php?id=13182.

37 Rosenberg, "The Fantastic and Grisly, Envisioned."

38 JL, "Eating People Is Wrong," *Modern Kicks*, January 23, 2006. www
.modernkicks.typepad.com/modern_kicks/2006/01/eating_people_
i.html.

39 Jerry Talmer, "Creation Is for Beauty Parlors," *New York Post*, April 9,
1977.

40 Max Beckmann, "Creative Credo," in *Art in Theory*, 268.

5: *The Estranger*

1 "Events," *In This Hello America*. www.inthishello.tumblr/events.

2 Claire Bishop, "The Social Turn: Collaboration and Its Discontents,"
Artforum, February 2006, 178–83. See also Claire Bishop, *Artificial Hells:
Participatory Art and the Politics of Spectatorship* (London: Verso Books,
2012).

3 Joseph Beuys, "I Am Searching for a Field Character," 1977, in *Joseph
Beuys in America: Energy Plan for the Western Man*, ed. Carin Kuoni
(New York: Four Walls Eight Windows, 1993).

4 Mary's mother later amended the anecdote, moving the site of the
hike seven hundred miles south to Big Bear Lake in the San Bernardino
Mountains.

5 Simone Menegoi, "A Question of Time," *Mousse* 11 (November
2007). www.moussemagazine.it/articolo.mm?id=62.

6 Co-taught with the art historian Katie Anania.

7 Mary Walling Blackburn, "XOXO Insanity, Institution," *e-flux journal* 26 (June 2011). www.e-flux.com/journal/xoxo-insanity-institution.

8 Jean-Luc Nancy, *Corpus*, Richard A. Rand, trans. (New York: Fordham University Press, 2008), 167.

6: *The End*

1 Sarah Lehrer-Graiwer, "Privacy, Self-Removal, Withdrawal, Dropout," in *Joint Dialogue Book* (Los Angeles: Overduin and Kite, 2010), 84.

2 Cindy Nemser, "Interview with Steve Kaltenbach," *Artforum*, November 1970, 48.

3 "Steven Kaltenbach interview." YouTube video, 6:11. Posted by Artillery-mag, August 21, 2010. www.youtube.com/watch?v=NqioPeGsS4Q.

4 Lee Lozano, *Grass Piece*, 1969, in *Joint Dialogue Book* (Los Angeles: Overduin and Kite, 2010), 22.

5 Lee Lozano, *no title ("Party/Paranoia, Painting, Real Money Piece")*, 1969, in *Joint Dialogue*, 27.

6 Sarah Lehrer-Graiwer, "Altered Ego," *Artforum*, September 2010, 137.

7 In Alexander Alberro and Patricia Norvell, eds., *Recording Conceptual Art* (Berkeley: University of California Press, 2001), 73.

8 Lucy R. Lippard, *Six Years: The Dematerialization of the Art Object, 1996 to 1972* (New York: Praeger, 1973).

9 Lucy R. Lippard and John Chandler, "The Dematerialization of Art," in *Conceptual Art: A Critical Anthology*, ed. Alexander Alberro and Blake Stimson (Cambridge, MA: MIT Press, 1999), 50.

10 Ursula Meyer, introduction to *Conceptual Art* (New York: E. P. Dutton and Co., 1972), xv.

11 Joseph Kosuth, "Art After Philosophy," in ibid., 161.

12 Gregory Battcock, introduction to *Idea Art: A Critical Anthology* (New York: E. P. Dutton and Co., 1973), 1.

13 Meyer, *Conceptual Art*, xx.

14 John Perreault, "It's Only Words," in Battcock, *Idea Art*, 137.

15 Lippard and Chandler, "The Dematerialization of Art," 49.

16 Nemser, "Interview with Steve Kaltenbach," 49.

17 Ibid.

18 Kynaston McShine, "Introduction to *Information*," in Alberro and Stimson, *Conceptual Art*, 213.

19 Lippard and Chandler, "The Dematerialization of Art," 49.

20 Page from Lee Lozano Private Notebook in *Joint Dialogue Book* (Los Angeles: Overduin and Kite, 2010), 72.

21 See ibid., 22–24, 46.

22 See Alexander Alberro, *Conceptual Art and the Politics of Publicity* (Cambridge, MA: MIT Press, 2003).

23 Ibid.

24 Benjamin H. D. Buchloh, "Conceptual Art, 1962–1969: From the Aesthetics of Administration to the Critique of Institutions," *October* 55 (1990): 129.

25 Lippard and Chandler, "The Dematerialization of Art," 47.

26 Michel Claura, "Interview with Lawrence Weiner," in Alberro and Stimson, *Conceptual Art*, 237.

27 In Alberro and Norvell, *Recording Conceptual Art*, 72.

28 Steven Kaltenbach, "The Brilliance of Lee Lozano . . .," in *Joint Dialogue*, 114.

29 Lucy R. Lippard, postface to *Six Years*, 263.

30 Ibid.

31 Dan Graham, "Art Workers' Coalition Open Hearing Presentation," in Alberro and Stimson, *Conceptual Art*, 93.

32 In New York, at least; for an introduction to the explicitly political development of Conceptual Art in Latin America, see Luis Camnitzer, *Conceptualism in Latin America: Didactics of Liberation* (Austin: University of Texas Press, 2007).

33 Sarah Lehrer-Graiwer, "Kaltenbach Speaks (with sporadic interruptions from listener)" (interview), *Pep Talk IV* (October, 2009): 12.

34 Ibid., 14.

35 "Steven Kaltenbach at interview, Overduin and Kite." Youtube video, 9:23. Posted by Artillerymag, June 26, 2011. www.youtube.com/watch?v=0q2kIYZ2KWA.

36 Buchloh, "Conceptual Art," 118.

INDEX

Note: page numbers followed by "f" and "n" refer to figures and endnotes, respectively.

A NOTE ON THE AUTHOR

ROGER WHITE IS a painter and writer who splits his time between Middlebury, Vermont, and Brooklyn, New York. He has exhibited his paintings in New York, Los Angeles, Chicago, and Tokyo. His work is represented by the Rachel Uffner Gallery in New York. He received an M.F.A. from Columbia University in 2000, and in 2007 he cofounded the art journal *Paper Monument*.